Professional

CHILDREN'S PORTRAIT PHOTOGRAPHY

Techniques and Images
from Master Photographers

LOU JACOBS JR.

AMHERST MEDIA, INC. ■ BUFFALO, NY

Front cover photographs by Brian McDonnell (large); Audrey Woulard (top inset); Alycia Alvarez (middle and bottom insets). Back cover photographs by Audrey Woulard (top) and Carrie Sandoval (bottom).

Published by:
Amherst Media, Inc.
P.O. Box 586
Buffalo, N.Y. 14226
Fax: 716-874-4508
www.AmherstMedia.com

Publisher: Craig Alesse
Senior Editor/Production Manager: Michelle Perkins
Assistant Editor: Barbara A. Lynch-Johnt
Editorial Assistance: Harvey Goldstein, Artie Vanderpool

ISBN-13: 978-1-58428-205-1
Library of Congress Control Number: 2006937286

Printed in Korea.
10 9 8 7 6 5 4 3 2 1

TABLE OF CONTENTS

INTRODUCTION

PROFESSIONAL ADDICTION

Many professional portrait photographers find that children can be addictive. In this book you will meet fifteen professionals in the children's portrait field who are charmed and enthusiastic about babies, toddlers, and older children. You should also be aware that kids are both challenging and engaging, and these photographers are usually paid well for the work they enjoy.

A majority of the professionals who make portraits of children are women who have children of their own. However, the men in this book are as fervent and empathetic about kids as the women, and most are fathers. Some contributors were motivated to become a professional photographer after their children were born; many left other forms of employment to photograph full time. Some in the group prefer studio work, while others photograph on location in parks or clients' homes.

KIDS ARE SO CUTE

Each chapter features the experiences and wisdom of an expert who explains his or her background and ap- proaches to children's portraiture. My group of photographers discuss subjects such as helping children warm up to the camera, lighting preferences, and methods of studio promotion. Each chapter is illustrated with photographs created by the individual who was interviewed.

Many parents bring their children to a professional photographer after seeing professional portraits of their friends' children. These parents will come to your studio because they want the same strong and attractive photos for themselves. The fifteen experts in this book will show you how to make the most of your opportunities when kids and their parents appear in front of your camera.

THE PHOTOGRAPHERS

Some men and women in this book were hooked on photography in high school, or they just started taking pictures of kids and selling them to friends. Some hung on to their daytime jobs until they were seriously involved. Audrey Woulard told me, "After my son was born, my husband came home with a professional digital camera for me and I took pictures of the baby as he grew. I was fas-

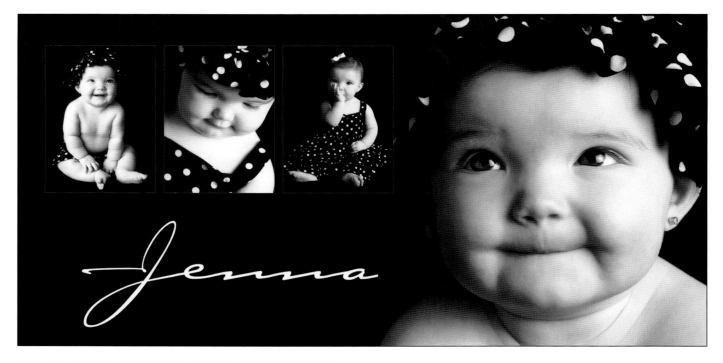

cinated by his movements, his expressions, his whole baby routine. Eventually, I started making pictures of other moms' children, and now I make a living doing what I love to do."

Some studied photography; some read books about technique and looked at many photographs. Some attended workshops and seminars; some had mentors to educate and encourage them. I met a few contributors through my *Rangefinder* articles. I also had helpful suggestions from photographers Dina Douglas and Audrey Woulard. Before getting acquainted, I checked everyone's web-site images and was impressed.

Stories you will read from these professionals will encourage readers who feel that formal education or assisting in someone's studio are required for success. Strong motivation, hard work and smart business practices are much more necessary. The words and pictures that follow will help you understand how experts have succeeded by being creative and resourceful.

INDIVIDUALITY

Study the photographs in this book and consider why you admire them. Individual images by various photographers may look similar, and that's not unusual. Unique, one-of-a-kind, child portrait styles are rare, but the same can be said about the styles of painters, writers, composers, actors, and even about the windups of baseball pitchers. Photographers are not being copycats when their creative minds come up with related visual solutions.

Photographic style is generated by imagination, inspiration, camera angles, poses, lighting, and backgrounds. The faces of children have individual appeal; your ability to charm kids is invaluable.

It is perfectly okay if you and I don't agree about which portraits are gems. Keep in mind that a lot of parents paid well for, and love, the photographs that are in this book. Please enjoy learning from my fifteen experts. They can help make your photography more fun and more profitable. Like the fortune cookie says, "New opportunities will surely follow."

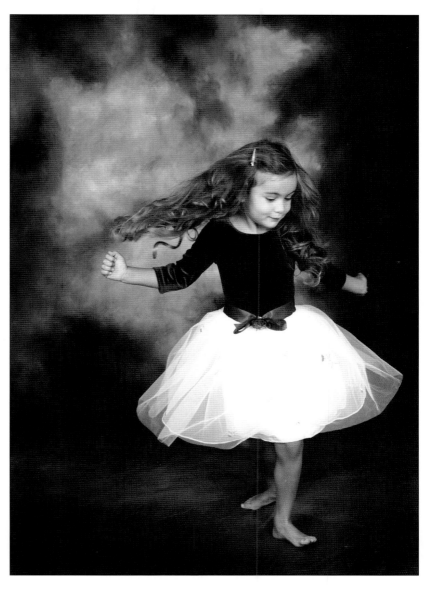

AUTHOR'S NOTE

Each photographer in this book was given the same topics to discuss, and I edited their responses for clarity. Some photographers combined topics. Techniques are mainly revealed in the same order so you can compare them easily. Some views and recommendations sound similar because good photographic practice prevails; ideas and suggestions repeated can be quite convincing.

This book is the opposite of a mystery. You see the evidence of each photographer's good works in his or her photographs. The photographers' motives are clear. This is not a whodunit, but rather, a how-to-do-it from the experiences of fifteen children's portrait photographers.

Above and facing page photos by Alycia Alvarez.

1. STACEY KANE

Stacey Kane of Scarborough, Maine, does lifestyle portraiture with a documentary approach, photographing babies, children, families, and photojournalistic weddings. She has a web site for her children and families and another for weddings. She photographs in her studio and on location, even during the long, cold, Maine winters. To learn more visit her at www.staceykane.com or www.staceykaneweddings.com.

What is your background?

I graduated from the University of New Hampshire as a communications major. Looking back, I realize that I was always the one with a camera, but a career in photography never occurred to me. After a lot of persuasion by friends and family, I started photographing children and discovered that I loved it and I was good at it.

I was pregnant with my third child (who is now five) when I photographed my first session. I photographed a family of three on a beach while thinking, "Oh please don't go into labor now." The pictures at that session came out beautifully, and my son waited two more weeks to arrive.

From the beginning, I planned only to photograph children and families, and was determined never to photograph weddings. However, when a couple saw some of my child images, they insisted that I photograph their wedding. I refused, pointing out that the pictures they admired were of a one-year-old. They didn't care and eventually wore me down. I am now in my third year of enjoying wedding coverage. The hard part is balancing photography schedules between children and weddings.

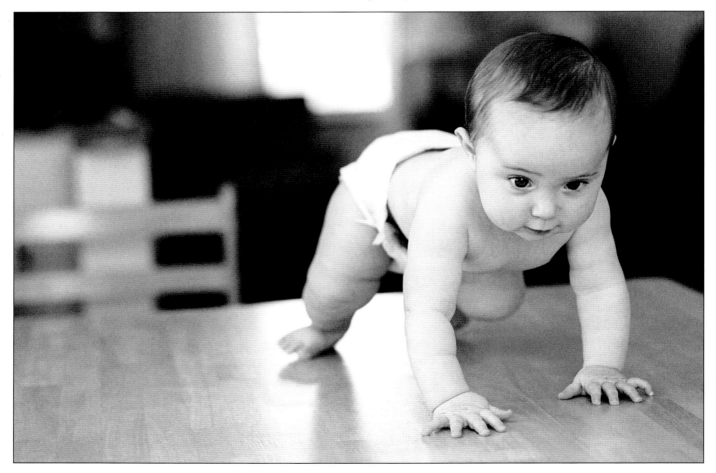

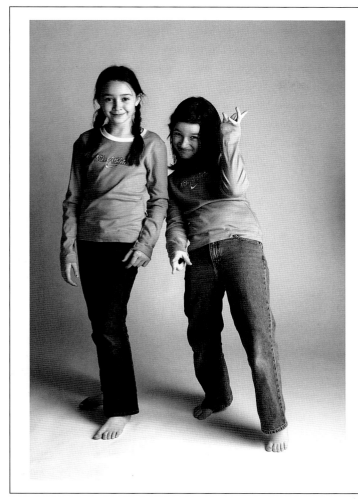
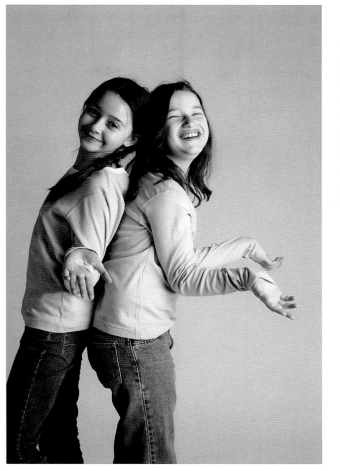

What have been your influences?

I have had no formal training. Before photography, when I owned a stationery store, a tuxedo business, and a wedding consulting business, I discovered my marketing skills are strong, which has benefited my photographic career.

Describe your studio.

I have a beautiful studio and gallery space in a former church from the 1800s where I occupy the second floor and third-floor loft. On one side of the second floor is a meeting area separated by a wall from my photography space. The studio has beautiful hardwood floors and a cathedral ceiling with original exposed beams. In spite of having this wonderful space, I still do all of my editing and computer work in my home office where I have found that I am simply more productive and focused.

Depending on the time of a session, the studio offers me the ability to photograph with natural light and/or studio lighting. I love the flexibility of my space, but I prefer to photograph on location.

I have no employees. Delegating would certainly make things easier, and hopefully I will hand off some of my workload eventually, but for now I prefer to do it myself.

How do you schedule sessions? When do you take time off?

I have a difficult time saying no to clients, and I am working on changing that. Two years ago I set a deadline for holiday orders, which eliminated some stress. I have also set aside a two-week period in autumn for our family's annual trip to Disney World. It's a welcome break between the craziness of the summer schedule and the holiday season, and my kids aren't the only ones who count down the days!

Have your children influenced your business?

I have an eleven-year-old daughter, a ten-year-old son, and a five-year-old son, and I would not be where I am today professionally without them. Through the children I found my passion and capability for taking photos of kids. My husband, Chris, is an amazing father, and better

at taking care of the home and our active kids than I am. I don't structure things around the business as much as I structure my business around my life. It isn't uncommon when I am on the telephone with clients that they will hear my kids stampeding through the door. On a typical day, when my husband pulls in from work, I head out to a meeting or a session. Fortunately, my studio is only ten minutes from my home. During the summer and fall, many of my sessions take place in the early evening, after dinner. When evening light falls earlier, I schedule sessions in the studio, or on occasional weekends when I don't have a wedding to photograph.

When you turned professional, were your expectations realistic?
I started without any expectations, so everything has been a pleasant surprise! It took me a while to say, "I'm a photographer." My approach to clients has always been fairly laid back and I interact with parents and subjects easily. I almost always wear jeans and a T-shirt at home and when I'm working. Photography is very personal and I believe that relationships with my clients are as important as the final prints I deliver. I relate the same with a client as I do with an old friend.

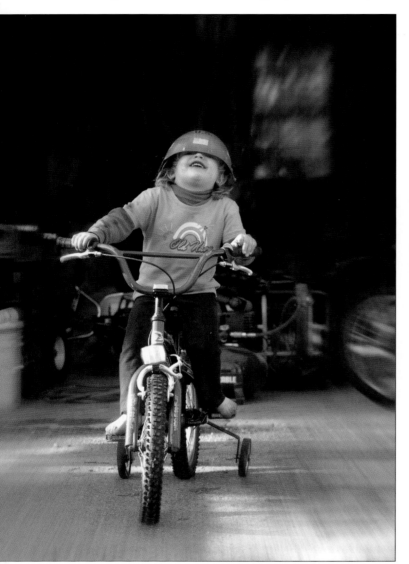

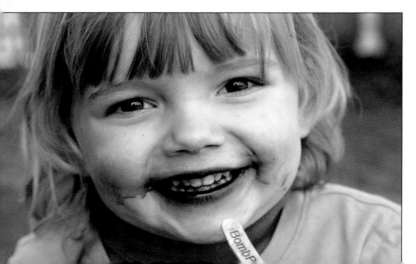

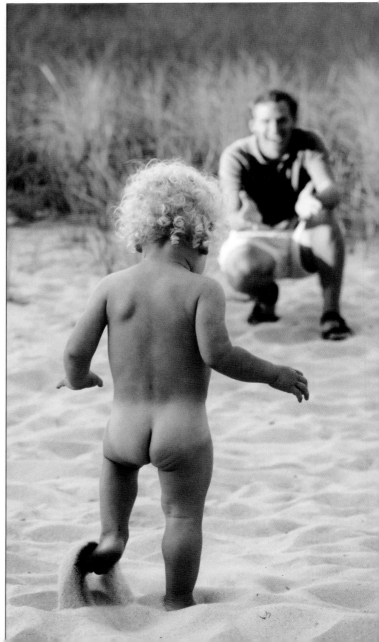

Tell us some of your techniques for photographing children.

Winning Their Cooperation. This is a challenge I enjoy. I know virtually every song from many children's shows and I make friends with kids easily. I also joke with them and have fun. Unfortunately, many children may have been conditioned by other photographers, and even their parents, that I will tell them what to do and how to smile. That is not my style. As I photograph, I talk to the children; parents can unintentionally (and sometimes intentionally!) divert their attention. Occasionally, I find it helpful to remove the parents from the equation. When children aren't being told what to do by an on-looker, they start playing and being themselves, and they decide that I'm okay. If all else fails, I use reverse psychology; it works like a charm.

Lighting. When I schedule a session, I offer the option of choosing a location or choosing the time, or I just choose both. That avoids some-one wanting to schedule a session at high noon on the beach. I also ex-plain that the time may have to be ad-justed on or before the day. If I plan a session just before sundown, and the day is overcast, I often call in the morning and advance the time, since the lighting will be even all day. I'll adjust everything and anything to ensure good light.

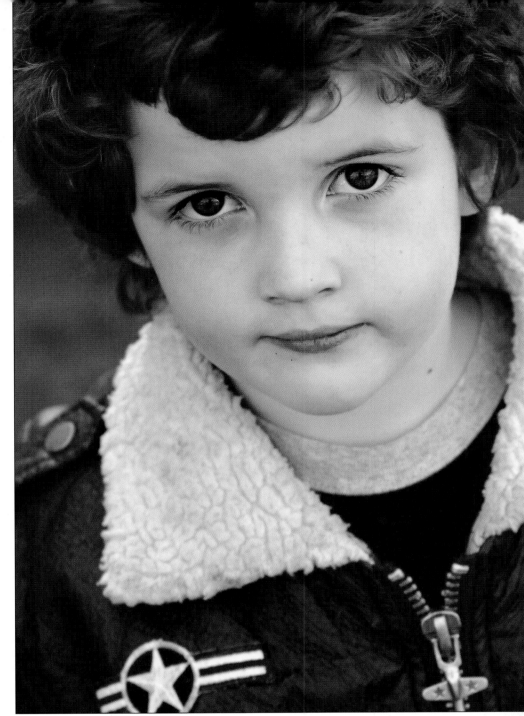

I don't use reflectors on location because I don't have enough hands! I prefer to let children be spontaneous rather than add the distraction of manipulating a reflector. Outdoors, I pay close attention to the direction of light. Working indoors at clients' homes, I photograph in areas where I find the most natural light. I only use fill flash when I work with a large group in harsh lighting.

Locations. I do a majority of my sessions at the beach, a park, or at a client's home using natural light. Though I occasionally do sessions in my studio, my favorite pho-tography places are always elsewhere. I am fortunate that my dad has a lovely landscaped yard where I frequently take clients. It has a beautiful stone wall, brick walkways, and gorgeous gardens. I also enjoy photographing chil-dren in their own environments, indoors and out. I have climbed into tree houses and drawn with chalk on drive-ways. Kids love to show off their stuff, and I am more than happy to photograph their antics. I encourage them to play in areas where I have enough natural light, which explains why I once found myself sitting under a kitchen table with a child and her cat.

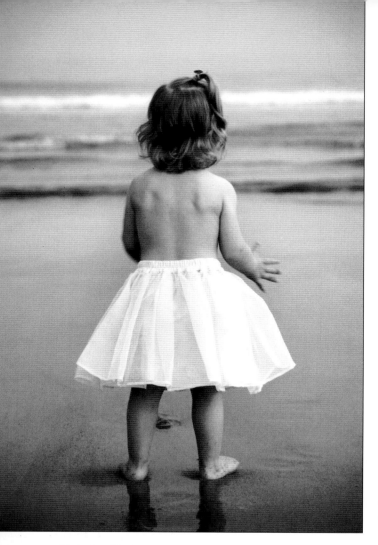

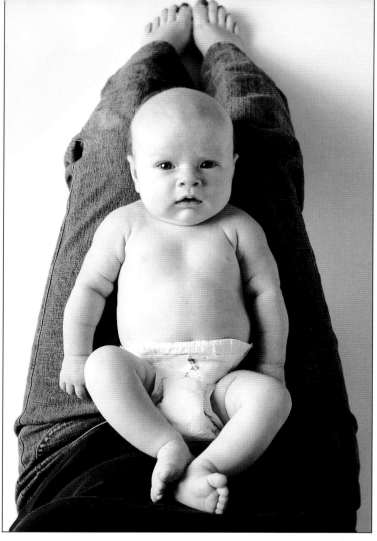

Digital or film?

I currently photograph using a mix of digital and film, but I have been finding myself using more and more digital capture. I still love film, but digital has allowed me the freedom to take more risks. I love black & white and choose it often because it is tremendously effective in revealing the personality of a child. Not the clothes, not the background, just who a child is. Many people on the Maine coast start out wanting a nice portrait of their child with sparkling blue water and skies, but those are not the images they connect with emotionally. It isn't about the environment, it's about the subject.

Do you use sequential bursts?

If a child is being particularly active running toward me, dancing around, blowing bubbles, or when there is great emotion like a genuine belly laugh, I photograph sequences. I also like to engage children in conversation, which sometimes leads to a range of expressions that I can capture in bursts.

Cameras and lenses?

My favorite cameras are my Nikon F100 and digital Nikon D2X; my favorite lens is the Nikkor 105mm f/2.8. I prefer the options the D2X gives me over film in terms of workflow, album designs, etc. I believe in keeping equipment simple for photographing children. A fixed lens and a camera is really all the equipment you need. I have a 70–200mm lens that I love, but I don't use it often because it's big and perhaps a bit intimidating. I try not to tote much equipment while trying to keep up with little ones.

I handhold my camera in the studio; I have tried working with a tripod and was not comfortable. I probably move as much as the kids so I can't have my camera tethered to something.

How do you promote your studio?

Because of my previous business experience, I knew that word-of-mouth is by far the most important form of marketing, and that has held very true in my photography

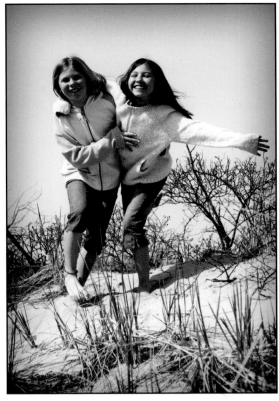
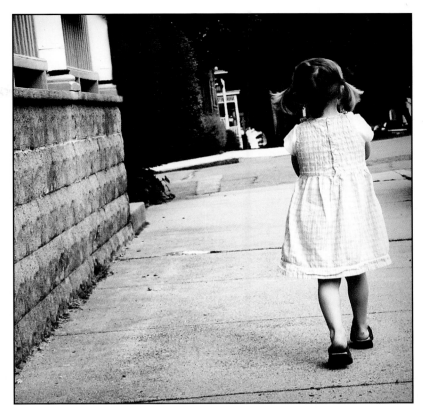
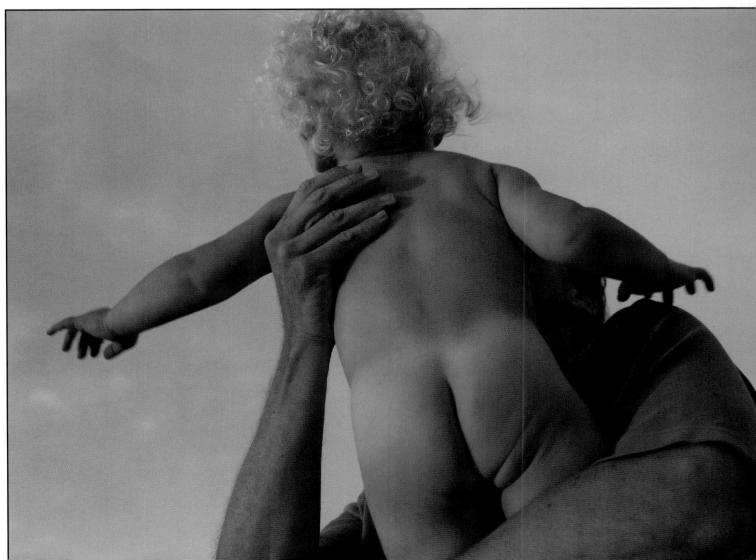

business. Friends and family did all the initial promoting! My very first job came about because a woman introduced me as a photographer at a yard sale. She had seen a scrapbook of my family and told a friend who asked to schedule a session. From there, everything took off by word-of-mouth, which is still my primary advertising. In fact, I have an unlisted phone number!

I did not want to stop photographing during the cold weather during my first winter in business, so I e-mailed a mothers' group I had joined and waived my session fee in exchange for families allowing me to build my portfolio with their kids. The response was amazing, and numerous indoor sessions that winter established my particular photographic style in the community and helped maintain income through the normally slow period.

Currently, my web site and the International Guild of Children's Photographers (IGOCP) and International Registry of Children's Photographers (IROCP) web sites are also effective advertising.

What are your pricing categories?
I charge a session fee and print prices. I do not offer any packages. My fees range in the high end, and everything is priced individually. I update my pricing as necessary based on costs and demand.

Describe your editing and printing process.
I edit everything and upload it to my lab, Pictage, which plays a very important role in my workflow and in the success of my business. They categorize my images and put them online where I rotate some, convert some to black & white or sepia, and add contrast or sharpness to many. Then I send an e-mail to the client with instructions and a password so that they can access their images online. They can put together folders of their favorites, order prints, arrange a DVD slideshow to share pictures with friends and family, and order holiday cards and coffee-table books.

I can also create albums using Pictage's album designer and have the pages printed and bound through Pictage and companies such as Leather Craftsman, Willowbooks, and Zookbinders, to name just a few.

Another benefit is being able to send Pictage untouched files and request color correction. They do the work and upload the files to me. They print the orders and send them directly to the client. This benefits family members who live out of state and creates additional sales for me. The system works

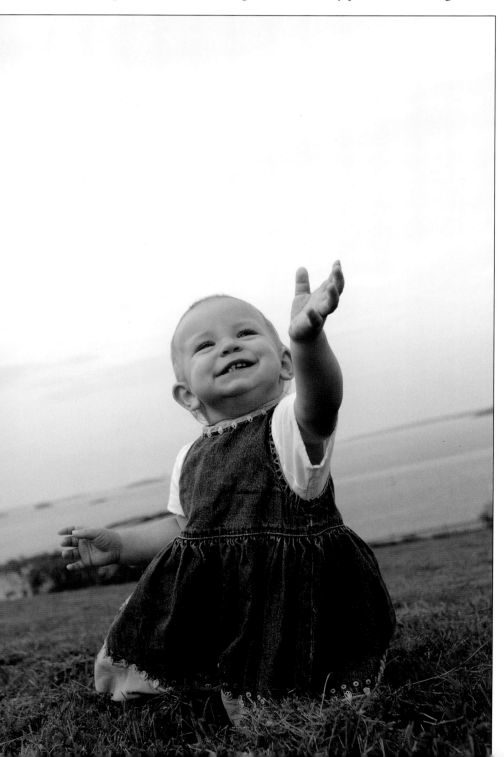

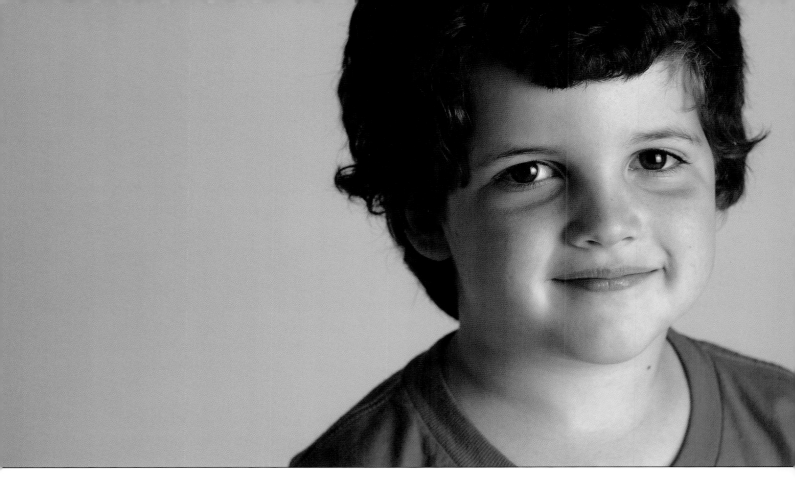

perfectly, because I could not manage my workflow and my family and home without help.

How do you present your pictures to clients?

When schedules and geography allow, I like to meet with what I call my "front line" clients—those who choose to go over their session images in person rather than order through Pictage. When we are together, I show them the possibilities on the computer screen, which helps them visualize their options. I like giving them additional help with decisions, and I can suggest how to group pictures they will display on their walls. I have used paper proofs, but I prefer the slideshow presentations on the computer screen in Photoshop or right on the Pictage site. I want clients to know how images will look best.

I also mat all photographs ordered directly through me. Some images look great matted together in a storyboard; others look better matted and framed separately. Some are best presented in square format; others in a panoramic format.

If a parent asks for touchups, I explain that I photograph in a documentary way to capture a child as they are at the time. It just doesn't seem right to me to alter a child's reality, so I prefer not to.

What are your most common print sizes?

My most popular print sizes range from 5x7 to 16x20 inches, in addition to square formats such as 5x5, 8x8, and 10x10 inches. I also do numerous storyboards featuring multiple images printed together or matted together in a frame. I prefer that my clients order a lot of smaller images rather than a couple of larger ones. I also recommend the look of a gallery wall rather than just a large single print. I display many wall combinations in my studio, and clients often choose what they order based on what they see. I may remove some studio wall prints and arrange them in different configurations on the floor until one works for the client. It's fun to play with all the options. Once we have it just right, I diagram it on their order form and place the order from that.

Does a photographer's personality influence their success?

Definitely. I believe my personality often convinces a client to hire me. It plays a big role in what clients order and in keeping them for the long term. When I have fun photographing, they have fun too. There is often laughter and silliness during a session, and when we finish, the little ones are usually giving me high fives, and the parents are thanking me for making it enjoyable.

2. RITA STEENSSENS

Rita Steenssens of Victoria, British Columbia, is a wedding and portrait photographer with a special love for children. She has been a photographer for over thirty years; however, she has been a full-time professional for only five years. She is married to a supportive man, and they have two grown daughters. Rita says, "Images have always spoken to me more powerfully than words." She prefers a photo-reportage style for weddings and enjoys the magic of a wedding day with its unknown possibilities. She also loves photographing children and babies, and plans to devote more of her time to them. She says, "The days of childhood slip by too quickly," and she strives to capture those moments.

What is your background?

I loved to draw as a child. The first money I earned went to buy paper and charcoals. At fifteen I used my dad's old bellows camera and developed film and printed images in the school darkroom. I was hooked when I saw that first image appear magically in the darkroom light. That summer I bought my first SLR, a Nikkormat FTN, and carried it everywhere. Film and processing were expensive, so I learned to photograph carefully. I read everything I could find on photography and I practiced almost obsessively, often with my four younger sisters as subjects. Eventually, I photographed my own children. From there, I photographed friends' and neighbors' children and began getting requests from people I didn't know, so I have followed my passion seriously.

Were you influenced by any mentors or seminar speakers?

I have no formal training in photography or in business. I have taken some workshops and, amazingly, they taught me that my instincts have been pretty good. I learned that if you are ardent enough about something, you will find a way. I continue to take workshops and to meet and learn from other photographers.

Describe your studio.

I have a small studio (17x28 feet) with a window that I use when natural light is right. I use a 6x4-foot softbox with two additional strobes in softboxes on the back-

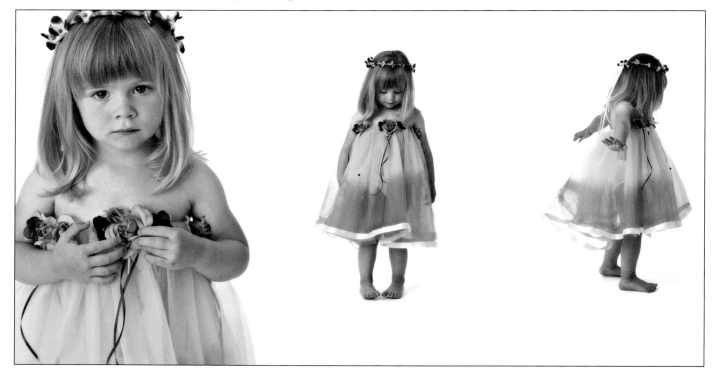

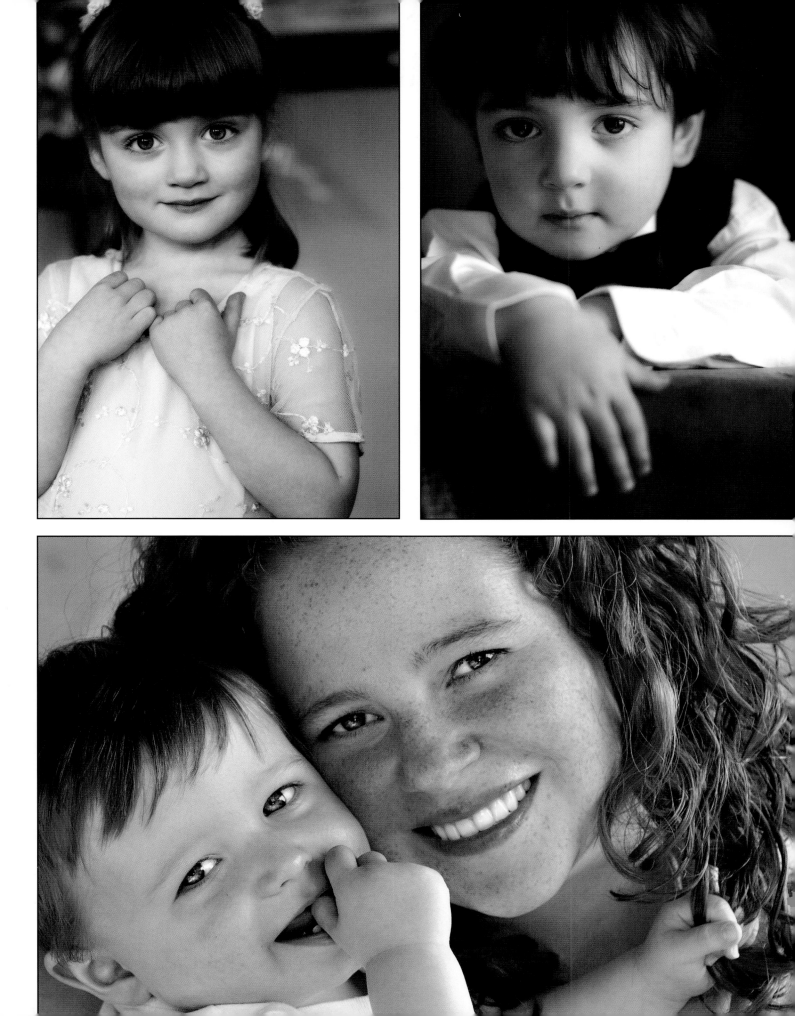

ground for high-key children's portraits. I also use a variety of reflectors. At times, I use the window as a backlight, pairing it with a strobe, angled across the subject, as the front light. I keep the room quite warm and play soothing music in the background.

How do you schedule sessions? When do you take time off?
I schedule one or two sessions a day, three or four days a week. I am pretty flexible about time and will also photograph on weekends. I like to photograph babies in the morning, which seems to be their best time. I prefer to photograph older children outdoors; late afternoon or

early evening is the ideal time to catch some sweet light. I try to schedule sessions three or four days in a row and then have three or four days with no photography appointments for rest and rehab time. If you don't schedule rest time, it won't happen.

Have your children influenced your business?
Because I was already an avid photographer before I had children, they were exposed to my camera when they were born. Even though I was passionate about photography, I only thought of it as a hobby in my early days, following a more practical path as a dental hygienist for chil-

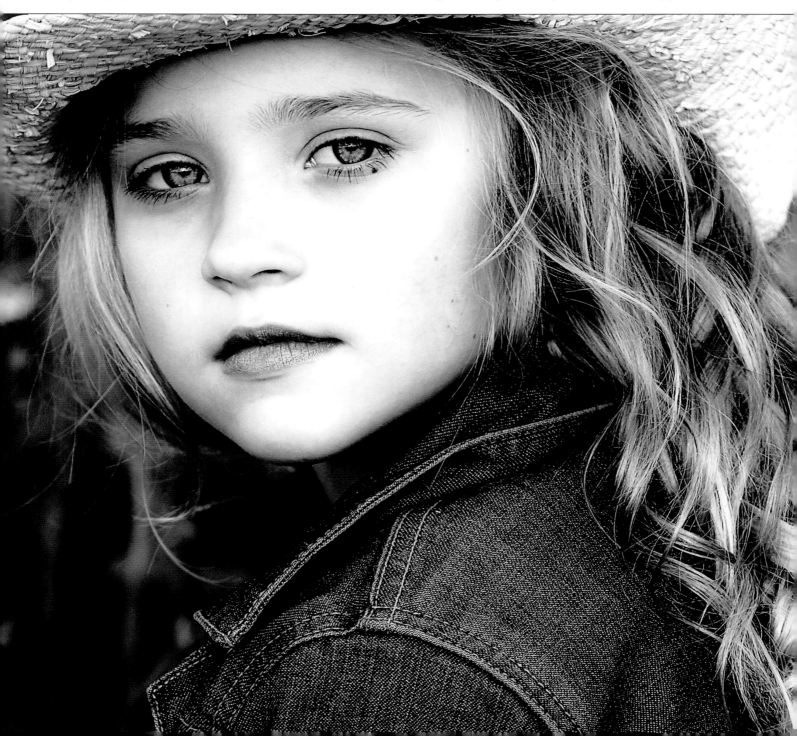

dren. It served me well and provided a steady income while my children were young. That experience helped me better understand and work with kids as subjects. My children, now grown, taught me to slow down and explore the finer details of life. Patience is the key to working with children—patience, and an understanding that kids command respect and consideration from adults.

Describe some of your techniques for photographing children.
Winning Their Cooperation. I like children and want them to like me. I get better images when they have a positive connection with me. Initially, I make eye contact with a child but keep my distance. If they are okay with this, I try to engage them in conversation, even if they are very young. A calm and gentle demeanor works best, because it doesn't intimidate or frighten them. I never talk down to a child, although sometimes I will talk nonsense and make a fool of myself. This can be a bit embarrassing, but it often works to engage them while I photograph.

Lighting. I prefer natural-light photography, outdoors or indoors. I photograph mostly on location in good weather to achieve a more "lifestyle" feel in the portraits. Light is my main concern at any location; background is secondary. It is easier to work with sweet light and a so-

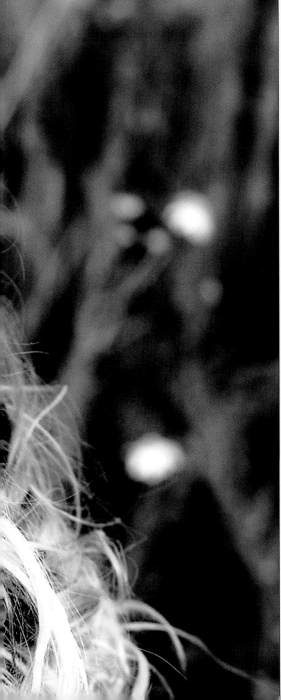

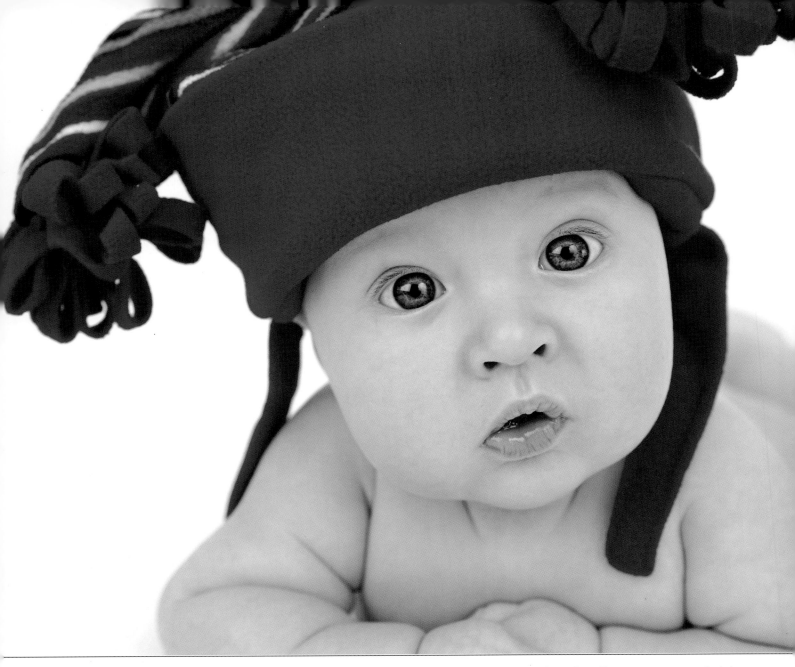

so background than with poor light and an awesome background. "Sweet light" is the term I use to describe the light you see on a subject's face that gives skin a beautiful glow and adds bright catchlights in their eyes.

I photograph a lot of portraits with shallow depth of field. This way, the backgrounds take on a kind of watercolor look that makes the subject the center of interest.

In my studio, I use a large softbox when photographing children. It gives them more space to move around—kids are usually active. I place the softbox to cover a fairly wide area where I can photograph with even lighting.

Props. I use props if I feel they enhance the image. It may be a child's favorite teddy bear or blanket or a parent's arms. At an outdoor location, I may use a precious stone the child has found, a flower, or even a ladybug. Children are delighted with their treasures, and I photograph them with whatever they find captivating.

Presence of Parents. There is always at least one parent present at my sessions. They usually just watch, but they sometimes help to manage a child who is a bit shy.

Reflectors or Flash Outdoors? I love sunny days, even though they can be quite challenging. You have to look hard at the light and look for beautiful spots, which aren't always where you think they will be. The old adage, "On a cloudy day the sky is a giant softbox, and you don't need to worry about the light," just doesn't cut it for me. On a cloudy day, the light still has direction and there is still a sweet spot. With experience, your eyes begin to find it.

I like to photograph on the edge of the light, where shade and full sun meet. I use reflectors when needed. I don't use flash fill—the sun gives me what I need. To avoid shadow areas on a face, I simply turn the face away from harsh light or look for something like an overhanging tree to block some of the light. Wherever I go and whatever I am doing, I am constantly aware of the light. When we are out and about, my husband says that most of my conversations begin with, "Wow! Look at the light over there."

How do you anticipate gestures and expressions?

I follow the child constantly with my eyes. Even if a parent talks to me, I maintain my relationship with the child. It is imperative to be ready to catch those fleeting moments that give you the images you want. When you observe carefully enough, you will begin to anticipate the child's next move or emotion. I need to see what they see, feel what they feel, and then capture decisive moments. For me, technical stuff needs to be solid, so it doesn't interfere with the process.

Do you shoot sequential bursts?

I photograph in sequential bursts quite often. I am always watching and waiting for a little series of images that will tell its own story when later viewed as a group. Often when I do this, I can fall into a "zone" where I am hardly aware of the camera; I just photograph from feeling.

Digital or film?

I have been photographing with a digital camera for three years. I still love film, but I just prefer the amount of control I have over my images when they are captured digitally. I photograph more in color than I do in black & white because I have never seen such pure color as I get out of my digital files. It blows me away.

The world as I see it has glorious color, and I like it in my images as well. I love black & white just as much, but for different reasons. Black & white shows more character and emotion, it has more depth, and can be moodier without the distraction of intense colors. With digital, I can have both. Often, I know right away which image will be in color and which will be in black & white. My approach is different for black & white images because the lighting is more critical; you can't hide behind beautiful color.

Camera and lenses?

My favorite camera presently is the Nikon D2X. The 85mm f/1.4 is my all-time favorite portrait lens followed by the 50mm f/1.4. I also use the 28–70mm f/2.8 and the 70–200mm f/2.8VR. I usually handhold my cameras and use a tripod for maternity images and low light. For children, you need a fast enough shutter speed to eliminate camera movement, because kids sprint instead of walk. With limited resources, I would bias my spending toward quality lenses and a mid-range digital SLR. Lenses

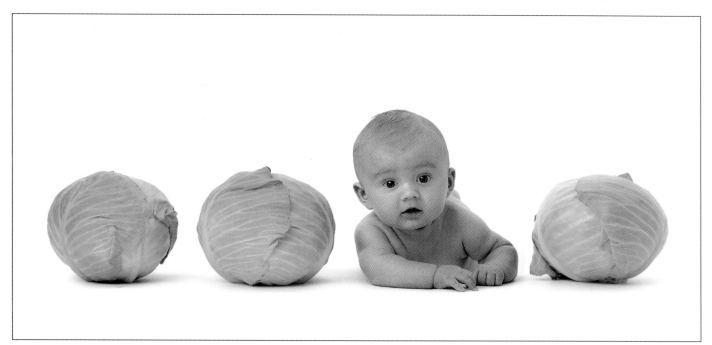

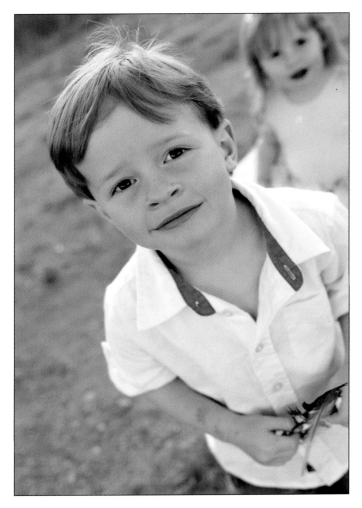

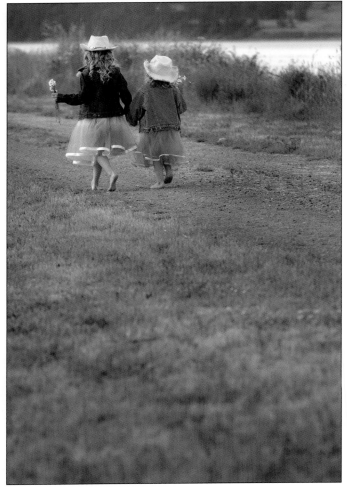

will serve you well for years; a digital camera body may be replaced in eighteen to twenty-four months.

How do you promote your studio?

My business has grown more rapidly than I expected it would, but most of my commissions continue to come through word of mouth. My web site has also been a valuable asset, and people are often ready to schedule an appointment after viewing my photo display.

What are your pricing categories?

Pricing is a big issue for me and I am learning to be comfortable with it. Photography was a hobby for so long that it was initially difficult for me to charge for what I love to do. I raise my prices to reflect the time and effort that it takes for me to deliver images that I can be proud of.

I had a customer tell me recently that if her house was on fire, and she knew her children and husband were safe, the first thing she would save would be the photos I took of her children.

Describe your editing and printing process.

I edit all my own work (read: control freak). For enlargements I use a professional lab or print them (up to 12x18 inches) on an Epson 2200 archival printer using fine-art paper.

How do you present your pictures to clients?

I do not use paper proofs. I used to provide clients with a CD of non-printable proofs showing images in both color and black & white, but I switched to online viewing of proofs in 2006 because it is more efficient.

Describe your album layouts and common print sizes.

I offer albums for weddings and portrait sessions. I still prefer to design the albums myself, although I may have to hire the work out in the future.

My most popular sizes for enlargements are 12x18 and 11x14 inches. I sell many 5x7- and 8x10-inch photographs, which are popular as gifts. All of my enlargements are edited in Photoshop. The only images I do not fine-

tune in Photoshop are wedding proofs or anything smaller than 5x7 inches.

Does a photographer's personality influence their success?
Yes. I am sure it does. I wake up every day eager and happy to pick up my camera—I am doing something I have always loved. Children are my favorite people, and spending time with them is a privilege. I am grateful that some let me be close enough to capture their uniqueness and their inner soul.

I learned the hard way that we do not always have as long as we need with those we truly love. In my lifetime, I will photograph what I can. The fleeting moments of childhood, the delicate tenderness of a newborn, the ripe lushness of a mother to be, the perfect story of a wedding day. And always, the remarkable faces of those who are loved.

Images that enable viewers to experience special moments, moods, or emotions are—for me, and for most clients—absolutely priceless. Photographs can be very powerful, as they kindle our memories. Photographers can be inspired by single moments, and we are apt to discover more memorable images when we review what we have taken. This especially holds true when children are the subjects.

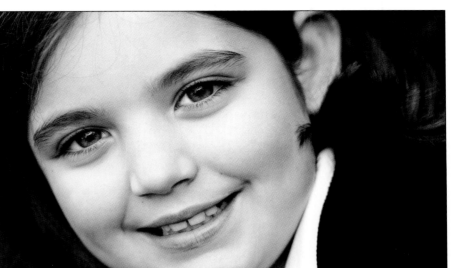

3. BRIAN McDONNELL

Brian McDonnell of Portland, Oregon, is a former Air Force aircraft mechanic. He moved into a career in photography with great enthusiasm after working as a station manager for a transportation company owned by his father. A portrait photographer for five years, Brian has a studio in an old warehouse where he specializes in children, seniors, and weddings. To learn more, visit www.bmac-photo.com.

What is your background?

When I was nineteen, I joined the Air Force and spent four years as an aircraft mechanic, serving in Saudi Arabia during Desert Storm for six months. I lived in Hawaii after my discharge from the military, attending college and planning to become a teacher. I then moved to Portland, Oregon, to work for my father after he purchased the Portland market for an international transportation company.

During my military service and in college I owned an Olympus OM-2. I took a black & white course at Spokane Falls Community College, which opened my eyes to a new world of creativity. I learned technique and composition, and after that I was taking pictures every day.

For a year, I photographed anyone willing to sit for me. People were my fascination, and not much else. I had little outside help, although I wished I had worked with another photographer to get a better feel for how things were done. When you make things up as you go along, you don't know what you are doing wrong or if there is an easier way. Knowing how others work can help you develop your own style.

I realized I had to find a way to make photography my life. I began studying photographs in magazines, on the Internet, and practicing on my own to get the same lighting effects. In 2002, I found my warehouse space. I was not prepared to become a full-time photographer, but I rented it to keep my dream alive. I sold my house and got rid of everything to survive long enough to make it in photography. I spent a period of time with few material things and often questioned whether I should continue; it was a stressful and challenging period.

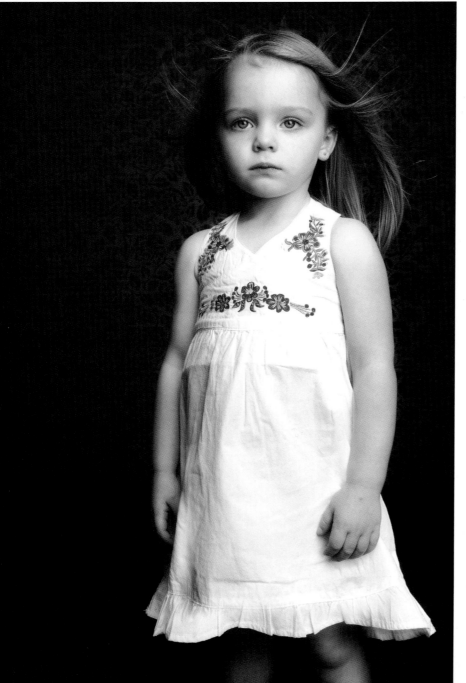

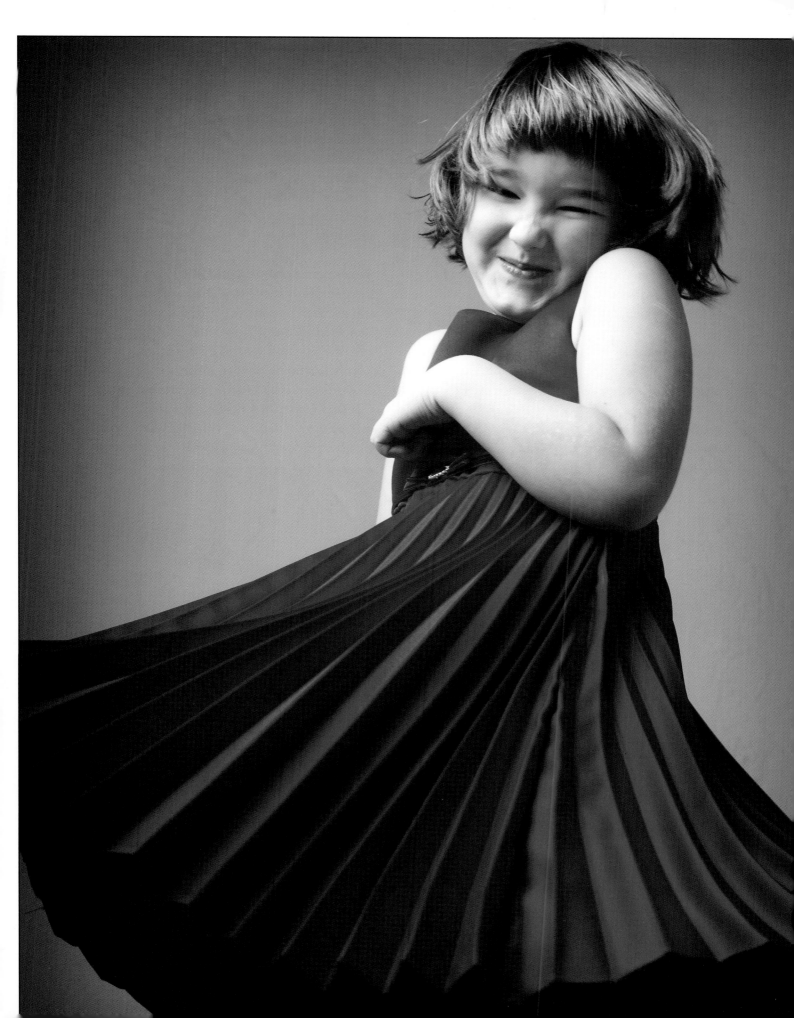

Were you influenced by any mentors or seminar speakers?

Two years ago I was fortunate enough to meet Brianna Graham (of Brianna Graham Photography) online at Digital Wedding Forum (www.digitalweddingforum.com). This forum includes a wonderful group of portrait photographers, and I had the opportunity to share my work with Brianna. We spent countless hours on the telephone and her valuable feedback played an integral part in creating my business and photography style. In addition, I gathered much of what I learned about photographing children from the portrait section of the forum. Many times, other photographers expressed that they had difficulties with whatever I had been struggling with, and I got valuable guidance looking at their work.

Describe your studio.

Originally, I worked in my living-room studio using a couple of hot Lowell lights. I now operate from a 1600 sq. ft. studio, the front half of which is the gallery plus production and meeting space. My desks sit next to couches in the meeting area so I can easily bring clients to the computer to show my work. The back half of the studio is an 800 sq. ft. photography space with a wall of windows eight feet high; I am able to create about 70 percent of my studio work using natural light. Each of five sections in the photography space has a different colored wall or backdrop and I can shift during a session.

I work alone in the studio, although a recent college graduate is interning and may become a regular employee. She handles marketing and scheduling to allow me to spend more time photographing.

How do you schedule sessions? When do you take time off?

Learning the art of scheduling has taken time. When I was relatively new in the business, I would schedule a session spontaneously. Now I know that it's okay to say no and to negotiate a suitable date. I begin scheduling more heavily around November until the holidays. I take Mondays off to relax and regenerate my photographic drive. I visit family over the Christmas holidays. Spring and summer are busy with portraits of children and weddings, and I enjoy the downtime in January and February when I

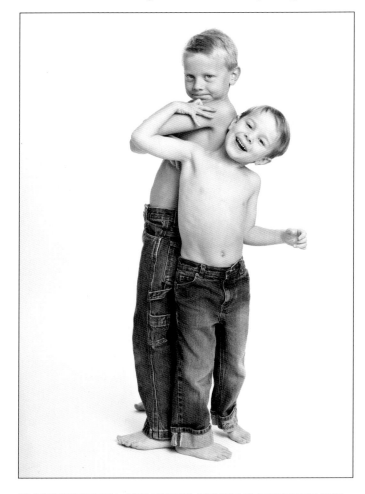

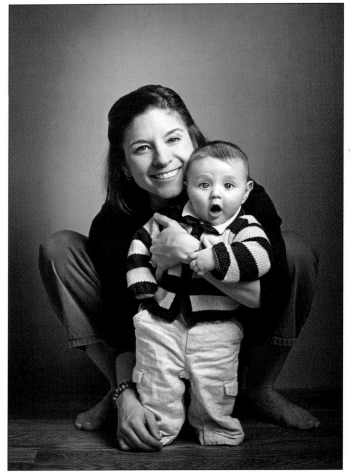

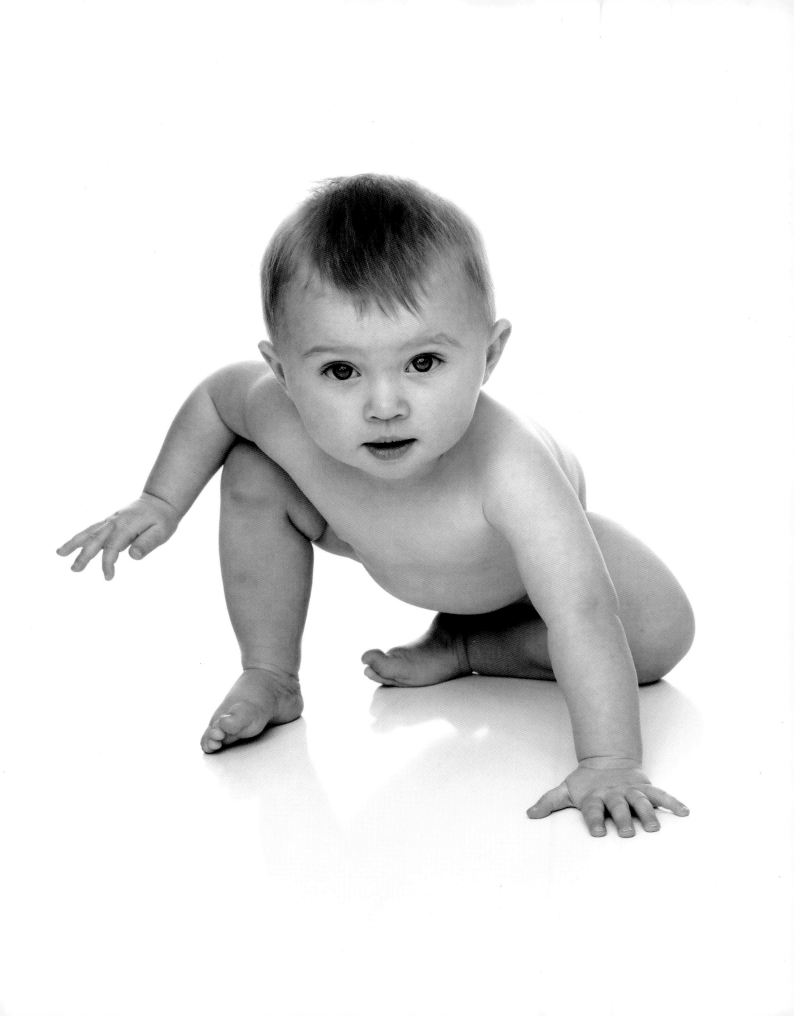

can come up with new ideas and projects. I love photographing kids and older people, and when I am away for just a few days, I have to get back to the studio.

To schedule children, I find out their nap time. When babies are wide awake after their naps, they tend to be at their best, and I try to take advantage of those moments and schedule toddlers in late mornings and early afternoons; older kids are photographed later in the day. I don't charge extra for weekends; I want the work produced to be what generates the income.

When you turned professional, were your expectations realistic?
At the start of my business, I believed it was going to be easy. I had taken pictures of family and friends and their kids, and they were happy with the results. I figured that with some advertising, other people would line up at my door. However, I discovered that luring clients would require a great deal more effort. For a shaky two years I made just enough money to pay the rent and expenses.

I came to realize that the portrait business, children or otherwise, takes constant word of mouth to succeed. Advertising brought in a few new clients, but it was some-

times discouraging. Now that my style and the quality of my images have vastly improved, and a lot more clients view pictures on my web site, I have found that it's easy to sell when you take beautiful pictures that come from within you. However, if you rely only on positive reactions from parents, you may enjoy little growth in your work and style; you must really push yourself to improve.

Describe some of your techniques for photographing children.
A personal transformation occurs when I have a camera around my neck and a child in front of me. It is fascinating because I don't know who that person (me) is or where he comes from. I become a bit of a goof and find myself hopping around like a madman. I love the silly interaction I have with children and the puzzled look on their faces as they watch me maneuver. I try to make the experience as playful and fun as possible, and I avoid forcing kids into uncomfortable poses. I let them be free as I capture their changing expressions. I let crawling babies do their thing, and when they move out of our working space, I put them back. I can do this five times, and they never notice whether they are coming or going.

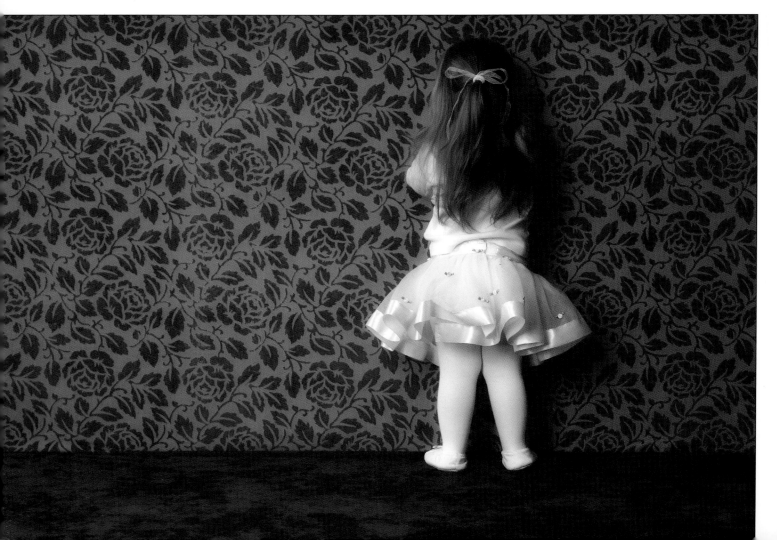

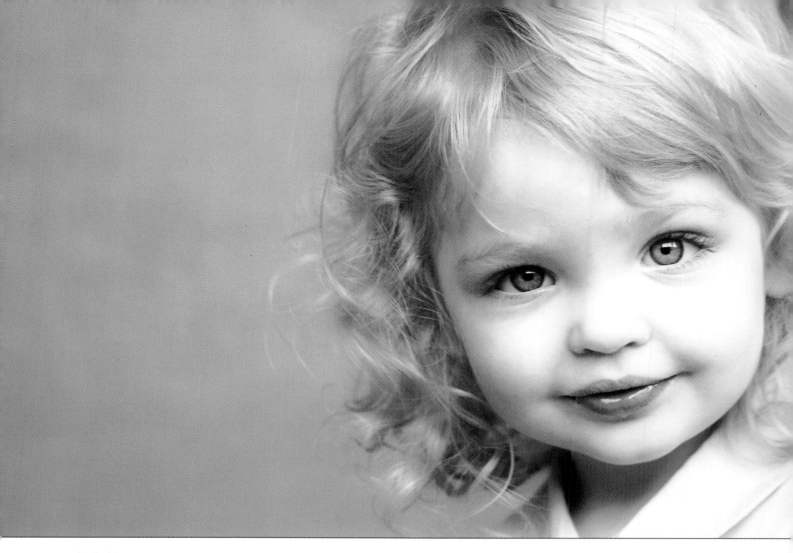

With children just starting to walk, I often chase them around the studio. Having a lot of natural light gives me flexibility. They can move among five different colored background areas and I can follow and work. Sometimes I need to coax them back to a desired location.

Props. I use very few props other than an old funky couch and chair. I do use toys to cajole young kids and a few boxes for those who need some help in standing. In the studio it is all about a clean and simple look that relies on expression, lighting, and emotion.

Parents. If parents are helpful, I keep them around. With the little ones, they are often required—but after a child is about two, I can do without parents. If I find that they can't resist telling a child how to smile, I send them to the waiting area; they are always understanding.

Studio Lighting. Children have freedom to move about because a wall of windows illuminates most of my photography area. I built large diffusion panels to hang over the windows when the light is too strong. I also use a portable 4x8-foot reflector for fill. At times I switch to a single strobe within a large softbox and natural light as the fill. It is easy to position the strobe about five feet from the subjects.

Outdoor Light. I look for open shade wherever I work. Because children are not at their best at dusk, waiting for the perfect light is not feasible. I find the light I want and get them to play in that area. I don't use reflectors, as I work alone. I concentrate on their emotions and expressions and less on perfect lighting.

How do you anticipate gestures and expressions?

When I start a session, I let the child dictate the mood. If they are shy, it's a great opportunity to capture the more delicate sweetness of a face. I try to slowly guide shy children into a more playful mood at their own comfortable pace. By the time they are somewhat tired, we typically have spanned a full range of emotions, which I strive for.

If the child is old enough to talk, even a little, the process is controlled through conversation and gestures; I let the tone of my voice and hand signs excite or calm

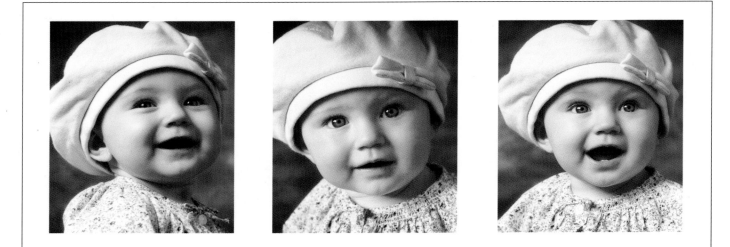

them. It can take a little time to connect, but that works for me. With babies it's pretty much required to use toys that make noise to get them to come to the camera. This is a time that having a parent behind me is mandatory so kids will respond to a familiar face and voice.

Digital or film?

I am 100-percent digital, which works perfectly for children because I can photograph constantly without film changes. When I present proofs, I mix black & white and color about 50/50, and while I give people the option of converting one way or another, I find the majority stay with half color and half black & white prints.

Do you shoot sequential bursts?

Small children can cover a spectrum of expressions in a matter of seconds. Because of this, and because I capture digitally, I tend to constantly photograph in bursts of multiple frames. Once I get the child into a setting, I try to induce them to be active. Once they are, I start photographing quickly, enjoying the phenomenon of watching kids change and momentarily erupt.

Camera and lenses?

I photograph with the Nikon D2X in the studio, which is a perfect camera for the fast pace of children. Its focusing speed gives me confidence that when the moment presents itself, I can compose and capture almost instantly. I usually use the Nikon 17–35mm f/2.8 zoom lens. To make a shot a bit funky, I jump to the 17mm setting. For a more traditional-looking picture, I switch to 35mm. Outdoors, I use a variety of lenses including the 50mm

f/1.4, 85mm f/1.4, and the 70–200mm f/2.8, each for different viewing reasons.

How do you promote your studio?

I have relied primarily on word of mouth to build my business. A single session with a family will often lead to at least three additional appointments. My web site has also been a key element of promotion because people contacting me have a good idea of what I do, which makes the process easier. I try to add fresh images to my web site fairly often. In the studio, clients see a variety of enlarged prints and collages of children and families on my gallery walls. Compared to seeing web-site photographs, the gallery display can be dramatic.

What are your pricing categories?

My current pricing structure is about average in the Portland market. I charge a fairly low fee per session plus options for individual prints and a few packages. My basic fee may seem low, but having talked extensively with other photographers, I believe many fee reports are exaggerated. I feel that my subjects can make a minimum investment, and if they like the results, the profit is there. I like it that an average $600 total investment results in more of my photographs in their homes.

I have raised my print prices with only a small increase in session fees. I also raise prices for session books and for new products. I take time to get a feel for how much work is involved and adjust prices accordingly.

When I first started, I offered some pretty amazing deals, but slowly phased them out. Now I just offer hot deals during slower periods to generate cash flow. As my

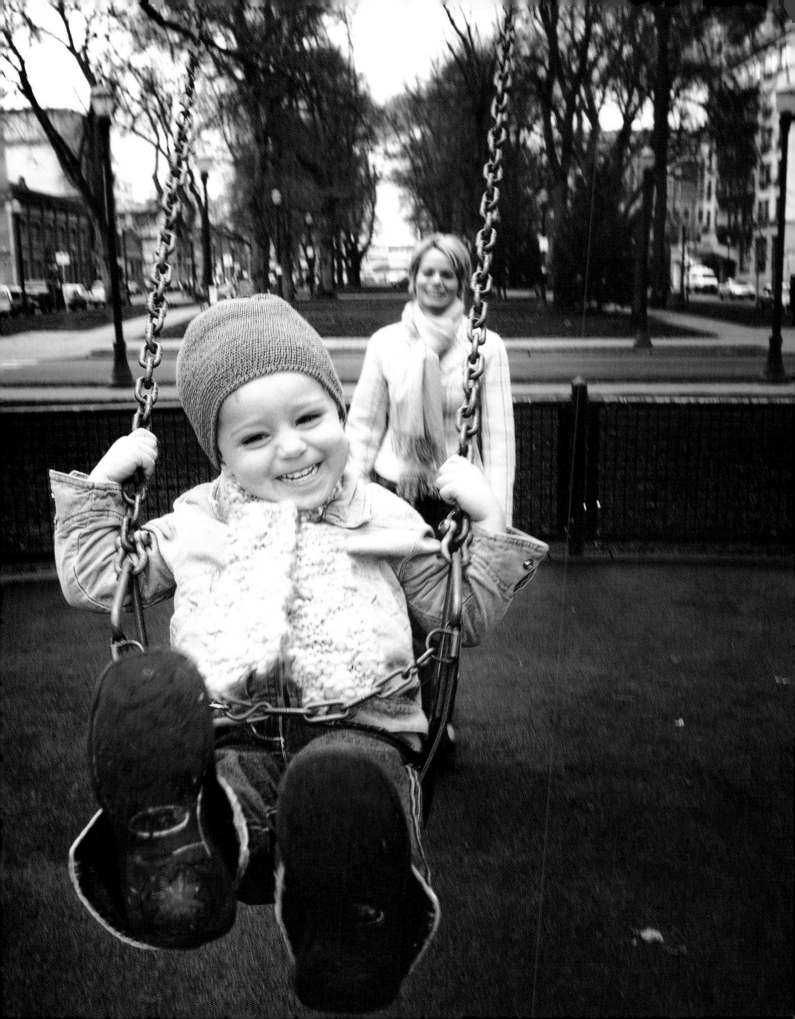

name grows and demand increases, I will raise prices further, although I want to remain affordable.

How do you present your pictures to clients?

I start my presentation with an online gallery where people can select ten to twenty images. Later, at a studio ordering session, they view paper proofs; they cannot take them home, but they can use the online gallery for further reference. I am currently considering the idea of projection sessions. I understand that the sales side of my business is important, but I just cannot bring myself to pressure clients.

Describe your editing and printing process.

I do all my own editing in Photoshop. When I receive a client's print order, I work the images and upload them to my lab for printing. They are returned to me ready for delivery. The Internet has made this side of the business very easy and time effective.

Describe your album layouts and common print sizes.

I offer custom-designed albums with a product I call "The Storybook Session," and I do the layouts myself. While these may not be best sellers, they lead to a number of new portrait clients. I would love to have clients purchase 16x20-inch and larger portraits, but they already buy a lot of 8x10-inch prints to display as a series instead.

Does a photographer's personality influence their success?

Without a doubt, personality can be as important as photography skills. People consistently leave my studio talking about how much fun they had. Some tell me about a previous bad experience that usually relates to the personality of the photographer.

Personality also comes into play just being out in public. Building my business and reputation in the community requires a lot of interaction with all sorts of people, and it certainly helps that I enjoy those contacts. It's a big reason why I became a portrait photographer.

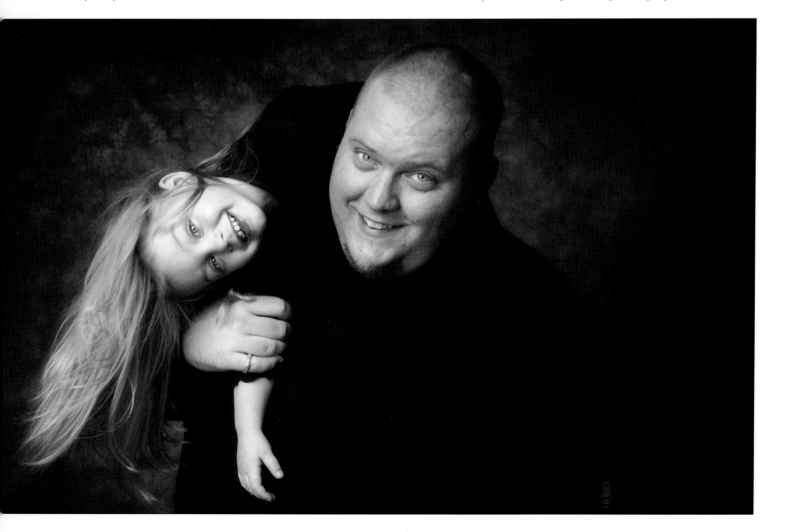

Alycia Alvarez vacated a bedroom photo studio after just a few years and moved to a separate studio in Riverside, Florida, just outside of Tampa. She understood advertising and promotion techniques early on—and she has used this know-how to build a successful business. As a mother, Alycia, like so many of the experts in this book, has worked hard to blend her family and her business responsibilities. For more, visit www.alyciaalvarezphotograph.com.

What is your background?

Using my first 110 film camera when I was six, I posed my dolls in backyard locations. As a teen I dressed up my four-year-old sister to pose for me. In college, I took an elective black & white darkroom class and was hooked. Shortly after graduation, I had my son and began capturing moments of his little world. After the birth of my daughter, my eagerness to learn more about photography exploded.

I photographed friends and family and, gradually, realized a photography career was not a crazy dream. In 2001, I invested in a new camera, props, and backgrounds, feeling that if I made enough to cover my investment, I would be satisfied. I converted a spare bedroom into a studio for my new career. Initially, I didn't plan to specialize, but I was most fulfilled at sessions with children and babies, so I decided to aim my marketing toward kids' portraiture.

What have been your influences?

My business has benefited from my appreciation of and talent for graphic design. I haven't been influenced by any one photographer, but I am a member of several Internet forums where numerous photographers have inspired, taught, and influenced me.

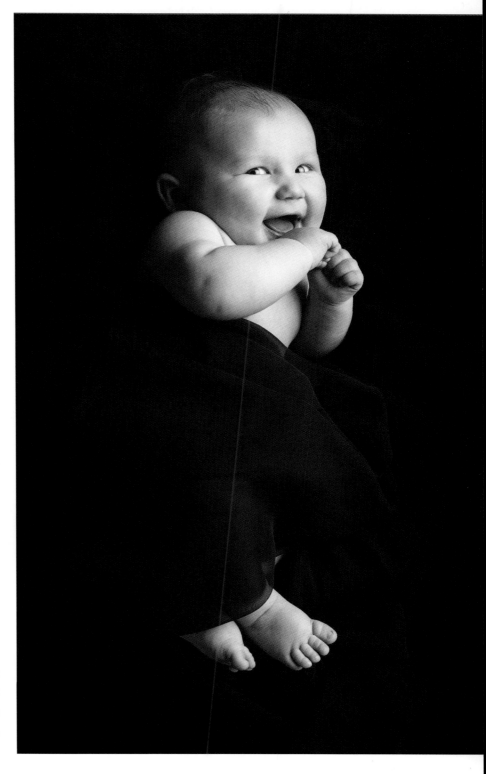

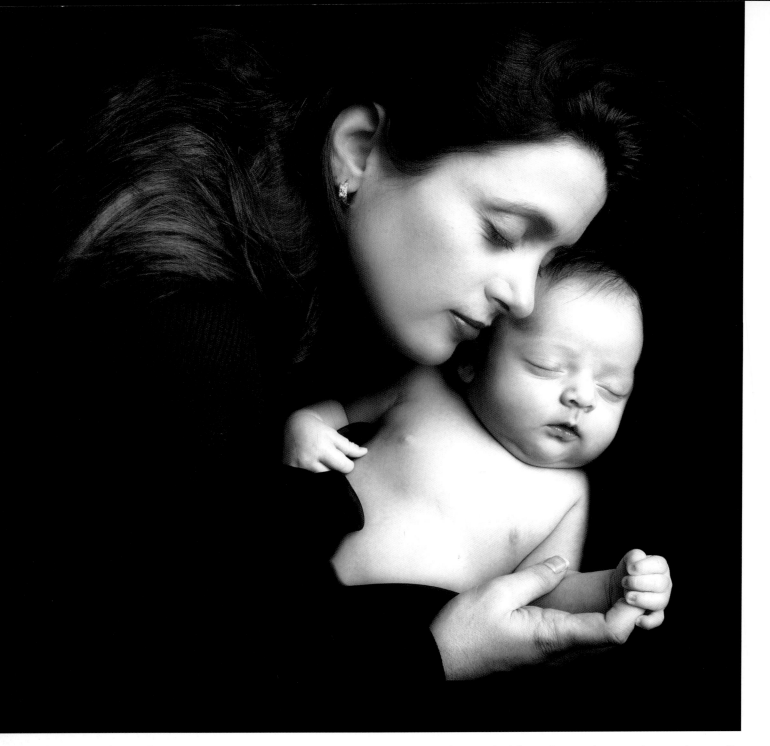

Describe your studio.

Business had expanded so well by 2004 that I moved my studio and office to a separate 1,700 sq. ft. house adjacent to a little lake. My studio has one large camera room, a smaller room for photographing and a room for presentation. The production office is upstairs. Cherry wood floors and a fountain in the brick driveway contribute to the studio's high-end feel. I have two employees. One answers the telephone, schedules appointments, briefs clients, and takes care of the framing, proof-album assembly, and errands. The other updates and runs the studio management software (Photo One from Granite Bear) and does some sales and proofing appointments.

How do you schedule sessions? When do you take time off?

I have a low-volume, high-quality studio, which is what I want to convey to clients. All appointments are given a two-hour time slot, and I photograph one or two sessions a day, from 10AM to 5PM, Tuesday through Friday. I emphasize the two-hour window because children are so un-

predictable, and clients appreciate the flexibility. Rarely are two hours needed, but moms can relax about feedings, diaper changes, or fussy babies. Weekends are for me and my family, and I spend Mondays on the computer. I schedule a week off occasionally to reenergize.

Have your children influenced your business?
Andrew is ten and Gabriela is six. They helped me conceptualize how mothers have an intense desire to remember the moments of their kids' childhood with por- traits. Knowing the habits and quirks of my own children, I can capture the expressions that other parents want.

I am the primary breadwinner in the family, and it's not easy to run a busy photography studio and be a good mom. I am constantly aware of how I must balance my time and attention, and I make an effort not to let work interfere with play or quiet time together. On weekends, we do fun things at home or we go out. I neutralize most "mom guilt" by giving my children lots of attention and positive reinforcement.

Describe some of your techniques for photographing children.
Winning Their Cooperation. When children arrive at my studio, I try to discover if they are shy, scared, nervous,

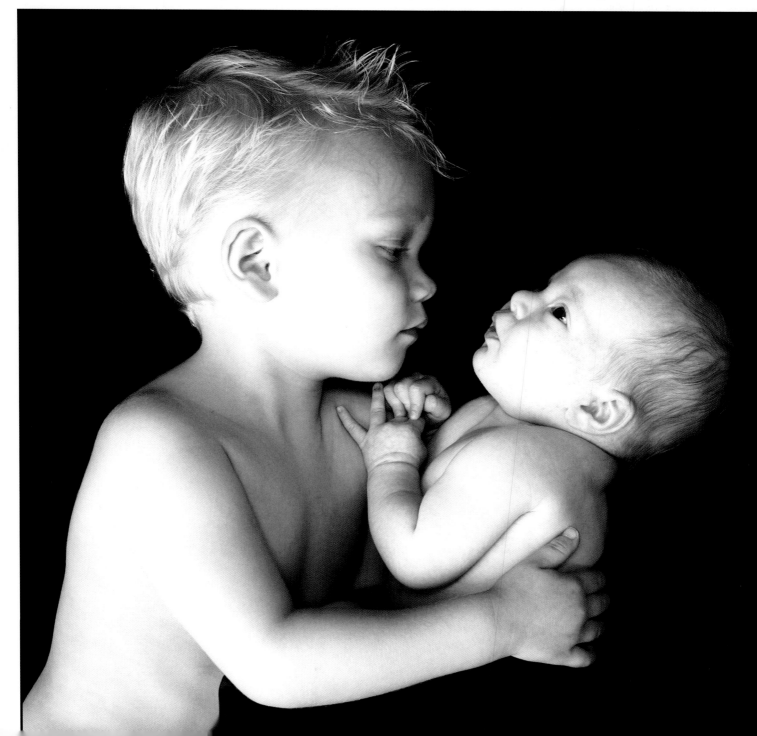

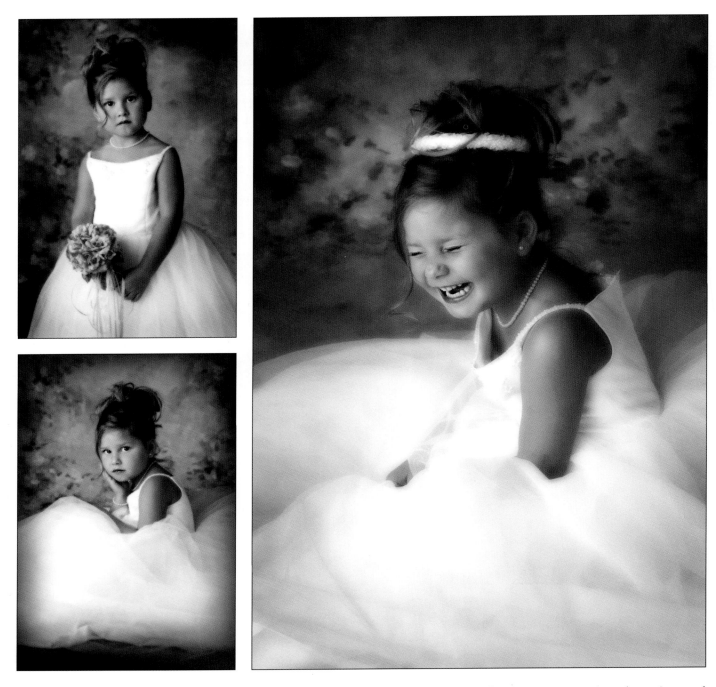

talkative, or just energetic. After discovering their type of personality, I tailor my approach accordingly. Sometimes a shy child can become very energetic very quickly.

I reassure parents of frightened or shy kids that we have plenty of time to let the child warm up. I sit a bit away and offer the child a toy while Mom changes their clothes or fixes their hair. I may ask their name and age, or comment on their beautiful shoes, or dress, etc.

When I think they might be ready I ask Mom or Dad to stay to the side of the backdrop. I do some close-ups while Mom lets the child know it's okay when the lights

flash. Children usually warm up to me in a short time and begin having fun.

With active children I may resort to bribery with animal cookies. I also have a bin full of little toys, and I promise a surprise if they do what I ask for a few minutes. The children love treats and will remember them every time they return. I make crazy noises, including a pig noise that children and parents find entertaining. I play peekaboo from behind my softbox. I always have music playing and often sing along with the children. I stay familiar with the latest toys and characters by checking toy

stores and TV channels. If I sing the theme from a favorite show, I can create an instant bond with the child.

Lighting. I keep lighting very simple for children and babies to cover them while they are on the move. My most popular lighting setup is a horizontal 4x6-foot Larson softbox, placed on the right and slightly feathered toward the child. I pair this with a large white reflector feathered on the left. I sometimes use a hair light. I find that the 4x6-foot softbox provides a lot of latitude when children move around. I love the look of the rectangular catchlights that are created by the softbox; it mimics the look of natural window light. On location, I prefer available light. If necessary, I attach a flash to my camera, but I don't care for the unnatural catchlights it creates.

Locations. It is often uncomfortably hot outdoors in Florida, and subjects tend to become irritated, so about 90 percent of my sessions are in the studio.

On occasion, I work at the beach or outside my studio near the lake.

Backgrounds and Props. Of my ten backgrounds, I probably use five, and the most popular is black velvet, which eliminates all the clutter. White paper is also very

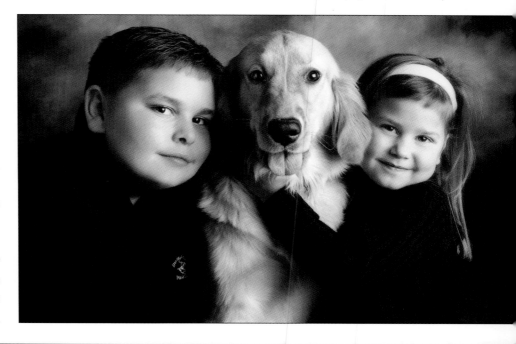

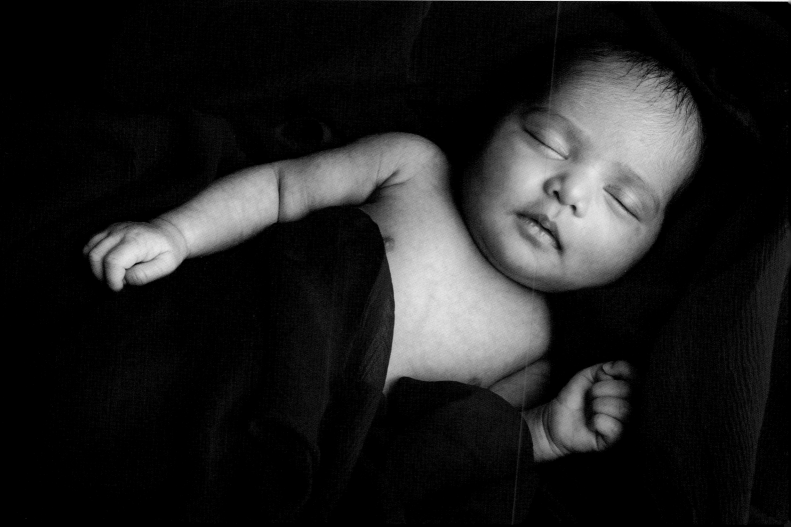

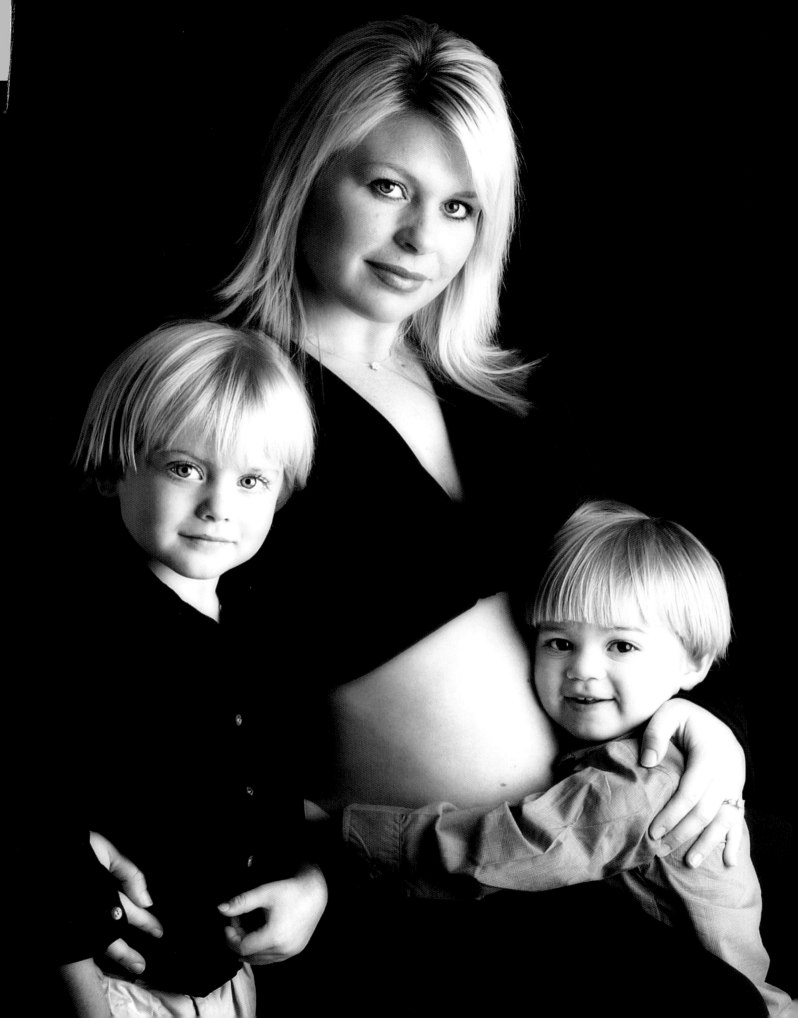

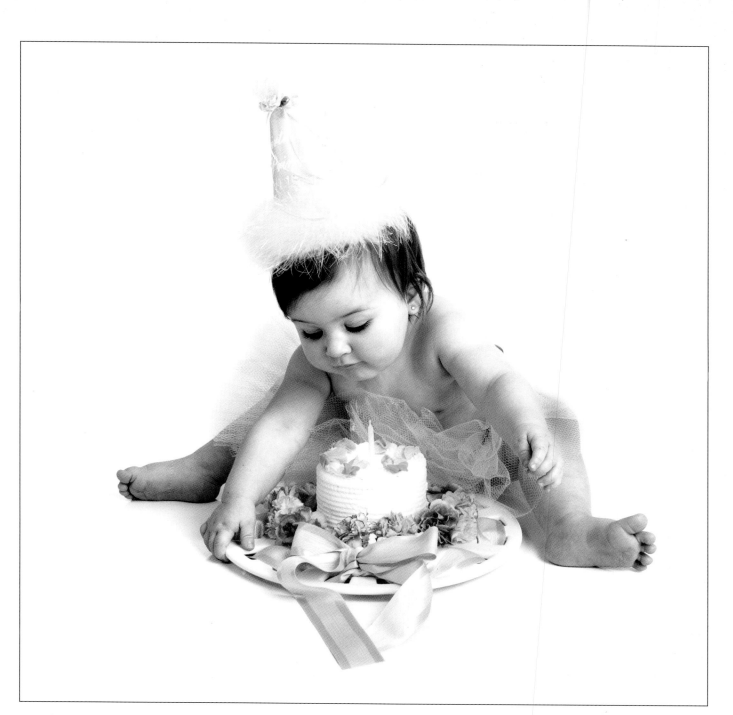

popular, as are Gale Winds by Les Brandt, Natural by Silverlake, and La Rosa by Background Artistry.

Parents love the close-ups and unique angles I create and are less interested in backgrounds or props competing for attention. For props, I like little chairs, and several white wicker benches and stools from Wicker by Design. I also like classic and timeless props, such as wooden airplanes, boats, and cars; a silver rattle; or a pretty rose tutu and tiara with tulle and petals all around.

Using an Assistant. I do not use an assistant during portrait sessions, but I do utilize Mom or Dad or both. They may make sure the child doesn't fall off a chair or they retrieve runaway kids. Sometimes I have a parent place bunny ears on me or throw a stuffed animal at me; these antics always make children smile.

Presence of Parents. If a child is inhibited or even acting out when a parent is there, I ask the parent to leave the room, provided the child will not be afraid and cry. I find that a child who misbehaves will act much better without Mom around. I also gently discourage parents from the "say cheese" bit in a way that indicates I don't need help getting a good expression.

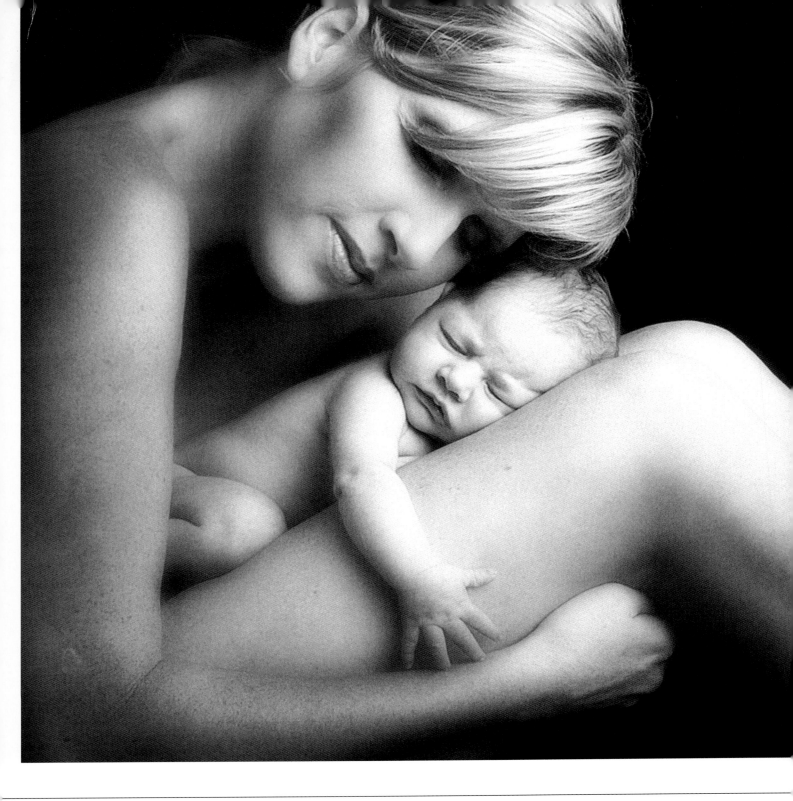

Personal Satisfaction. I feel satisfied when I know I have given my all during a session. Creating a fun experience for everyone is rewarding. When I am told a session is upbeat, it makes me smile! I love it when a client is open to photographic suggestions, letting me play and direct the session. I am most creative and enthusiastic when I photograph my way.

How do you anticipate gestures and expressions?
Expression is everything. Sometimes all you need do is tell the child, "Show me those little teeth in your big old smile," or say, "No smile this time," for a serious expression, which can draw viewers in more than a big happy grin. Sometimes I get the best smiles when I tell a child, "Don't you smile at me . . . don't you do it!"

ask about their room, its wall colors, or bedspread patterns. Who is their best friend? Do they like animals? The whole time, I am taking pictures.

Do you shoot sequential bursts?

When a child is cracking up, I do a series of exposures. When we "finish the session," I may let kids make crazy faces (I promise this to get them through the session) while exposing numerous pictures. I may ask a little girl in a dress to spin and dance while I photograph in rapid sequences. Telling kids to jump up and down is also lots of fun. I can make entertaining collages from sequences.

Cameras and lenses? Digital or film?

I currently photograph with a Canon 1DS digital camera, and I recommend the L-series lenses. My favorite is the 24–70mm f/2.8L. It is helpful to zoom when working with children. I always handhold the camera to enjoy the freedom to move about in the studio.

About 60 to 70 percent of my photographs are in black & white, which is popular because those images are timeless and classic, and yet contemporary. I often use a solid black background and believe its simplicity keeps attention on the child. I market black & white images heavily, although I photograph in color and convert in Photoshop, so images can be printed either way. My client may want black & white, but Grandma wants color.

How do you promote your studio?

My promotion, at first, was all word of mouth. I was unsure about advertising until another photographer told me, "Running a business without advertising is like winking at a pretty girl in the dark. You know what you're doing, but no one else does." This truly impacted my thinking.

Each month I create simple, eye-catching ads to run in a local magazine for parents called *The Kids Directory* (www.kidsdirectory.com). It's available free at many doctors' offices, children's boutiques, preschool/daycares, and even Blockbuster. Clients love to be featured in my ads. In addition, I advertise in a smaller, local newspaper that targets higher-income homes with young children. I have displays at children's boutiques, doctors' offices, and occasionally at Starbucks. My displays are usually black & white images in simple black frames with double mats. I often include large prints as well as collages and "series"

To get a genuine smile if the child is under two, I just act silly. I make noises, or play peekaboo while photographing. If the child is not fearful, I pretend I am going to tickle them. If they seem reluctant, I may tickle Mom or Dad if they are in the photograph. For a more somber look from an older child, I may say I'm going to ask questions, and not to answer, but just think about them. I may

frames. I always keep business cards or postcards at the displays and often include a coffee-table album of my work. Displays are very pricey, but I consider them permanent ads that pay for themselves.

My most important and effective marketing is still word of mouth. I have a VIP referral program in which I reward clients with a complimentary 8x10-inch print (or the dollar value) for every referral. Moms want to know they can trust me with their prized possessions, and recommendations reassure them. Clients in my VIP program are my best spenders, and I do not charge them a session fee. They can come in as often as they wish, although they still spend money on prints and albums.

I have a display booth every year at the local Junior League's holiday market, which attracts many new clients. Baby fairs at hospitals are also great for getting your name known. Presentation and branding are crucial for a successful photography studio. I have my logo on everything.

Of course a strong and professional web site is very important to promote your images and studio. A web site is often a potential client's first impression, offering evidence of what you can do for them and their children. I include little slices of my personality in the web-site copy that runs with my pictures.

I update my web galleries two to four times a year, except for a "recent favorite" section I update every week or two. I have also added a blog, which has become very popular. It includes small write-ups about recent sessions and shows a few images, plus personal pictures and stories about my life. Clients often check to see if their child is my current favorite or is mentioned on the blog.

What are your pricing categories?

I used to be opposed to packages, but clients love them. They help with decisions about what to purchase and give the client a feeling of special pricing.

I don't mind being more expensive than others, as this creates the impression of worth and value. I don't want to be the most expensive either, because that might limit portrait visits for some clients whose friendship I enjoy.

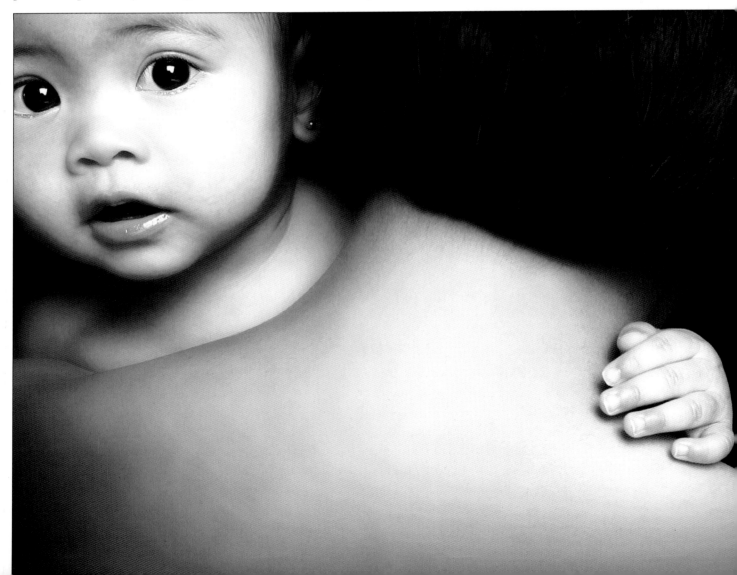

I adjust prices in January and sometimes in July, based on my business needs and status. I add new features and packages at any time if I feel there is a need for them.

How do you present your pictures to clients?

I do my own editing in Photoshop and use a professional lab for my printing and mounting because I prefer to spend my time photographing and running my business.

When the client comes in to place an order, I present a slide show of all the images from the session. This is projected on a large wall screen and set to music. I then present the 4x6-inch proof-set album, which is pink or blue for babies and black for basic family and maternity. I find that paper proofs are very popular, and albums are purchased 90 percent of the time, generating a big part of my profit.

Proofs are basically retouched, and final prints are always retouched and mounted. In general, children do not need much work done in Photoshop, although I always touch up under the eyes where most people, even children, have dark circles. Proofs never leave the studio unless they are paid for.

Describe your album layouts and common print sizes.

I do my own custom coffee-table album designs. I do not specialize in large wall portraits, but sell them occasionally, with 20x30-inch images being my most popular wall size. My best seller is the nine-up collage with a variety of images, and my Collage Collection that showcases children or a family sells well. Storyboards, in series frames, do well, too.

Does a photographer's personality influence their success?

Definitely. I'm easygoing, with a genuine love for children and babies, and my approach endears me to kids and parents. I make the entire photo session a fun one. When clients return, the children almost always run to me with open arms, and leave blowing kisses. That really has to be the most rewarding part of this business for me.

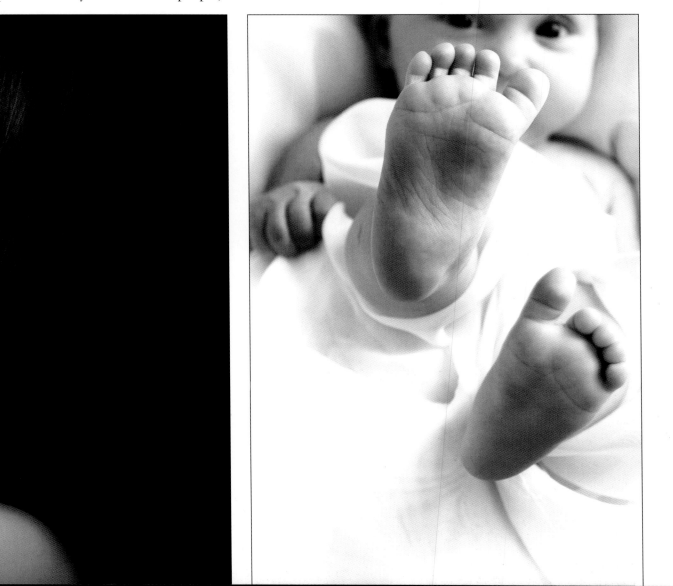

5. KATHLEEN NEVILLE AND PAM OSINSKI

Kathleen and Pam, each with their own studio, collaborate via a unique working agreement. With Kathleen's studio in Novi, Michigan, and Pam's studio in Milford, Michigan, they are only a few miles apart. Over the past ten years these two photographers have formed a seamless business union. Kathleen is the creative partner, Pam is the technical expert. They support and assist each other with the daily functions of their portrait businesses. Each contributed to this chapter. For more on Kathleen, whose images appear on pages 42–46, visit www.heirloomonline.com. For more on Pam, whose images appear on pages 47–50, go to www.imagesfromtheheart.com.

What are your backgrounds?

Kathleen (K): My father was a shutterbug, so I was raised with photography in my blood. In high school I enjoyed learning the basics of black & white, including darkroom techniques. Because my high-school guidance counselor discouraged me from studying photography in college, I majored in computer programming and marketing. After college I was employed as a computer programmer, but I never felt like I was going down the right path.

When my son turned three, I left my job to stay home and raise him, and my husband became the sole bread-

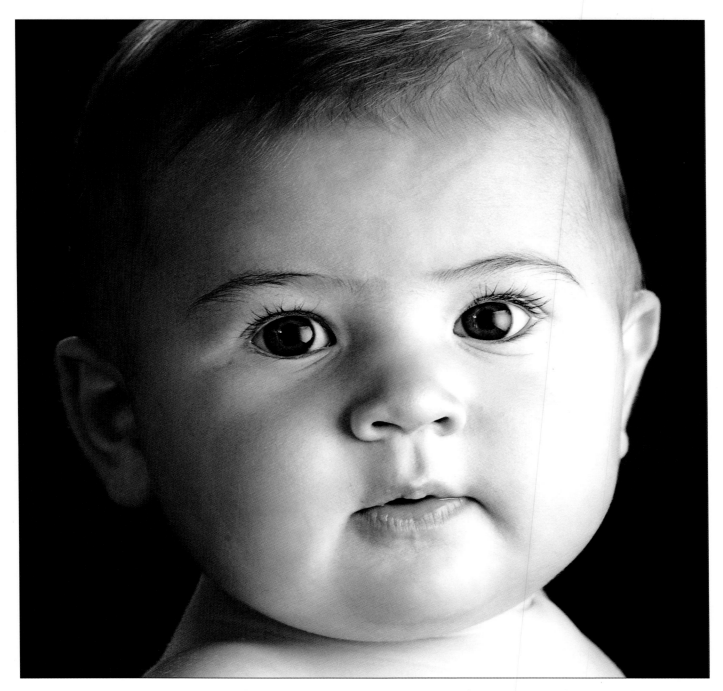

winner. But I also made time to complete my MBA studies in marketing and management and returned to photography. By the time our second child came along five years later, I was taking photographs for neighbors and friends. A portrait photography class at our local community college taught me how to handle light in a studio and on location. Subsequently, I knew that studio portrait photography would change my life.

In 1998 I hung out a shingle, joined our local professional photographers' group, and met some ladies with small children who also ran studios out of their homes.

Pam was one of the women, and we soon discovered we both loved children and studio portraiture. Together, we studied with some gifted family and child photographers including Bev and Tim Walden from Kentucky. They taught us their simple lighting and emotional capture techniques—exactly the direction we wanted to go.

Pam (P): My grandmother influenced my love of photography, and when I was about seventeen she gave me a Nikon EM with a 50mm lens. It fueled my passion and started a lifelong devotion to Nikon equipment. My grandmother mentored me in photographic and dark-

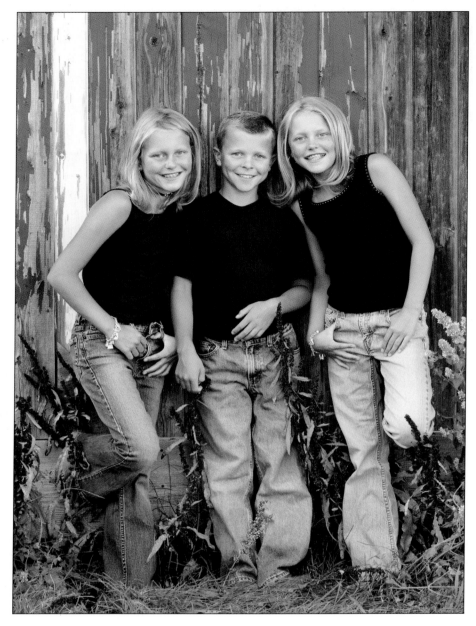

would quit photographing and stay home to raise them. But after my daughter was six months old, my husband and I created a studio in our home and I started photographing a few friends' children. My business grew, although it was tricky at times to care for the kids and also schedule work. Now I wouldn't trade my business for any other.

Tell us more about your studios, home life, and leisure time.

K: Both Pam and I use the entire lower levels of our homes as studios. We have had thoughts of combining our efforts within a storefront studio, but we agreed that being with our families and following our passion for photography is the best combination of all. Ours is a delicate balancing act, but one we have perfected.

P: My schedule is kept full by my clients as well as my family. Hailey is eight and Michael is six, and my husband, Mark, is experienced in juggling the children's activities to allow me time to create my portraits.

K: My family includes an active teenager, Brenden, who is a senior in high school, and Claire, who is nine. My husband plays a vital role in making the studio and the home front run smoothly. Running a professional business out of your home poses special challenges, and having families who support and understand them puts us way ahead of the game.

Children are the majority of our subjects in both our studios, with families running a close second, followed by seniors. Photographing small children is a special craft. Making a child feel at ease in the studio, through the entire process, is the key to creating emotional, captivating portraits.

room basics, and I saved to buy more lenses, a flash, and other equipment.

After graduating high school, I worked in office jobs and was never happy. During my early twenties, a woman saw an image of mine on the office wall and immediately bought an 8x10-inch print. I was shocked and then realized that I could actually do photography for a living. I felt liberated, and shortly after, I quit my job to devote myself to full-time photography. I had various photo jobs and apprenticed with a commercial photographer to learn whatever I could about the business. I was in love with portrait photography.

I worked for various studios for several years, and my husband and I decided that when we had children, I

How do you go about collaborating?

K: Our studios are about twelve miles from each other, which makes it nice when one of us needs an assistant.

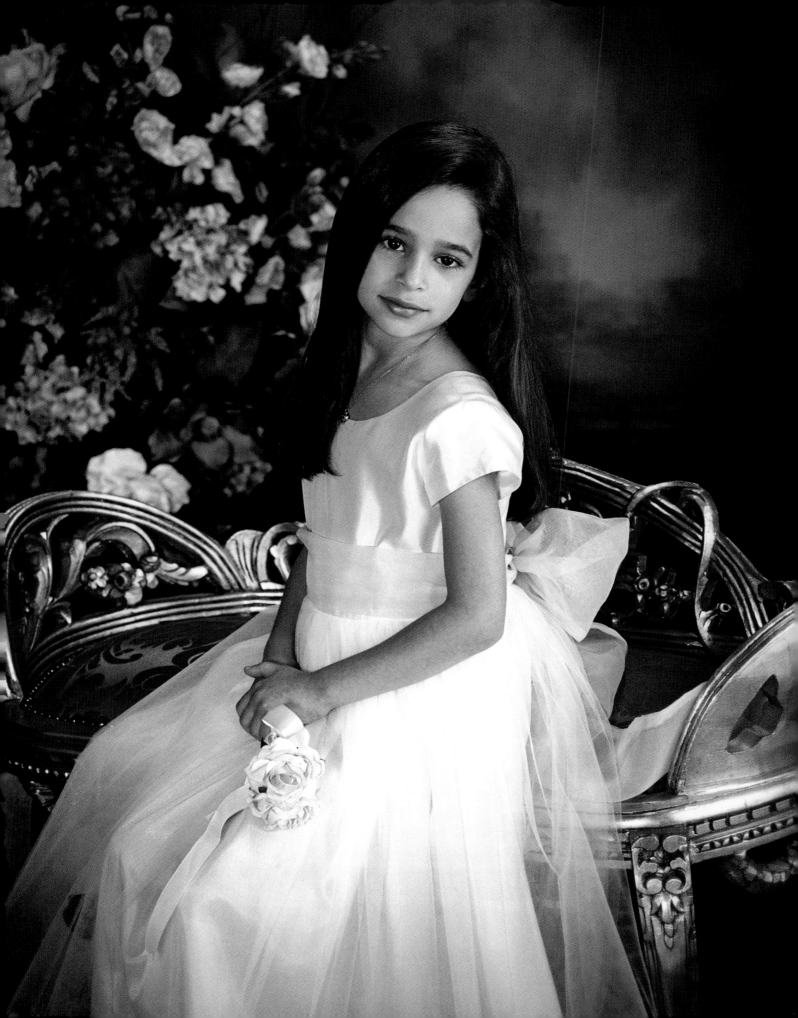

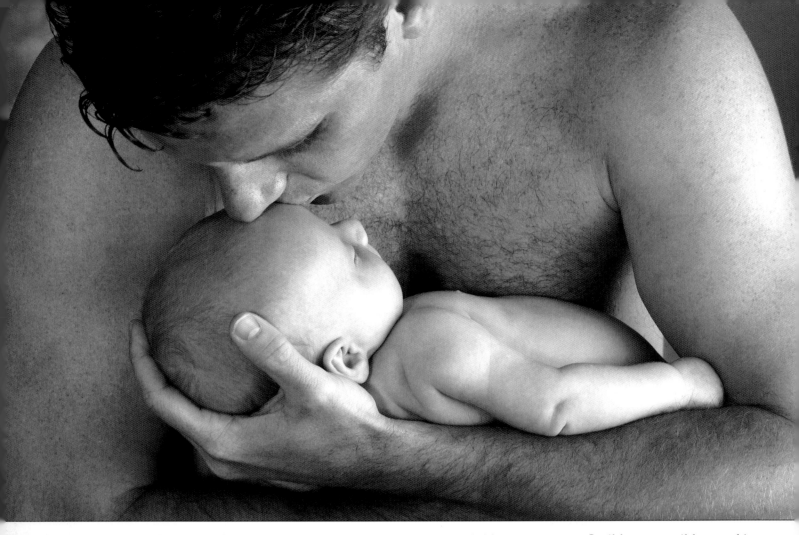

The larger studio is used for groups. Both studios include lights, props, backgrounds, and computer equipment. We each have a small, cozy area for digital preview projection and separate work areas for packaging orders. We aid each other on large studio and location sessions. Our individual styles overlap in ways that produce seamlessly executed sessions—even in stressful situations. Pam's abilities in the technical arena have taken us safely into the digital world and keep both our digital workflows running smoothly.

P: Kathleen's area of expertise on the creative side includes looking for new ways to promote our work and putting the right personal twist on media opportunities. Through the years, our studio policies have become similar, and we have learned from each other's experiences.

How do you go about scheduling?

K: We both try to see one client per day for consultation, presentation, or photographing. Saturdays and evenings are very popular with busy families. We always request at least two hours per photographic session so we won't have to rush to capture expressive emotions. With very small children we are as flexible as possible, working around nap times and feeding times. This means a small child will be in better spirits and our work is easier. If a little one starts to lose patience, we give Mom or Dad time to feed and nurture them.

P: Sundays are reserved for our families, and we all but close down for the month of December. That means a heavier load in November, but afterwards our families are able to spend quality time together and decompress.

When you turned professional, were your expectations realistic?

K: When we first turned professional, we did not have confidence in the quality of our images. We were too spread out, photographing kids in Halloween costumes, kids with bunnies, etc., and we were not happy with what we were doing. The more we educated ourselves, the more we found our need to be more focused on high-quality children's portraiture. Every photographer has a niche that makes them proud. Pam and I were fortunate enough to find our niche in classic portraits of children outdoors and in the studio.

Describe some of your techniques for photographing children.

K and P: *Winning Their Cooperation.* We begin each portrait experience in our studios with a face-to-face consultation with the parents and we request that the children be included. This pre-session consultation gives us a feel for what the parents want, but more importantly, we have an opportunity to get acquainted with the child. We show them around the studio and put them at ease. Often, we show them the camera, let them sit in prop chairs, and show them how to set off strobe lights. We have found that when they return for their session, we are like old friends and the child is comfortable. We believe you can see this openness in a child's attitude and in the expressions we are able to capture.

Parents are always welcome in our studios while we are photographing. We do this because if they are asked to stay outside the camera room, parents of small children may unconsciously convey their own insecurities to their kids. If a child is very timid and just cannot seem to let go of Mom or Dad, we include the parent in the portrait as a prop. Small children by nature want to control their environment. As parents of young children, we understand their reactions and try to work with them to produce outstanding portraits.

Posing. Part of the right approach to capturing the emotions of children is not to always get a big toothy smile. Sometimes, a big-eyed, soft expression melts the hearts of viewers. Children come in to the studio with their parents and are shown where to sit. We never over-excite the children and we have soft music playing in the background. We draw on quiet speech patterns and a gentle touch to put children at ease. Light-hearted conversation engages the child and holds their attention. If this doesn't work, we make up wonderful stories that keep them focused on us for the entire session.

Props. In our sessions we try to limit the number of props. There are times, however, when a more formal portrait is requested, and over the years, we have collected some timeless pieces of furniture that add a sense of drama and class to portraits. In these cases we are careful to make the subject the focal point, and not the props.

Lighting. Lighting equipment is similar in both of our studios. We use a large softbox as a main, a smaller softbox at the rear of the studio for overall soft fill, plus a hair

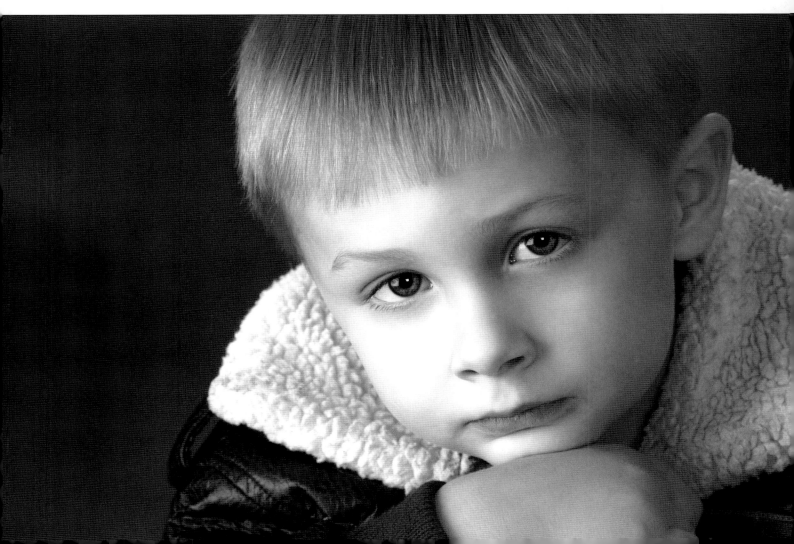

light mounted to the ceiling. We may sometimes supplement this lighting with a bit of rim light if the situation requires it. Our monolights are Photogenic and the softboxes are Larson and Photoflex.

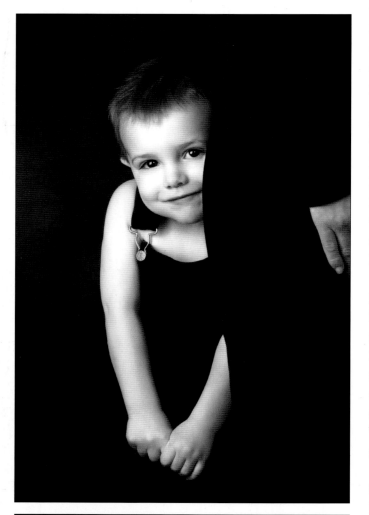

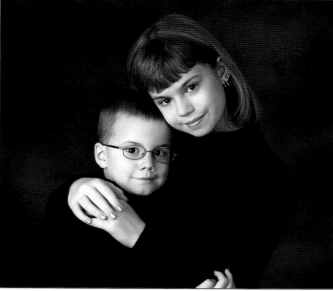

Describe how you work in outdoor locations.
P: Lighting decisions outdoors when we go on location are based on the quality of light when we arrive. Sometimes the light is perfect, soft or diffused; other times we use large reflectors to softly fill shadows and add eye highlights. We may use a Quantum Q Flash and Turbo Z, with and without an umbrella, to brighten subjects to an acceptable level. We constantly re-meter to be as close to a perfect exposure as possible.

Cameras and equipment?
What is your editing and printing process?
K: Both our studios use the Nikon D100s and the Nikon D2X. Our favorite lens is the Nikkor 70–200mm f/2.8 ED-IF VR. Once we were accustomed to the size and weight of the camera and lens, we found our images to be stunning. We also enjoy the Nikkor 28–70 f/2.8D ED-IF, which allows us to work more closely with children.

 P: We prefer ISO 100 but use ISO 200–320 in lower light levels. We capture everything in RAW format. We back up our images to the hard drive as soon as the session is over, then to an alternate drive, and then to CD. Backups are good insurance in postproduction. We edit the previews and present the best to the client. Once the client orders, we do our own retouching using Photoshop and Painter, then upload images to the lab for printing. We rely on the lab to do black & white conversion as well as color balancing.

How do you present your images to clients?
K: Clients set up workshop appointments to view their images projected on a 3x4-foot screen. We call this a "workshop" because we work with the client to select the best images. Appointments may take place at the studio or in the client's home by using a laptop and portable projection screen. After viewing digital projections, most clients purchase large wall portraits for their homes. We have happily dispensed with paper proofs.

What products do you offer?
P: Since we limit the number of different items offered for sale, we do not offer albums or packages. Although we offer smaller print sizes, our goal is wonderful wall portraits. We stopped framing our portraits to spend more time on producing quality portraits. We now control every aspect of the process and have less interest in ancil-

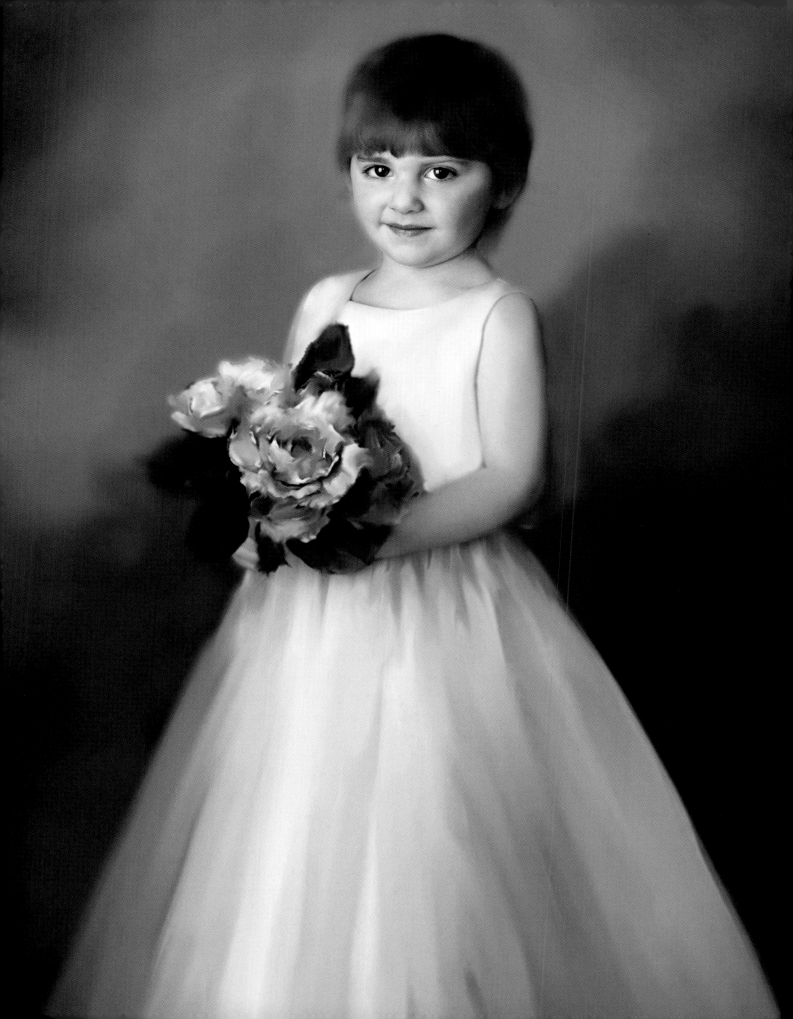

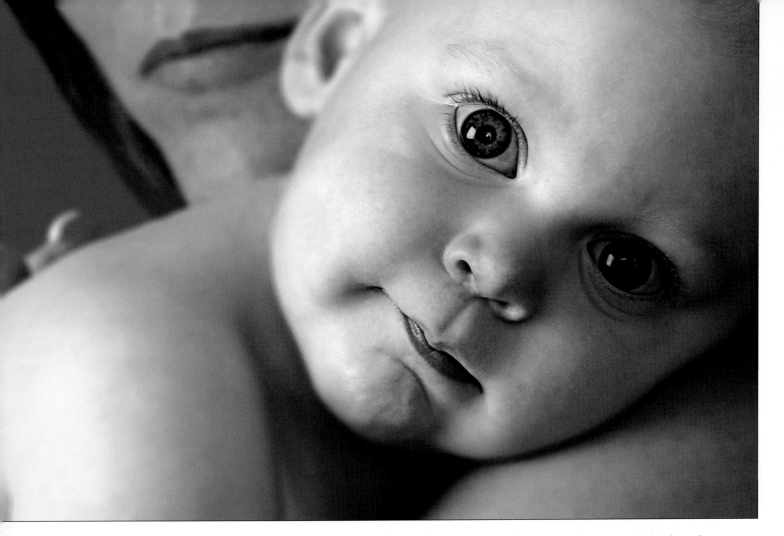

lary products. We have made agreements with quality framers in each of our towns and recommend them exclusively. Upon request we accompany clients to the frame shops to help them with their decisions.

How do you promote your studio?

K: We both have created web sites to inform prospective clients about our work in the comfort of their own homes. We try to change web images twice a year. Most of our business comes from word-of-mouth references from satisfied clients. We do not usually advertise in our vicinity, although we have sent out mailers to targeted local areas, and the results were good.

What are your pricing categories?

K: After years of toiling with the issue of pricing, Pam and I have finally reached a level where we are happy. Early on we did not believe in ourselves and the quality of our work, which resulted in very low prices, reflecting our own self-doubt. With experience, we found the artistic license that allows us to believe in our work as an art form.

Since then, we have priced our work higher than many other photographers in the area. We try to re-evaluate prices at least once a year to ensure our costs are adequately covered.

Does a photographer's personality influence their success?

K: We believe that a photographer's personality can make or break the success of a studio. From the first phone contact to the last thank-you card, we are very conscious of how we project ourselves. We are careful to approach each client with respect for their time and compassion for their children. We avoid adding to a family's stress. We pride ourselves on superior customer service and make sessions and visits to our studios as pleasant as possible.

Our children's portrait business has been a constant and welcome challenge for both Pam and I. Changing technology and rewarding results have added to our personal growth. Creating portraits that are cherished by families for generations to come is a special gift we have been given. We never take it for granted.

Catherine Huch was employed in the corporate world for a number of years before she decided that photographing children and families was her true destiny. She has a home studio in Canton, Georgia, in the Atlanta metropolitan area. She was a business major at the University of Pittsburgh, which has been helpful in owning her own business. Catherine feels that her style is constantly evolving, which indicates that her learning curve motivates her creativity. To learn more about Catherine's work, visit www.colorwashcreations.com.

What is your background?

I became interested in photography during a trip to Paris when I was eighteen. I watched a professional fashion-model photo shoot while I was on the top of the Eiffel Tower, and I was mesmerized by the photographer and the process. My photographic interest vacillated for a few years, but after my first daughter was born, I became obsessed with documenting her life, because I have only a few photos of myself as a child. I envisioned that when Bethany was grown, we would have shoeboxes of photos to view and compare. Now Bethany is nine years old and I have been a professional photographer for eight years.

Were you influenced by any mentors or seminar speakers?

I have not studied photography or art, but I do have a business education and spent many years in administration and marketing for corporate real-estate firms. I have always had a creative flair for design, which I learned through practice and experimentation.

When I started my business in 1997 with images of my daughter as samples, I was lucky to have Steve, the owner of a local film lab, become my mentor. He informed and encouraged me into my business.

Describe your studio.

My studio is at home, but completely separate from it. It is approximately 1,200 sq. ft., with a reception room, wide-plank hardwood floors, a restroom, changing room, and a 30x20-foot photography space with backgrounds

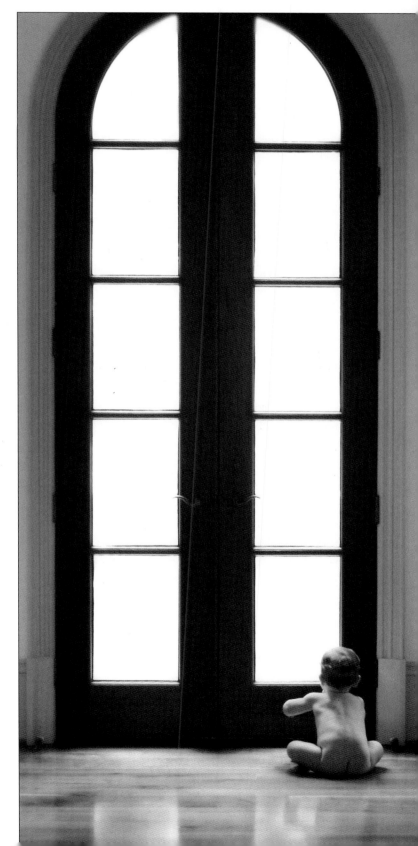

such as a wood wall, a brick wall, faux barn doors, and painted canvas. Clients comment that they and their children can relax easily in my comfortable studio. I also offer location sessions and can carry a studio setup to clients' homes or use the great outdoors. I have a part-time office assistant who I hired when the business of photography became pretty overwhelming.

How do you schedule sessions? When do you take time off?
I schedule via telephone and the Internet, and I am open two days per week while my children are at school. Since parents work during the week, I also offer weekend sessions (when my husband is at home) for which I charge extra. In general, babies are at their best in the morning, so I work with their schedules and photograph only one session per day for flexibility. Some newborn sessions have taken as much as five hours. My clients tend to want many posing configurations, such as baby alone, then with sibling, with Mom, with Dad, and finally the whole family together—and I accommodate them.

When running your own business, there is not much time for yourself. Days off for me usually come as a necessity to avoid getting burned out. Besides making the portraits, I also do the marketing, designing, editing, filing, ordering, and whatever else is necessary to operate profitably. We take a vacation in the summer at the beach, where I also schedule beach portrait sessions. In addition, we take a week off in the winter to go skiing. I have the advantage of blocking time off when my children are out of school, and after school I make sure that we are together for homework, dinner, sports activities, etc. I will sometimes go back to work after the kids are in bed.

Have your children influenced your business?
I have two sweet, smart, and beautiful daughters who are close in age and are great sisters to each other. I took a lot of pictures of them while training to become a professional, so it can be said that they influenced my awareness and techniques. I also practiced on family and friends and charged a minimal amount to cover expenses, with the profits going back into the business. The kids still influence my business because I photograph when they are in school and on Saturdays when Dad can watch them.

Were your expectations realistic when you turned professional?
Yes. With a background in business, I knew it would be a lot of work, but fortunately, it's enjoyable work. I get to see

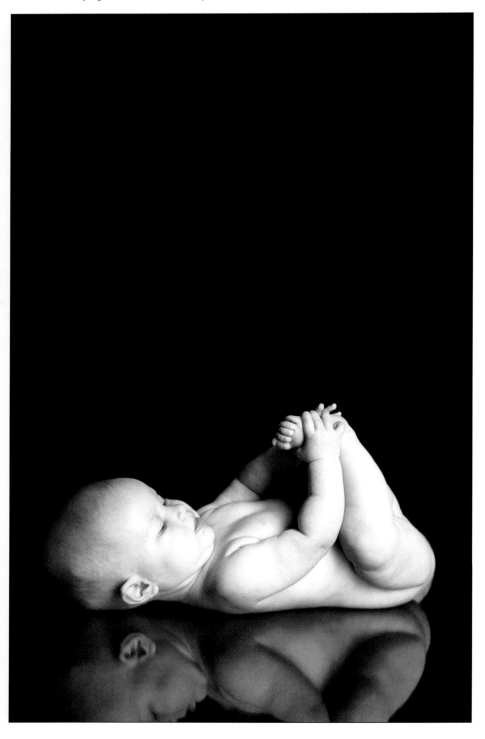

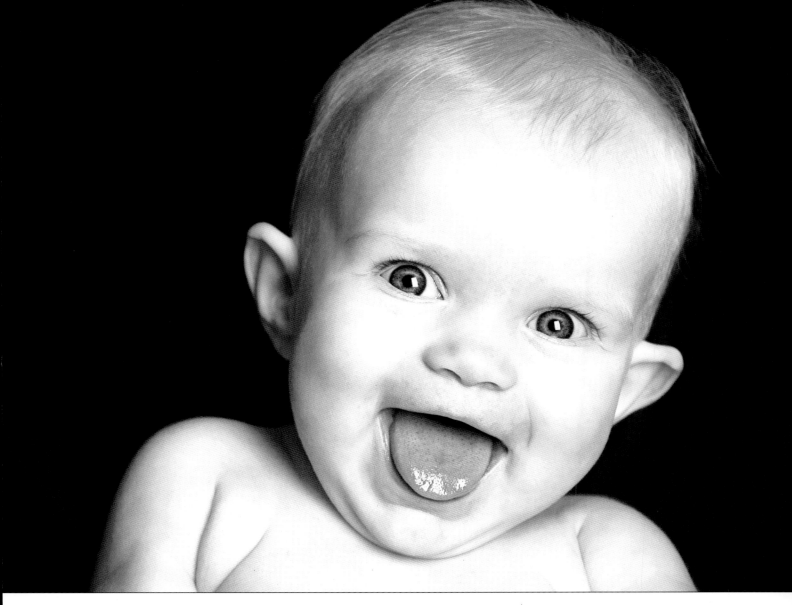

brand-new babies with mothers crying tears of joy. I get to photograph toddlers' eyes filled with wonder. I get to meet beautiful little girls who believe that by putting on a princess dress, all the magic will happen. Although I never imagined that I would combine my creative inclination with business, I discovered that I am good at this photography gig.

While polishing my rapport with people, I have made all the mistakes, but I have also made changes. I continually learn and grow with my approach to photographing children and families. My photography prices, packages, policies, and marketing have changed drastically from when I first started; whether from behind the camera or as business owners, we need to evolve and expand our businesses accordingly.

Describe some of your techniques for photographing children.

Winning Their Cooperation. Patience, patience, patience. I have never met a child that I couldn't outlast. I talk to them as people, not babies or toddlers. I find something that connects with them and go with it. I always tell the parents, "We can plan as much as we want, but your children are going to let me do as much or as little as they wish." This informs parents that I will not force a child into anything they do not want to do, which keeps a session natural and open.

Lighting. In the studio I use two softboxes and one barn door, and—on rare occasions—two umbrellas. I prefer light from softboxes because it is softer and emulates window lighting. I prefer square or rectangular catchlights rather than round ones. I keep my lighting simple. If a child is pretty active, I work with my largest softbox. If

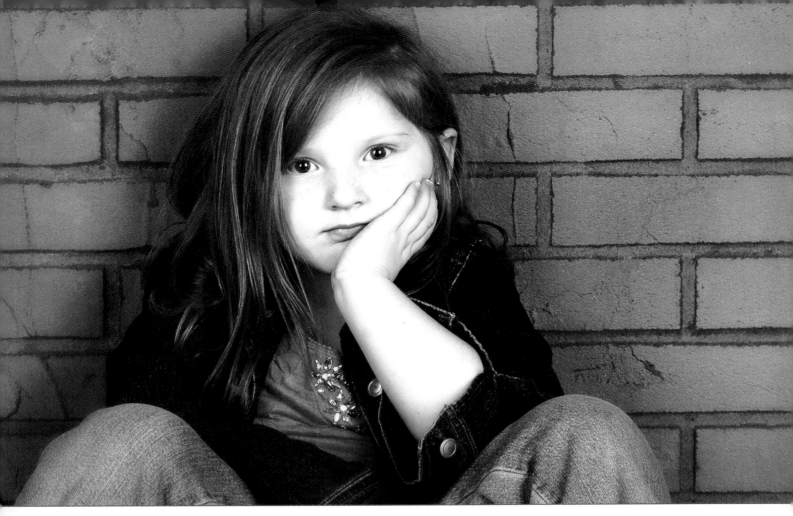

they sit in one place and take direction, I turn on the backlighting. I look for simple locations without busy backgrounds.

I use a 42-inch reflector or a small 20-inch reflector when I work outdoors, depending on the size of the space I am working in. I don't use reflectors or a fill light in open shade if I have a very active child. I pay close attention to lighting the child's eyes, and hope for the best.

Props. I only use a few props, and only when it is absolutely necessary. I have an antique replica of a 1950s style red pickup truck for boys. With babies, toddlers, and younger children, bubbles keep their attention and help create magical expressions. I never use an assistant in my sessions; that time is just between the children and me, so I try to avoid distractions.

Presence of Parents. I don't mind if parents watch and participate as long as they don't interfere with my interaction with their child while I have his/her attention. I actually enjoy most parents. Having professional photographs of their child is like a milestone, to them and I want them to be there. However, if they hamper me by making the child say "Cheese!" or constantly interfering

while I try to get that special photograph, I have no problem asking them to leave. Once I take control, the interaction I get with my subjects is awesome and the parents are eventually thankful.

Personal Satisfaction. I really just strive to do my best to capture the true child with natural expressions and responses. I am in a much better mood after a great session than I am after a difficult one—and my husband and daughters sense this, too.

How do you anticipate gestures and expressions?

I anticipate based on my interaction with the child or children. I talk to them; I ask them to tell me a story, or I ask silly questions, such as, "Does your dad have stinky feet?" Acute anticipation evolves from experience; it is easier to predict children's reactions and expressions now than when I first started. Kids and babies can sense that I love them, and they respond. I enjoy getting to their level. The hugs I get at the end of the sessions make it worth it to give my all and generate fun for kids. I may use props to stimulate some gestures and expressions, but talking works better.

Digital or film?

I presently photograph with a digital camera, although I contemplated switching back to film because I have a love/hate relationship with digital. I love the control and freedom it gives me, but I hate the amount of time I spend in the digital darkroom. However, I will probably remain a digital photographer because the process is getting more comfortable.

I specialize in black & white and handcoloring; it is what I do best. I only offer color with a repeat client who wants something different. I am not being temperamental. I *see* in black & white—tones, textures, and expressions. I do not see color. I love the old-fashioned artistic aspect of adding color after the fact by hand with oils, pencils, and pastels. Most clients seek me out when they are specifically looking for black & white.

The Fuji cameras that I photograph with have a fabulous black & white mode so I don't have to convert, which I dislike. I believe that clients are conditioned to want color and photographers give it to them—and the generations that had only black & white don't want it ever again. It is a shame, because black & white is so beautiful and classic.

Do you shoot sequential bursts?

I photograph sequential bursts in all circumstances. If I see quickly changing facial expressions on a six-month-old, I photograph a sequence and the result could be a look of wonder, a smile, a full belly laugh, and then perhaps a pout. What parent could resist all of those expressions in a series of prints? I can't, so I photograph it!

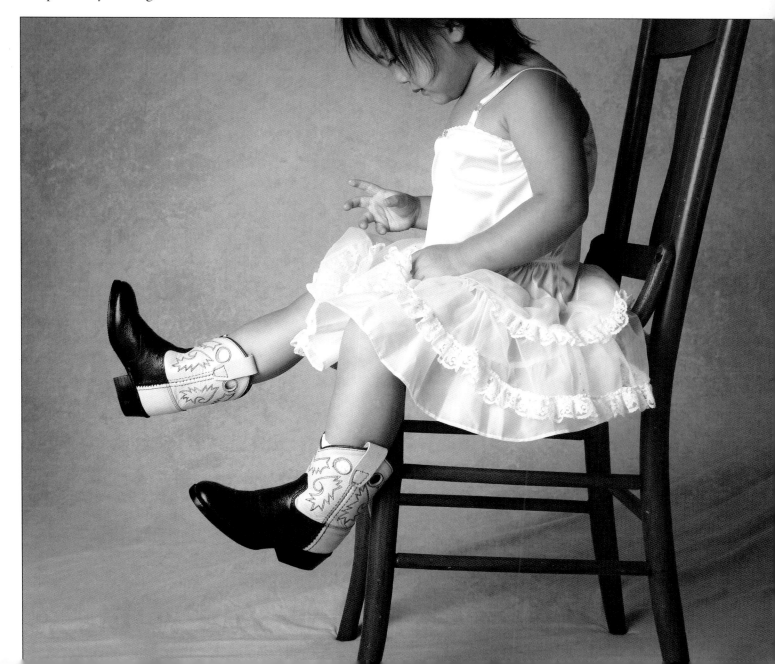

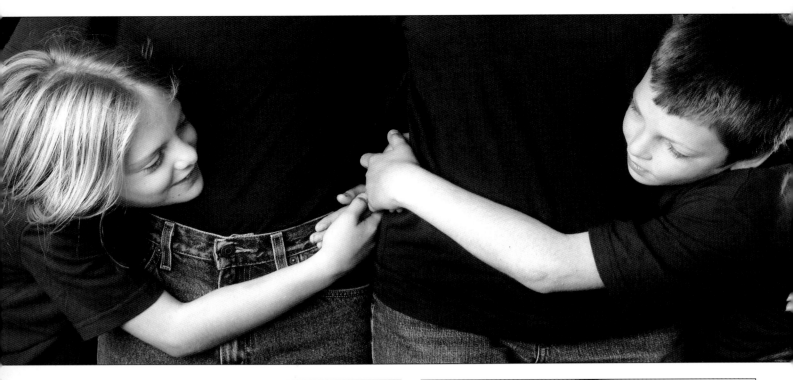

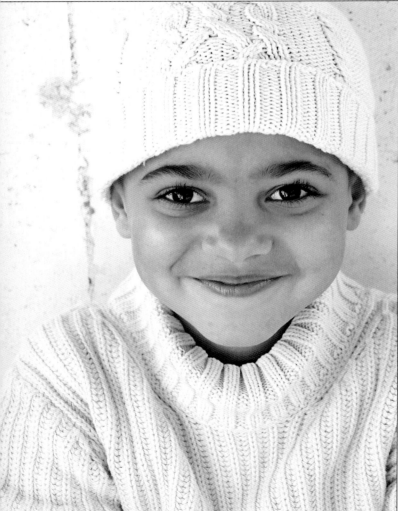

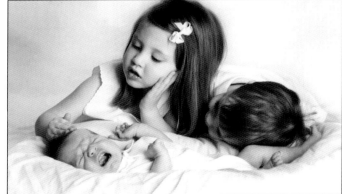

Camera and lenses?

I love Nikon lenses and I use Nikon N90s, Fuji S1, Fuji S2, and Nikon D70. My advice about choosing equipment for photographing children is this: keep it simple. You don't need a lot of gadgets that too often end up in a closet. My basic recommendations would be: a main camera plus a backup camera (which should always be with you); three good lenses (a wide-angle prime, a portrait prime, and a fast zoom); a light meter; a reflector; two strobes (one with a softbox for indoor studio use); and one main backdrop, preferably of a neutral color. For outdoor sessions, the same list applies—minus the strobes and backdrop.

I always handhold the camera, whether in the studio or outdoors. I don't have any flexibility with a tripod, and I need to move quickly with children.

How do you promote your studio?

For my first three years, promotion was completely word of mouth, some of which was generated by contributing to a local organization that displayed my business cards. I also depend on my web site now, but I still have a good print ad that runs in a local, full-color, monthly directory for children's services. It is a great parents' resource that generates a lot business for me. Ideally, I change web-site images once a year because the upkeep is very time consuming. I had a web person update my site when I first started, and it was an awful experience; now, I do it myself.

Word-of-mouth marketing still helps me get the message across that my studio offers custom, not cookie-cutter, photography. I really get to know my clients and maintain friendships with them, so their satisfaction goes a long way.

What are your pricing categories?

I offer studio and location price categories. Fees are for my time only, and location sessions are higher. I offer three packages, a premier category that includes proofs, another for maternity and newborn, and one for baby's first year. The latter includes four sessions with prints from each session. I am in the medium price range compared to in-town photographers, but in the high range compared to most others in the suburbs. I raise prices according to the supply and demand theory; if I am too busy, I raise my prices. In the beginning it was once a year, and more recently, three times in one year.

Describe your editing and printing process.

I have finally found a fantastic lab and I trust them to do a great job. It is not to my benefit, either time-wise or monetarily, to print my own photographs. I do control the entire image-editing process, however, and I retouch any image that needs it. I have a reputation for my images being perfect, and I like that.

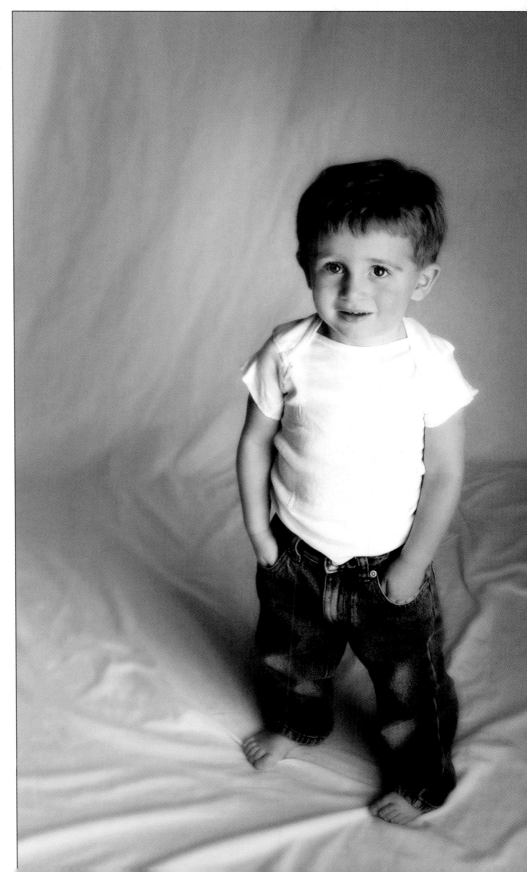

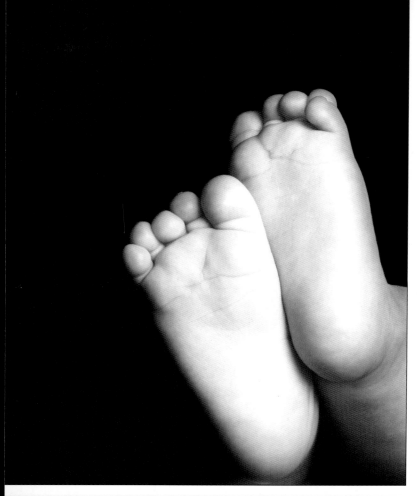

The amount of Photoshop I use on photographs of children varies. Newborns get acne that needs to be touched up in their portraits. Sometimes toddlers need a snack and get cracker on their faces. Rather than miss an expression, I photograph crackers and all, then remove the crumbs later if necessary.

How do you present your images to clients?

I offer two options: online previewing or purchasing a proof album, which is included with the price of the premier session. My clients usually prefer to view proof albums at home so 99 percent of them choose the premier session.

Describe your album layouts and common print sizes.

I wanted to offer albums where designing layouts in coffee table style books was involved, but I decided not to take on the additional work. Album suppliers do the layouts for me.

My most popular print sizes are 5x7, 8x10, and 11x14 inches. I sell a lot of wall-size portraits (16x20, 20x24, 30x30, and 30x40 inches), but the sheer quantity of smaller prints purchased indicates that they are the most popular. Creating home gallery walls with multiple photos of different sizes has become extremely fashionable, and I have amazing wall space in my studio to do this. In general, you sell what you show.

Does a photographer's personality influence their success?

Most children's portrait specialists are upbeat people, because a sunny disposition resonates well with kids and their parents. I think you have to absolutely love children to dedicate yourself to them. You have to have a great deal of patience and you have to be extremely driven to succeed. You should expect a lot of photo and business bumps and bruises along the way, but in my opinion, my specialty wouldn't be worth it without them. I guess I am trying to say that the pleasures of working with babies, children, and families are worth all the headaches along the way!

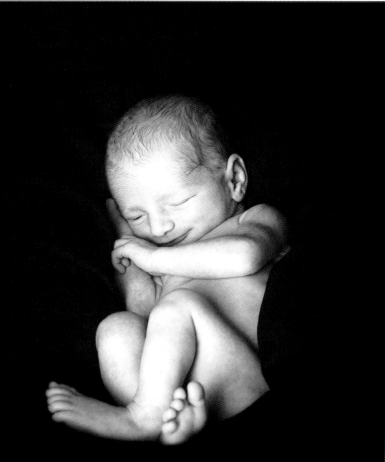

Eddie Bonfigli of West Palm Beach, Florida, started as a wedding photographer before concentrating on children's portraiture. His style, refined over sixteen years, depends on simplifying his methods and searching for the "decisive moment." Though he has no children, kids have a distinct appeal to him, which helps generate the patience that accompanies his sense of portrait design. In addition to portrait work, Eddie runs a web site for children's portrait photographers located at www.ilovephotography.com. You can learn more about Eddie at www.eddiebonfigli.com.

What is your background?

I bought my first camera at age nineteen—a Nikon FE with an 80–210mm f/4.5 zoom. After graduating from the University of Vermont with a degree in psychology, I began a solo bike tour of Florida, where I used the Nikon to record nature and street scenes in interesting light. My early images on Kodachrome 64 were made most often in early morning or late afternoon.

After relocating to Florida, I held a job at an art supply store where a contact led to photographing my first wedding. Although I felt critical of the results, the images were acceptable, and my techniques improved over five years of wedding photography. Eventually, after some soul searching, I turned to children's portraiture as my specialty, because I wanted to use my camera to capture the innocence and perfection that children represent.

Were you influenced by any mentors or seminar speakers?

Although I never formally studied photography or attended workshops, I pored over books that celebrated the impact of light on a subject or scene. I was particularly taken with *The Family of Man* and Ernst Haas's *Creation*,

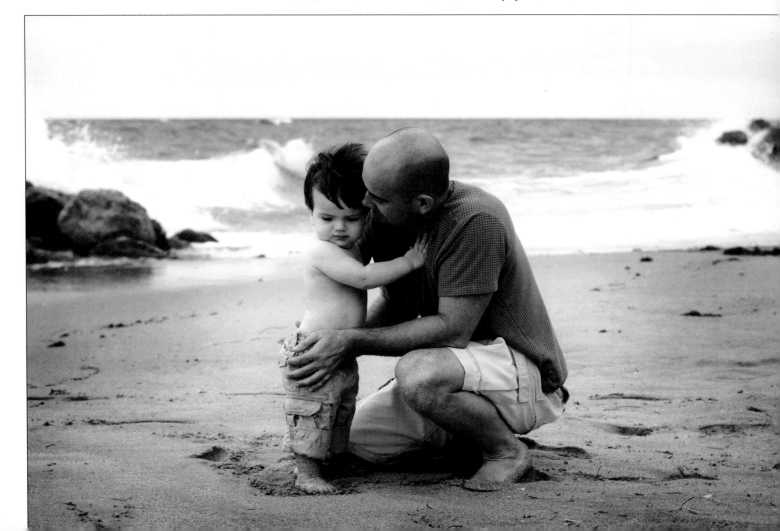

and I also paid close attention to lighting in television commercials. Books by Dean Collins helped validate my desire to photograph with one light. Business courses never interested me, so I considered myself fortunate when I met a loyal fan of my work who would become my business partner and manager; this allowed me to concentrate on being creative.

Describe your studio.

I once ran my business from a studio but decided I liked working on the beach, at parks, or at peoples' homes. I never meet or photograph clients at my home, but I do everything else there. A prospective client usually discovers my work through friends. When I receive a call, I either schedule the session or refer the caller to my web site. After the session, I send the client a proof book, and soon afterward it is mailed back to me with an order. This works very well and only occasionally do I have difficulty getting a book back.

How do you schedule sessions? When do you take time off?

My business is low volume; I schedule about two sessions per week at moderately high prices. I tend to schedule sessions to suit busy moms who have certain windows of opportunity. I will take a so-called vacation if an upcoming month looks slow.

When you turned professional, were your expectations realistic?

At first I wanted to make lots of money and gain fame as the Patrick DeMarchelier of children's portraiture. I soon realized I was happiest creating portraits of kids for parents and keeping things low key. My business is relatively small but I try to be the area's best choice for children's black & white images.

Early on, I set out to keep photography fun, even after discovering that kids could be really unpredictable. My psychology degree was only a limited help in getting kids to cooperate, so I discarded notions about control and began going with the flow. My preference for simple settings and a minimalist mind-set made planning sessions easier. When on location, I need only a white or black backdrop; a short wooden stool for kids to sit, stand, or play on; and one light. If you receive clients at home, I suggest you enforce a "by appointment only" rule. If this arrangement doesn't work or feel right, I meet and photograph at clients' homes.

Describe some of your techniques for photographing children.

Winning Their Cooperation. My mood before a session is serious, somewhat intense. But once the session begins, I feel very comfortable interacting with my little subjects. I like being silly, frivolous, and sometimes dramatic with them. Hopefully, a session will be a fun experience for the kids, because that leads to good photographs. I talk to

kids gently with a slightly higher and lighter voice. I always get down to their level by kneeling or sitting. I have found that kids often respond better to questions they don't hear often, so instead of asking their age, I might say, "Where in the world did you get the money to buy those shoes?" To capture eye contact, I will blurt out the child's name. This usually gets me a proof-book-worthy expression. To capture a child's quiet moments, I stay alert at all times.

Being somewhat a loner, I don't work with an assistant whose participation might be counterproductive. Our eyes are innately drawn to people, so when I try to get kids to look at my camera, it is better not to have an assistant next to me. If a mom helps me during a session, I

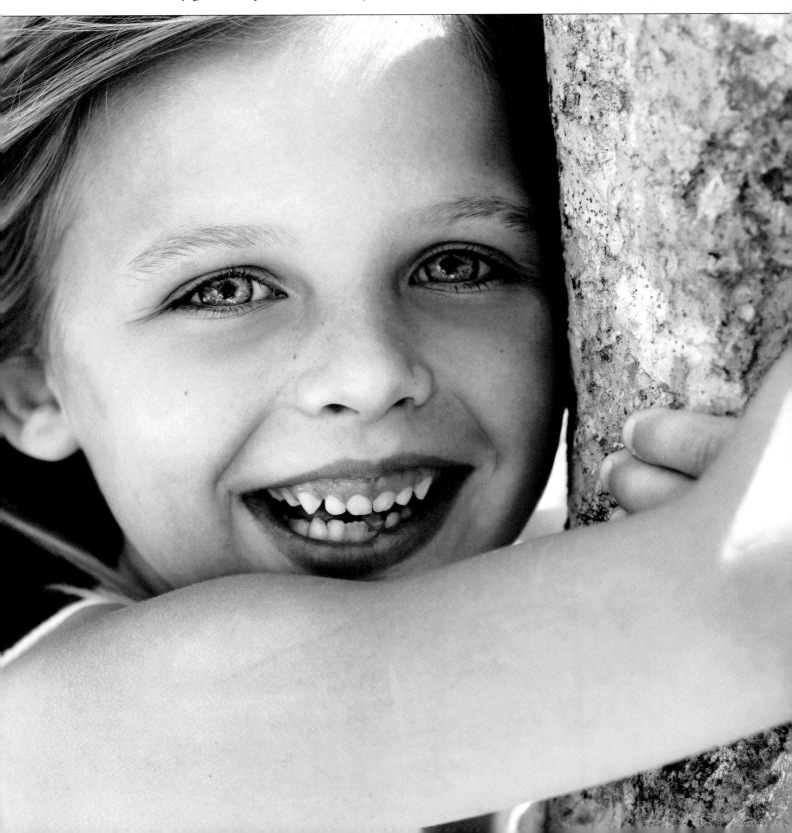

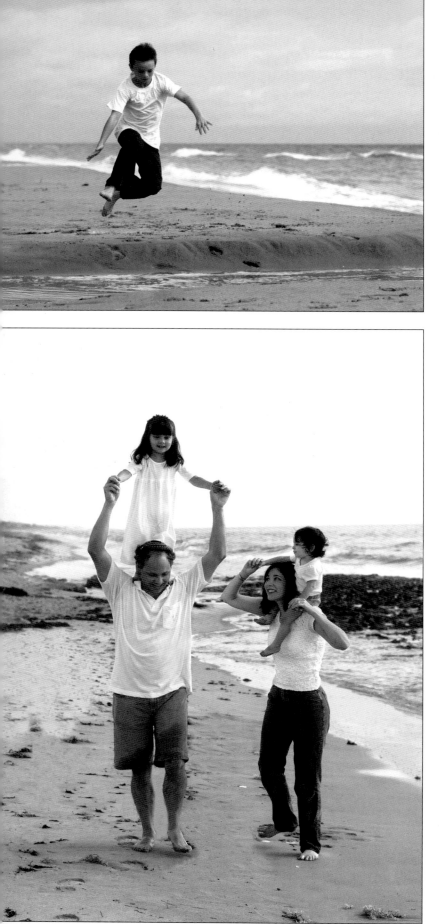

always ask her to get directly behind me, so when the baby looks at Mom he is looking at my lens, too.

Lighting Indoors. I aim to achieve natural-looking light in my portraits, outdoors or with studio lights on location. Inside a home, I seek a window that offers soft light. Otherwise, I use a large or extra-large softbox as my one and only light, and a white or silver reflector to fill shadows. I prefer rectangular softboxes that produce window-shaped catchlights. Diffused light gives young skin a healthy glow with soft shadows. To open up shadows on a face, I use a white reflector opposite the main light source. A single light best approximates natural light outdoors, though my preference is reflected or diffused light.

After photographing children for sixteen years, I am convinced that photography is mainly about finding the right light and capturing expressions. To me, Henry Cartier Bresson's "decisive moment," combined with pleasing light, is what children's portraiture is all about.

Outdoor Lighting. I look for open shade consisting of soft and directional light from a patch of sky in front of the subject, or I try for a situation where the subject is just inside the front end of a "tunnel of shade," with the sun located behind him or her. The tunnel can be foliage or a man-made structure. This keeps overhead light from producing eye-socket shadows and side light from spoiling subtle modeling produced by front light. I never use fill flash when I photograph kids outdoors, except with large family groups when existing light is not ideal.

In order to work confidently without extra fill, I choose the location and the session's starting time carefully. If an open shade location is chosen wisely, extra reflectors or fill flash should be unnecessary. This strategy allows me to photograph in a carefree way with few meter readings.

Handholding the Camera. For family sessions where everyone is relatively still, I use a tripod, and often a remote release. I handhold the camera when photographing children, both for still or action sequences.

How do you anticipate gestures and expressions?

I watch eagerly for delicate expressions to appear naturally. I may try to guide a child into a moment of repose by pretending that something is wrong with my

camera. Then I photograph them when they are distracted. If I am lucky, the child will experience a range of emotions, and I will photograph a lot of frames when these expressions happen. If a child has been subdued by a pinch from a little brother, or a sharp word from a big sister, the challenge is to be ready. When a kid seems carefree, capture a photo sequence. Don't worry about overshooting; see it as taking advantage of the moment.

Black & white or color?

I photograph only digital black & white files for children's portraits and for my own personal work. Now that I am digital-based, I am often advised by colleagues to capture the files in color and convert them later to black & white. However, what is most important to me is to satisfy my artistic side, so I photograph in black & white, using the JPEG mode, in order to see the image in black & white from the start. This is a must for me on a creative level.

Do you shoot sequential bursts?

I shoot sequential bursts in the situations mentioned above and wherever they are helpful. If I am photograph-

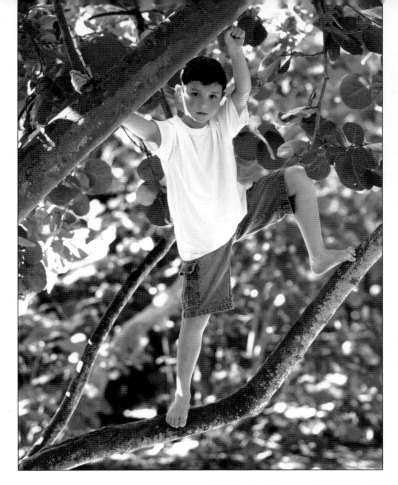

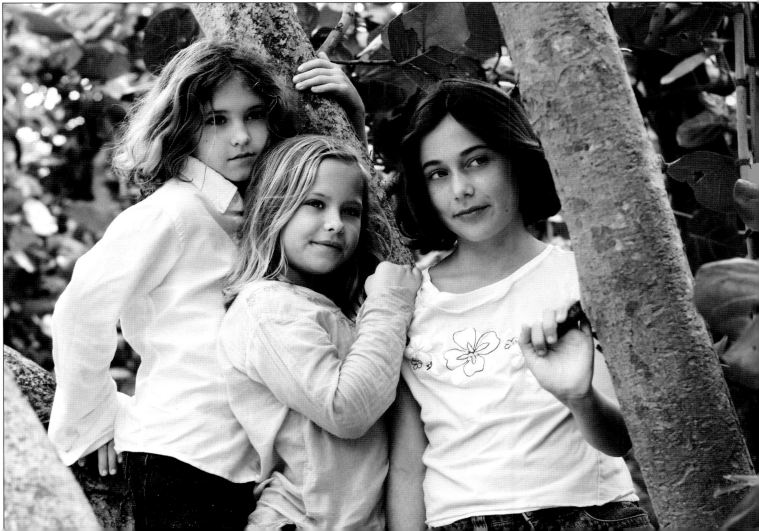

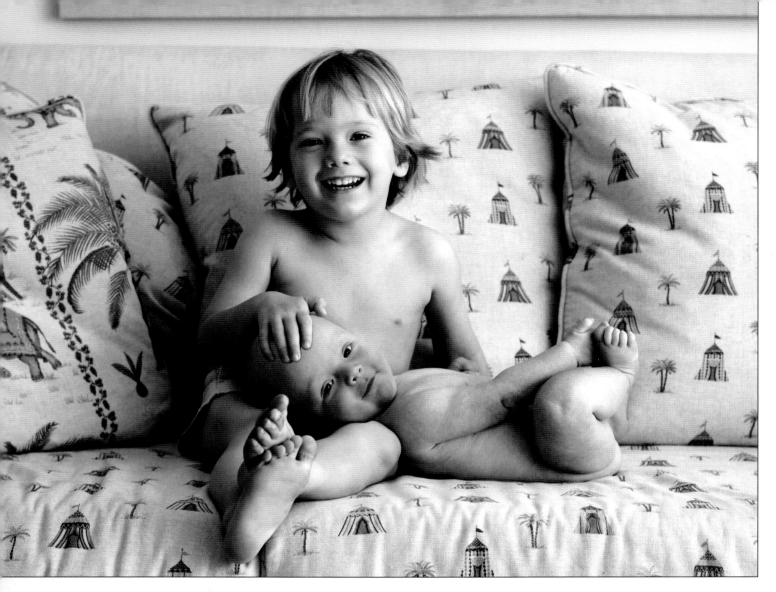

ing a group of kids or adults and suddenly they break into laughter, I capture this in rapid succession to get that one exposure where all of that exuberance falls into place. When kids are immersed in being themselves and ignoring me, I photograph calculated sequences, aiming for those moments where light and expression complement each other.

Camera and lenses?

When I photographed with film, I used a Nikon F100 with an 85mm f/1.8 lens which creates beautiful out-of-focus highlights at wide apertures. I am still using that lens on a Fuji S2 and S3, along with a 60mm f/2.8 macro lens, which gets me much closer to a subject's face. For children's portraiture, SLR cameras are ideal. For a while, in my film years, I used a Pentax 67 with a variety of lenses, and loved the larger negatives. With kids, I have more speed and agility using a 35mm camera.

How do you promote your studio?

At first, an ad in the phone book was my most effective promotional tool, and although it brought many new clients, some were not in the economic position I preferred. Eventually, word-of-mouth advertising established my reputation to the point where I could be more selective. In the hair salon I frequented, I started showing black & white portraits of the owner's daughter. The shop's high-end clientele viewed them and called me; the owner also "talked me up," partly because I gave her a good deal on enlargements.

I made the same arrangement with the owner of a high-quality stationery shop, and after she displayed portraits of her daughter, she also gave my name to her trendy friends. You will find that practical give-and-take relationships can often help to grow your business.

I also promoted myself in the beginning by including 8x10-inch enlargements with proof books loaned to

moms. I knew that many of their friends would see the pictures, and the enlargements made a statement. Donating gift certificates to charity functions also played a role in my self-promotion, and it still does. Those techniques spread word-of-mouth in a big way.

My web site shows prospective clients my work and prices. Many web-site referrals are from people who already know of me, who visit to confirm that my style is what they are looking for. I also attract a number of out-of-town vacationers wanting a family portrait during their Florida stay. They will perform searches for child photographers located in the town they will visit, so a web site helps tremendously. However, I find it difficult to keep my web site updated as much as would be ideal.

What are your pricing categories?

I keep things simple in pricing my services and products. Portrait sessions require a sitting fee, whether or not the client orders prints. After the client is loaned a "proof"-stamped book, they choose the images they want enlarged. These are sold individually; I do not offer packages. I offer a reduced price only on quantity 4x6-inch prints that clients insert in custom holiday cards. My print prices and session fees are appropriate for the Palm Beach area; some photographers charge less, others more. I raise my prices when my volume becomes too great to handle. A sophisticated clientele will not expect good work to come at an inexpensive price. My prices will evolve with time in order to become more in line with a select market of discriminating portrait lovers in my area.

Describe your editing and printing process.

I handle my own digital image editing, mostly because I want the con-

trol. Eventually, I will consider having this done for me, because it consumes a large amount of my time, and someone highly trained in Photoshop might do a better job than I do. Since I photograph almost exclusively in backlight, it is common that face brightness and contrast have to be judiciously corrected; these are issues that I am currently reluctant to hand over.

Using an accurately calibrated monitor, I adjust contrast and density, often burning and dodging, before I upload files to a professional lab. I use the lab's "no cor-

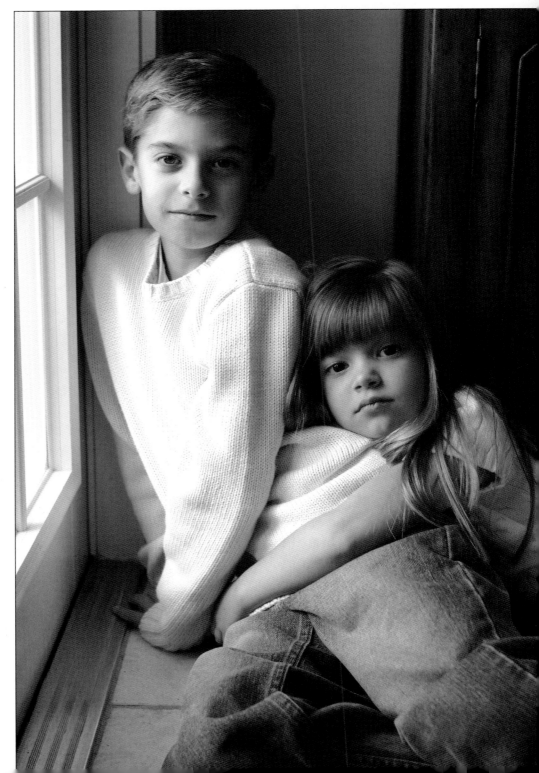

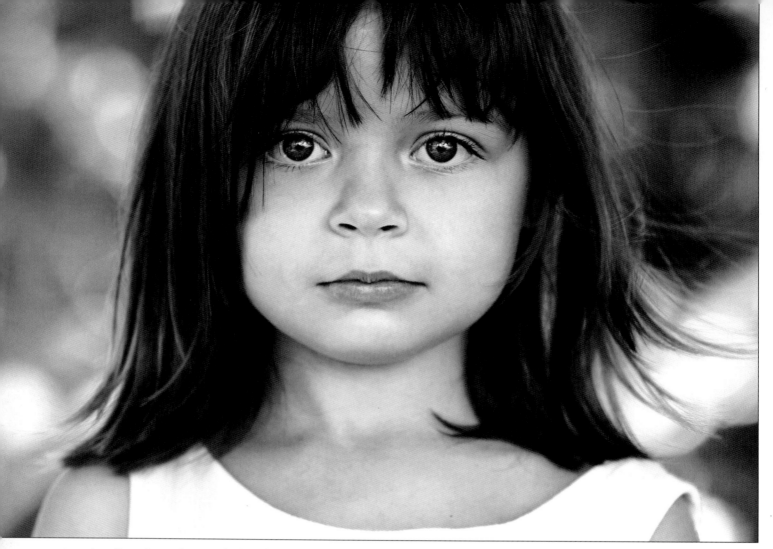

rections" option when ordering final prints, and this has worked well. Since children's faces and bodies are often perfect just as they are, tedious retouching is not involved. The fifty to eighty proofs I show usually do not get the burning and dodging treatment, which saves time during the proofing stage.

How do you present your pictures to clients?

Currently, I use paper proofs; I tried online proofing, and didn't like it. When several longtime customers remarked that they missed being able to sit with their families to look at the proofs, I switched back to paper. Two or three weeks after a session, I mail the proof book with a written agreement that the client will return the proof book with an order within two weeks. A proof book consists of 10x13-inch black pages with six wallet-sized images printed on a page. Each image is stamped "proof" to discourage copying.

I do not offer albums, slide show CDs, or other extras. I admire many of my colleagues who offer the whole spec-

trum of products, but it would be overwhelming for me.

My most-ordered print size is 5x7 inches, with 8x10 inches a close second. My clients tend to order many smaller enlargements instead of a few large prints, and I am happy with this.

Does a photographer's personality influence their success?

I believe that in order to work well with children, a photographer must have a "soft" side. He/she must be comfortable with the mental and emotional effort, and be gentle with kids. It can't be an act. Children have the ability to pick up your real feelings. Were you to pretend to enjoy kids, you would not last long unless you also possessed the one attribute this vocation demands: patience. It is best if you are patient by nature, because children can push you to extreme limits, especially when a portrait session doesn't go as planned. Patience enables youto keep trying for that elusive, decisive moment in the otherwise immensely rewarding specialty of children's portrait photography.

Autumn Hull's studio is in Valencia, California, where she gracefully mixes photography with raising children. She built her business with $300 and a credit card, and it took a while to "figure out what I was doing," but now she is thriving. She has been featured on two national television shows, and she teaches an online workshop answering participants' questions by e-mail. Some of her workshop advice is distilled in this chapter. To learn more, visit www.autumnhullphoto.com.

What is your background?

I took a basic photography course in high school and another in college as a hobby. I experimented with portraits, borrowing friends and family. After college, I worked as a production assistant at Walt Disney Feature Animation and later at Sony Pictures as a recording coordinator. When my son was born, my husband bought me a Canon Rebel, and I was hooked. My son was six weeks old for his first baby portrait, and the pose, exposure, and lighting were dreadful. It was frustrating to see what I wanted in my mind and be unable to produce it.

I took a short photography course at a community center and recovered much of what I had forgotten. My images began to improve, but they still weren't what I envisioned. I read books by celebrated portrait photogra-

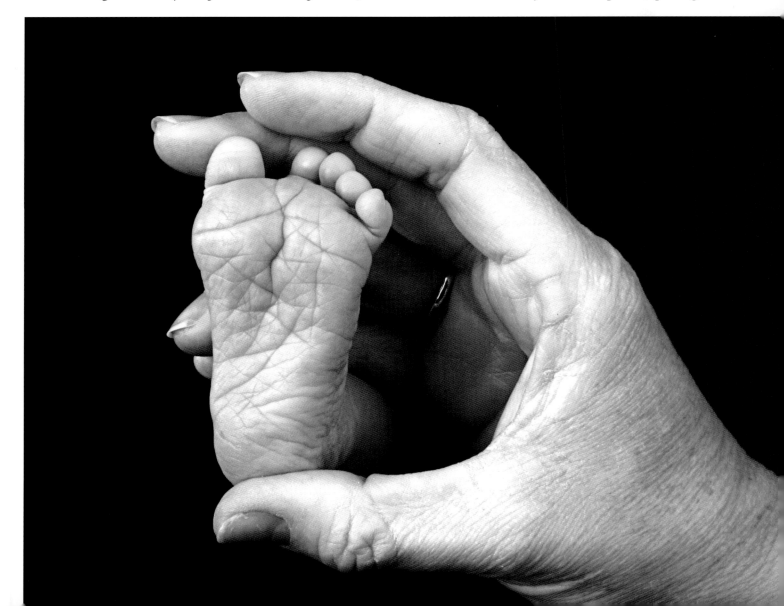

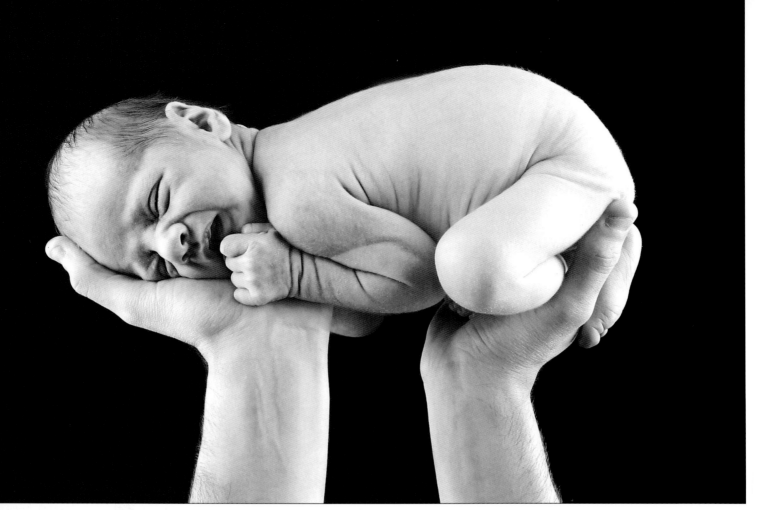

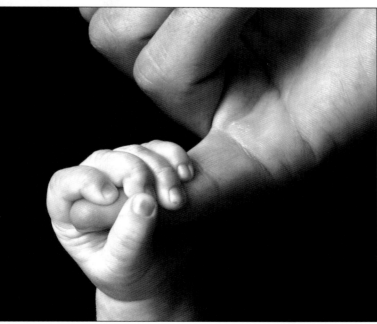

I started trying to duplicate images in Geddes's book. Though I never came close enough, I learned a lot about posing and lighting, and those experiments helped me find my own photographic "voice." Seven years later, about 90 percent of my subjects are children under the age of five; the rest are older children and families.

Were you influenced by any mentors or seminar speakers?
My interest in graphic design has had the biggest influence on my photographic style. In high school, I attended a design and layout retreat, and I have been hooked on design ever since. In college, I worked part time designing brochures. I like the clean, basic look, which I feel has been translated into my photographic style.

I developed a business sense from various sources, including magazines, speakers at photography conferences, and especially from online photo communities like www.ilovephotography.com. One of the best "nuggets" I found was a quote from a Donald Trump book. Asked how he handles competition, he responded, "I raise my prices." I've found that advice really works.

phers, and Anne Geddes's black & white work took my breath away. I observed her lighting closely, how she posed babies and children, and especially how few props were involved.

Describe your studio.

My studio, located in my garage, is set up for every session and taken down immediately afterward. Time and money made the garage a clean, attractive, practical environment. The floors have an epoxy finish; custom cabinets were installed for equipment and family stuff. I set up attractive room dividers to cover the water heater, etc. Now a comfortable, pleasant space does double duty.

After a session, I edit and do Photoshop work in my home office, perfecting each image for the lab to print. I don't know which pictures clients will order, so I prepare each image selected with care and prepare a DVD slideshow. My scheduler and sales manager works from an office in her own home a couple of miles away. She schedules photo sessions, presents slide shows on a large screen in her home office, takes orders, handles payments, and sends images to the lab. When orders are shipped to her from the lab, she checks to be sure they are correct and packages the pictures; clients usually pick them up from her. She also handles telephone calls from clients who have had their sessions.

I am free to photograph sessions, do my Photoshop work, and confer on other business. I still do my own bookkeeping and marketing.

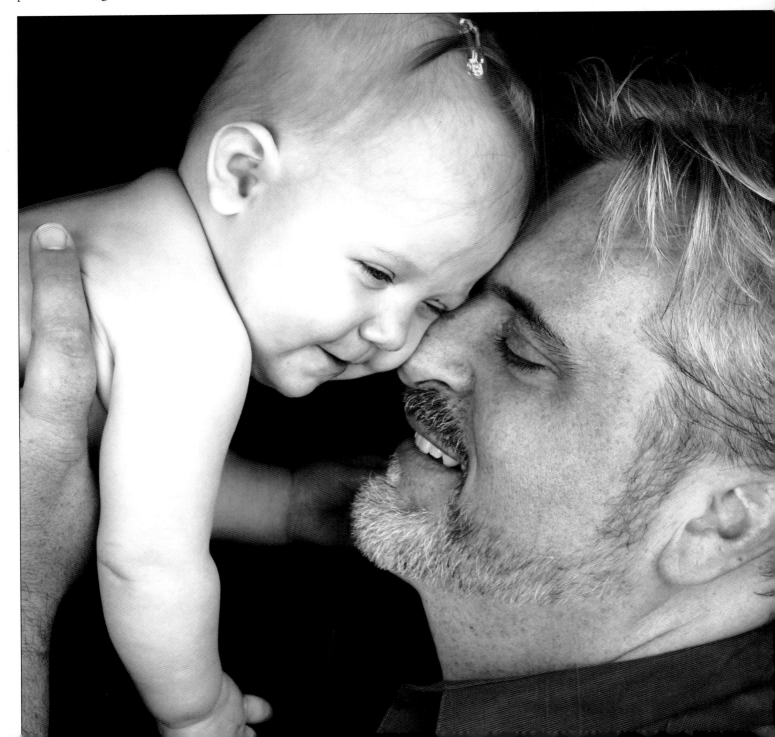

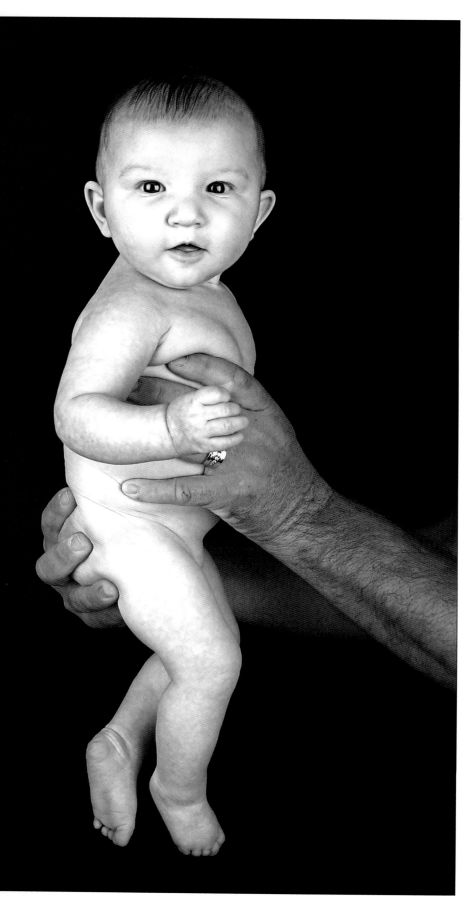

How do you schedule sessions? When do you take time off?

I routinely decide my schedule months in advance, and photograph up to ten sessions per month on the days and times chosen. I guide people to the page on my site to choose a day and time, and keep track of appointments. I usually work every other Saturday, up to three sessions a day, and I photograph on occasional weekday mornings. Available monthly appointments are posted on my web site. Predictable sessions allow my family to know months in advance when I will be working. I schedule a babysitter two hours a day, five days a week, to enable me to do office work. The rest of my daytimes are spent with my family or on business details.

I no longer allow clients to dictate session times. I now photograph more sessions because clients call much earlier to schedule their appointments. Typically, I am booked up for two to three months in advance.

Have your children influenced your business?

I have a son who is seven, a daughter who is four, and one-year-old twin boys. When my daughter was born I took time off to examine my business and realized that a "go with the flow" approach wasn't working. I devised a tightly scheduled business approach to avoid falling behind. If I said yes to immediate pictures of a newborn, or if I worked evenings when the kids were in bed, I would miss limited alone-time with my husband. If I sneaked away from the children to do some work in the office, it wasn't fair to any of us. I learned the hard way to follow a sensible, predetermined schedule.

When you turned professional, were your expectations realistic?

I was naïve to think that I could just do photography on the side, and the first few years were pretty hectic. My most valuable lesson was to firmly follow my priorities and to strive for balance. I also learned that I needed help.

My husband cares for the children on Saturday mornings when I photograph, and a babysitter cares for them while I do office work at prescheduled times.

Describe some of your techniques for photographing children.
Winning Their Cooperation. In most cases, I find it better not to address a child right away unless they already know me. It is better to talk with parents until the child is more comfortable. As we start, I usually ask the parent to sit in the middle of the photography area, so the child realizes that it is not a scary place. Shy children usually sit right next to or on the parent's lap. If they remain shy, I start photographing both, zooming close to the child alone. By the time the child is used to lights popping and feels relatively relaxed, we talk and make more eye contact. When I sense they are okay with me, I am talking, singing, making faces, etc.

Studio Lighting. I keep it simple. As backdrops, I mostly use black muslin or white seamless paper. With white seamless, I use large softboxes as my main light and fill light, but my two background lights are not softboxed. With a black background, I use two softboxes and aim

them directly toward the muslin. I may use a light on very dark hair. With kids under four or five, getting them to stay where I set the hair light isn't easy, so I use a setup without a hair light, allowing them to move more freely. I rarely photograph outdoors, but when I do, I may use a reflector and fill flash.

Props. I keep props to a bare minimum. I have used a large metal washtub for years; older kids sit on it, barely standing babies use it to help them up, I put toddlers in it, and I let kids stand on it to make them feel tall (which makes them smile!). I even sit on it myself to get at a nice eye level with kids. This washtub has been in almost every session I have done, though it's only apparent about a third of the time.

Anticipating Expressions. I tend to make a lot of exposures. Subjects become comfortable and soon they don't notice me shooting. I do throwaway shots; I tell children to make a big cheesy smile, and we laugh about it—that's when I get the shot I wanted. Sometimes I tell a kid not to smile no matter what, and they try so hard they burst out laughing. I'll have them make monster faces, mad faces, silly faces, etc., and capture their amusement with

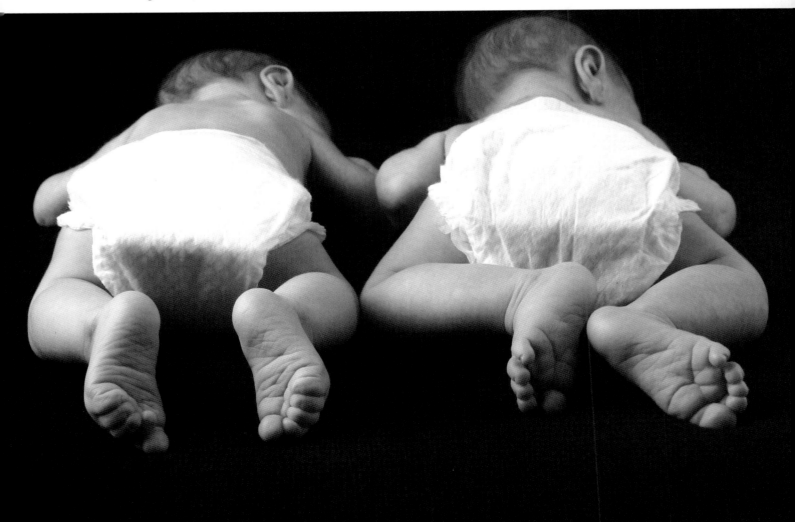

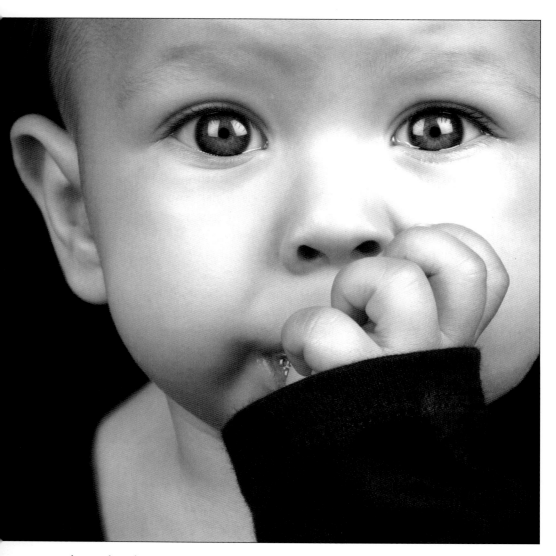

and we get all the shots we need. Parents are always happily surprised when they see the proofs.

Digital or film?

Digital photography increases the possibilities of personal satisfaction at every photo session. I can be less concerned about counting exposures, freeing me to photograph until I feel I have got the very best pictures. It is a rare occurrence when a client has left and I am not satisfied with the session.

I love working in Photoshop almost as much as I love the actual photo session. I often photograph in black & white, unless the client requests color. I find that black & white eliminates all the distracting elements of color, and attracts awareness to the child's face. Black & white is timeless and elegant, qualities I aim for. I don't want images to look dated or trendy.

themselves between expressions. With younger children, I play peek-a-boo, make "raspberry" sounds with my tongue, sing, and generate ridiculous noises and faces.

Using an Assistant. I rarely do. With minimum props and few lighting adjustments, an assistant isn't much needed. When I have up-and-coming photographers observing a session, I put them to work.

Presence of Parents. This really depends on the parents. With easygoing people, I use them as assistants to engage their child. For instance, I will have the parent hide behind me and pop out at the count of three, or I will have them make silly faces. Sometimes shy kids don't want to see me at all, so I try to stay hidden behind the camera using a parent to draw out expressions. In general, parents are an asset to the session unless their attitude shows anxiety. I try to calm them, and if this doesn't help, and the child is old enough, I ask a parent to go for a little walk and allow me to work alone. The child inevitably relaxes,

Do you shoot sequential bursts?

I rarely photograph in sequences, with one exception: I do a special "baby's first birthday" session where the client brings a cake and the child is encouraged to dig in and destroy it. In this instance, I often photograph sequential bursts to capture a series of expressions when they either dive in or get repulsed.

Camera and lenses?

I use the Canon 20D for all of my sessions, usually with a 28–80mm zoom. With shy children, I use a 75–300mm lens for close-ups without intimidating the child. I also have a macro lens for ultra close-ups of baby toes, fingers, etc. I upgraded to the 20D from earlier Canon models mainly for its black & white option, which saves me hours of computer conversion. Since I pay a babysitter while I work on the computer, the 20D paid for itself within a year! You can own all of the latest cameras and lenses, but

that doesn't mean your photography will improve. It's more important to know your equipment well enough to get the results you want with confidence.

I photograph exclusively handheld in the studio. Much of the time I am on the floor at the child's level, and I am constantly leaning one way or another to follow them or to get a better angle.

How do you promote your studio?

I had no budget for marketing in the beginning. Other mothers in a once-a-week playgroup gave me permission to photograph their children for my portfolio. My business grew slowly from word of mouth. I left my cards at various child-related businesses, which brought me a few clients. I offered incentives to clients who brought in other clients, such as a credit toward future sessions or prints. This marketing strategy was successful.

My web site has also been profitable. I keep it packed with information about myself, my business, my prices, my policies, samples of my work, my photography schedule, and information about my products. By the time people call, they are ready to make an appointment.

Since I post proofs on my web site, viewers constantly see new images. I also update my gallery every few months, but my "recent sessions" proof pages are a terrific adjunct. People see what a typical session produces, and this is a strong sales tool.

What are your pricing categories?

I charge the same rate to photograph one child or an entire family. My fee covers time in the studio and on the computer. There are no packages, everything is à la carte.

My prices are high-end for my area. I evaluate my price list twice a year, and raise prices depending on how far in advance I am scheduling, how many clients I have to turn away, how much competition there is in the area, and how much my costs have increased.

I also raise prices if there is more competition at my level and quality; price increases are based on business needs and status.

How do you present your pictures to clients?

I do all of my editing and retouching in Photoshop. I like having complete control over each image, and spend a lot of time to get it just right. Pictures of children still need some retouching, although not as much as adults. Children often have little scratches, patches of flaky skin, a runny nose, a scar, or a bruise.

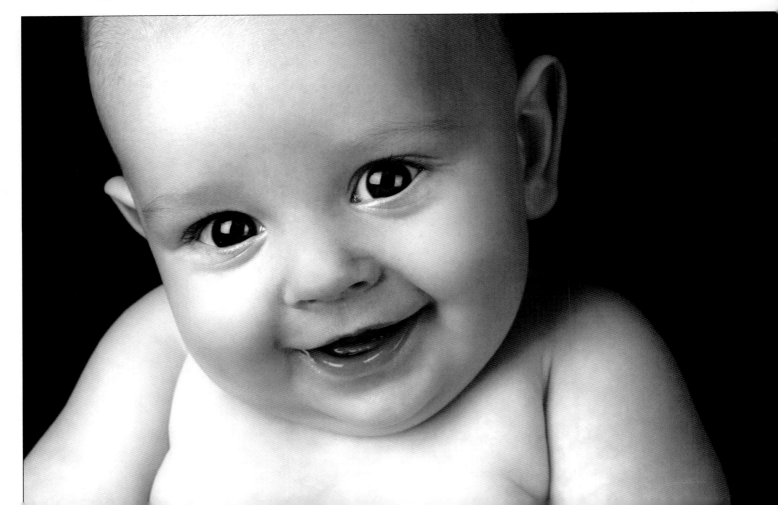

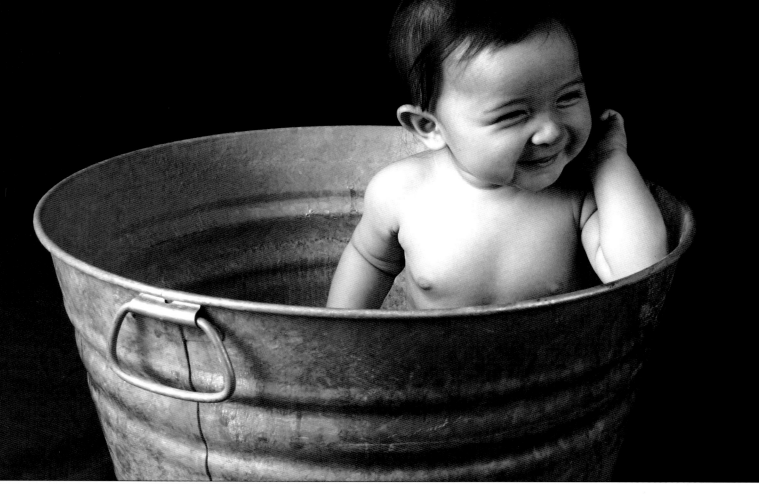

Online proofing via web sites is a controversial practice because clients take longer to place orders, and those orders tend to be smaller. But presenting proofs online allows me to spend more time with my family. Now that my sales manager handles slide shows and takes orders on the spot, my income is higher. If I were showing the proofs, I would also be working more business hours, which I am not willing to do.

Describe your album layouts and common print sizes.
I do all of my album layouts in Photoshop, as well as the collages that are admired by my clients.

Print sizes like 5x7 and 8x10 inches are popular. On the occasions that my sales manager has sat with a client showing all sizes, clients are more apt to purchase 11x14s, 16x20s, and larger. The main influence is the size of the proofs. A slide-show presentation on a big screen will result in more large-print orders.

Does a photographer's personality influence their success?
If you want to photograph children and babies, you must find children adorable and hilarious, no matter what their temperament may be. I am the oldest of four children and I started babysitting when I was twelve. I was a third-grade teacher's assistant in high school and have always had an easy time relating to kids. I understand how they operate. When they are shy, you need to give them space to come to you on their own. I know when they are really upset or if they are just working their parents. I know how to bring them out of their shell, and I am not afraid to look silly in front of their parents.

You need an upbeat attitude and patience. When a two-year-old child throws a tantrum or scowls, you have to see the humor in it. If a mom realizes her kid's behavior doesn't bother you, she can relax, which helps the child to relax. You need to be the most relaxed and happiest person in the room.

Stephanie Clark enjoys a studio and home in a historic mansion in Ashland, Kentucky. Stephanie was a stay-at-home-mom with a graphic-design background and a rarely used darkroom. She turned to photography for creative gratification, and now specializes in fine-art portraiture of babies, children, and families. Her photography style "relies on a relaxed environment in which subtle expressions and playful attitudes are clearly revealed." Her classy studio has been successful in the tri-state area of Kentucky, West Virginia, and Ohio. To learn more, visit www.stephanie clark.com.

What is your background?

I took black & white photography in college. After I had my first daughter I carried a point-and-shoot camera everywhere. When my second daughter was born, I graduated to a digital point-and-shoot, which combined with motherhood, was the catalyst for my career. After becoming obsessed with instant digital gratification, I purchased a digital SLR.

I was enthralled with taking pictures, so I learned to evaluate scenes, and how to make camera adjustments, and I absorbed as much technical information as possible. I began photographing my friends' children, and then their friends' children. Eventually, I started charging to cover my expenses and transformed a bedroom of our home into my studio. Less than a year later, I shifted my studio to a larger space in the garage. Word spread, and I found myself photographing complete strangers.

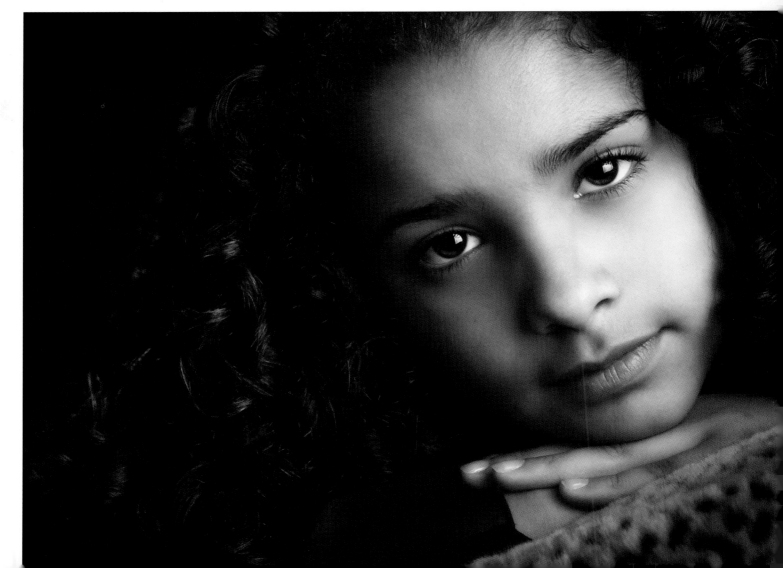

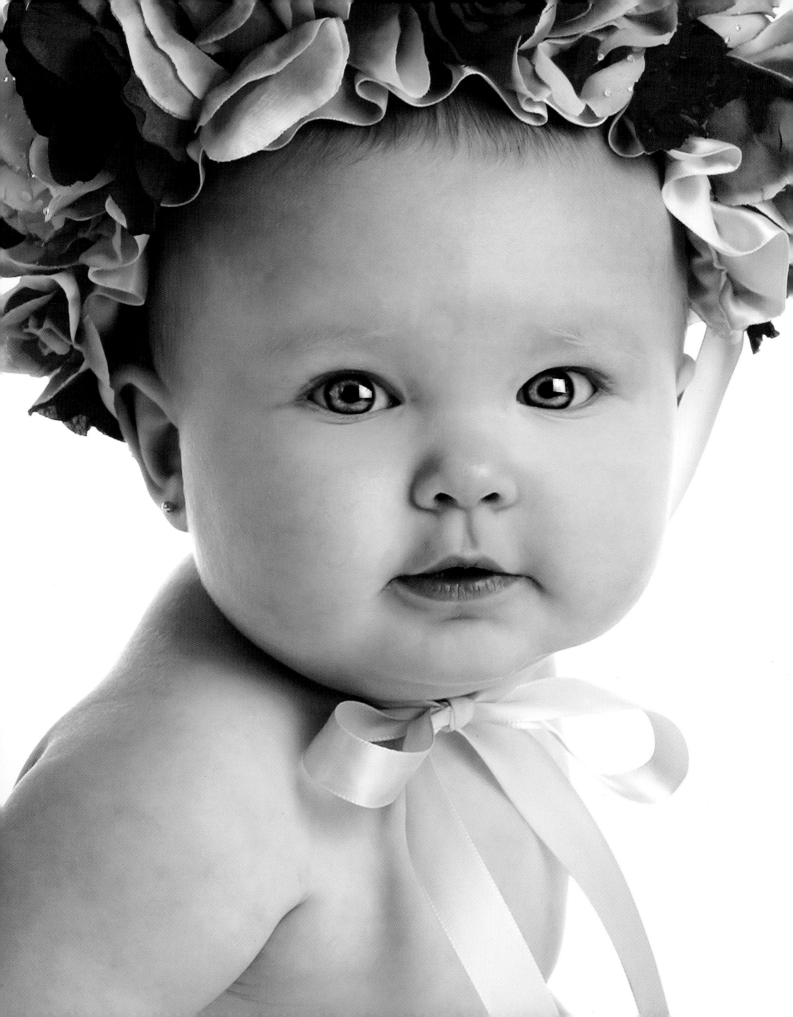

I had aspirations for a "real" work space, and in 2004 my studio was transferred to a historic 1917 mansion in downtown Ashland, Kentucky. The entire first floor is dedicated to my business, and we live on the second and third floors. It is really a dream come true. The majority of my clients are babies and children, but I also photograph families, maternity, and high-school seniors, but no weddings.

Were you influenced by any mentors or seminar speakers?
Growing up, I took various art classes and spent time drawing, painting, and doing crafts. My parents are both educators and did a wonderful job of nurturing my creativity. A graphic-design background reinforced my photographic vision, and my husband's shrewd business sense has helped make my photography business successful.

My greatest education came from the Internet. Early on, I spent many hours online researching photographic details. Two photography forums proved most valuable: www.ilovephotography.com and www.pro4um.com. Even now, I know I can find answers to questions on these sites.

In 2005 I got involved with PPA (Professional Photographers of America) and KPPA (Kentucky Professional Photographers Association). Both offer a wealth of educational opportunities.

Describe your studio.
My studio is in a perfect setting, the whole first floor of a 17,000 sq. ft. mansion. I mostly use studio lighting because of the absolute control it offers. The quality of my work has not changed since my old studio, but I have more credibility as a professional. I have two employees who answer the telephone, schedule appointments, help with retouching, and handle presentation and sales. They free me to photograph and edit. My husband, with the help of our accountant, oversees my financial records.

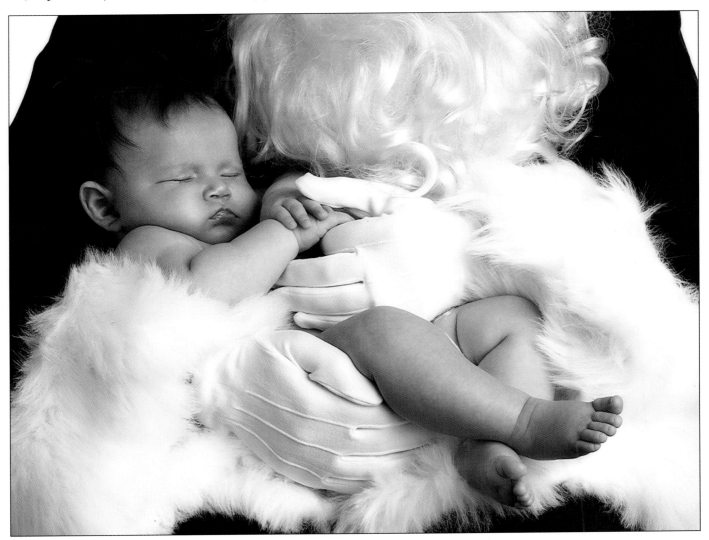

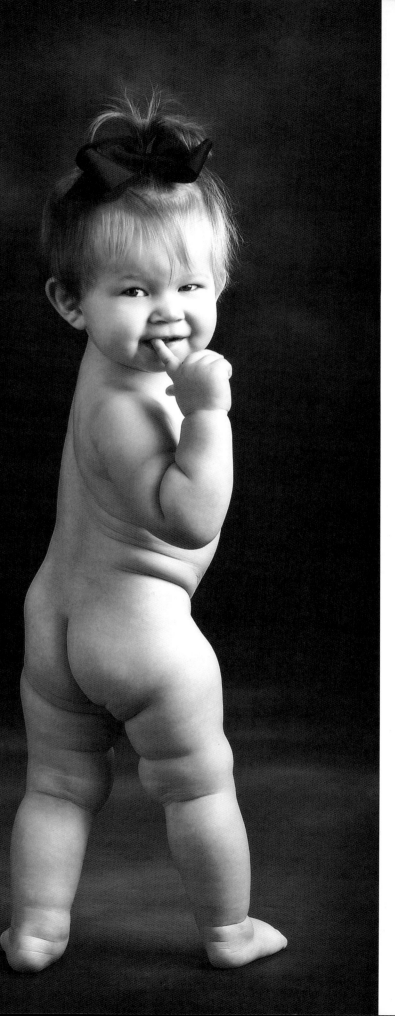

How do you schedule sessions? When do you take time off?

We schedule sessions Tuesday through Friday, and on Monday we prepare for the week ahead. I will photograph on Saturdays or after 5:00PM during the week, but these sessions are priced to persuade clients to accommodate our weekday schedules. We prefer not to schedule more than two or three sessions a day.

Senior sessions, which may take close to three hours, typically take place after school. An average child's session lasts about an hour and a half to two hours. Newborn sessions may last longer because of feeding breaks—and colicky babies require more soothing, which takes longer. I undress every newborn, which results in a lot of cleanup.

I spend more time in front of my computer than I do behind my camera. My average workday lasts about twelve hours, with a few breaks to fulfill mommy duties. After I transfer images to my computer, burn a disc and go upstairs, it is 7:30 or 8:00PM. November and December require even longer workdays. To avoid twelve-hour days, I am ready for another price increase.

Have your children influenced your business?

I have two daughters: Carlyle, who is ten, and Annabelle, who is five. As I was learning photography, my children were my only subjects. I was obsessed with mastering the medium, and I wish that I had started when I was younger, but my experiences have helped bring me to where I am now.

Balancing work and family is a constant struggle, and I am fortunate that my studio is at home. I am able to pick up both girls from school, attend their school parties, take them to their dance classes, etc. Luckily, school is only three to four minutes from our house. When senior ses-

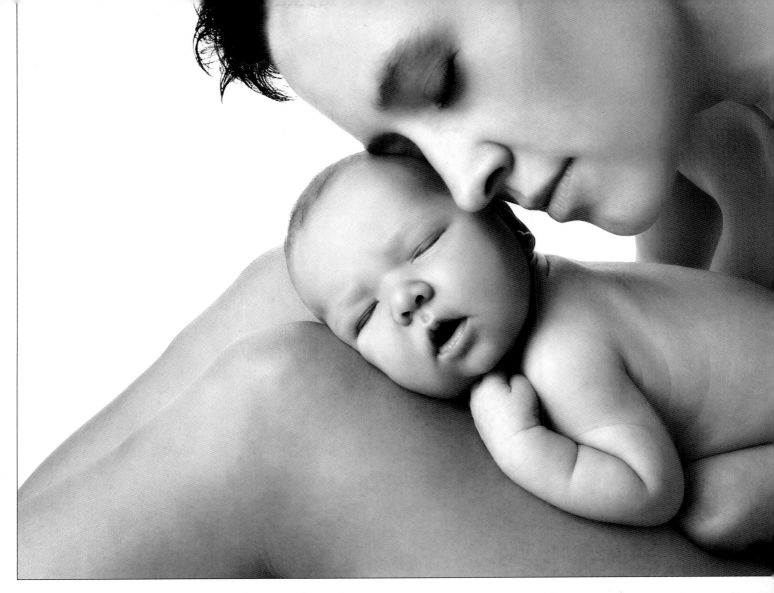

sions take place after school, my girls are with me in the camera room. Because some evening work is often required, it can be an exhausting schedule that needs periodic evaluation.

When you turned professional, were your expectations realistic?
The transformation from hobby to profession happened quickly, and I had little chance to ponder the future. I did discover that I had no business sense and needed to rely on someone else. I also realized that I needed assistance, though delegating is an acquired talent!

Describe some of your techniques for photographing children.
Winning Children's Cooperation. I think I have a friendly and calm personality, which is conducive to photographing children. When I first meet a child, I kneel down to their level. I tell them my name and ask for their name and age, and I compliment them in some way. To increase

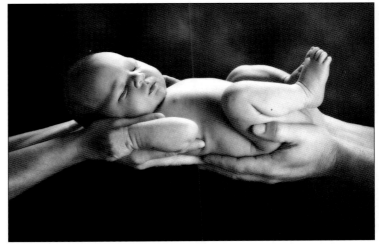

the rapport, I will ask for help with something like pushing the button on my light meter. I am not above bribery; I keep a supply of Smarties, which I will give out one at a time. I act silly, but not loud and obnoxious. If the child behaves poorly, it may be beneficial to ask Mom to leave.

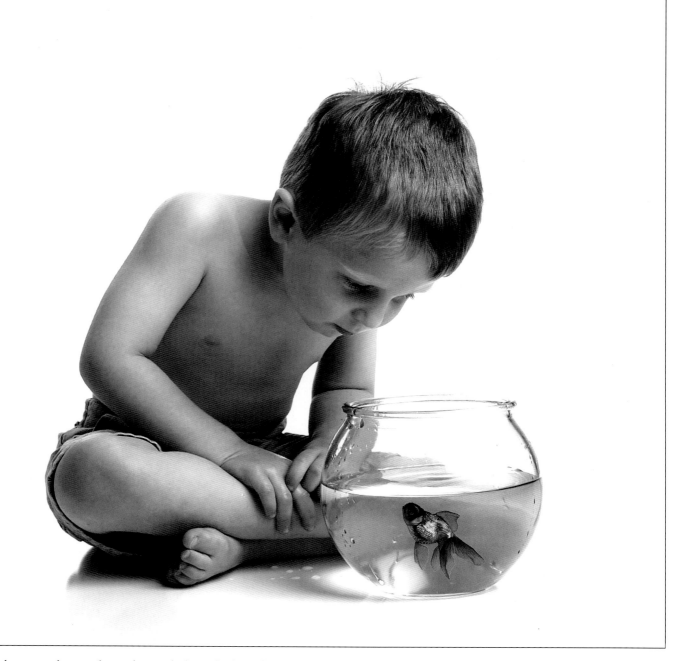

Children are almost always better behaved when their parents are not around. I promise children a treat after the session if they help me out and give them little bubble pens with my logo on them, a marketing practice that won't give them cavities. My style is simple and I use very few props; I want the focus to be on the child.

I photograph in color and then convert the images to black & white in Photoshop. I prefer black & white, but I usually show some color images, especially if the child has beautiful coloring. I usually add a warm brown tone for enhanced black & white richness.

I handhold my camera almost 100 percent of the time in the studio. I love to photograph at funky angles and move around, so a camera stand would inhibit me. The only time I use a tripod is when working outdoors with the 70–200mm lens.

How do you anticipate gestures and expressions?

Photographing with a digital camera is beneficial in capturing appealing expressions, because with a 2GB memory card, photography can be unlimited.

Throughout the session, I carry on a conversation with the child, but my favorite facial expressions are non-smiling and contemplative. I usually position the child facing the light, but never with their bodies square to the camera. A chair, a bench, or even a basket is useful to keep them still. Sometimes, I will give children something to hold, like a wooden block, a small book, a teddy bear, or

a flower. I distract their attention from what they are holding and quickly click the shutter. This often provides a delicate gesture with their eyes as the focus of the image. Trying for big smiles, I act like a complete fool; this comes easily to me.

Describe your studio and outdoor lighting.

I use a 4x6-foot Larson softbox as my main light and a large silver rectangular reflector as fill. I place the softbox at camera right at about a 45-degree angle to the subject, who is approximately three feet away. I feather the light slightly away from the subject toward the reflector on the opposite side; I love the large rectangular catchlights that a 4x6-foot softbox provides.

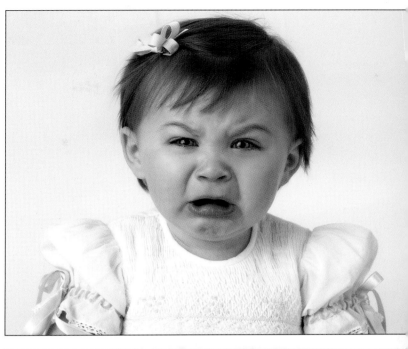

When I am working outdoors, I like to photograph in the shade with open sky in front of the subject. My favorite times of day are early morning or early evening when the sun is low behind a building, with a blue sky overhead. If it is too cloudy, the sky isn't bright enough to provide the great catchlights that I am after. If the sun is too high, I have to work harder to find perfect shade. If I can't find this scenario, I use a reflector to bounce some light into the subject's face; I never use on-camera flash.

Do you shoot sequential bursts?

I had rarely photographed sequences until I had a senior boy ask me to capture his golf swing. That was fun! I'm experimenting further with sequences for active kids.

Camera and lenses?

I use a digital Nikon D2X with a Nikon 28–70mm f/2.8D ED-IF autofocus lens 95 percent of the time. It is fast, tack sharp, and I can get close enough to my subject to provoke the expressions I am after. I also love the Nikon 70–200mm f/2.8D when I am outdoors and it is not critical to be close to the subject. I adore its long lens shallow depth of field. The *bokeh* I can achieve is yummy. *Bokeh* is a Japanese term for the subjective, aesthetic quality of out-of-focus areas in a photographic image—it is the round, blurry dots that you see in the background of an image with very shallow depth of field.

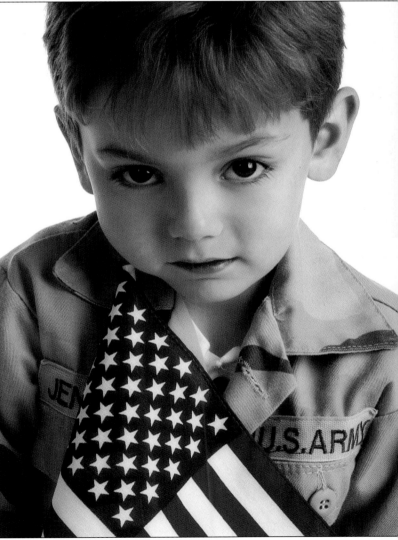

How do you promote your studio?

Word-of-mouth and my web site are my main sources of advertising. A web site is absolutely critical. During the

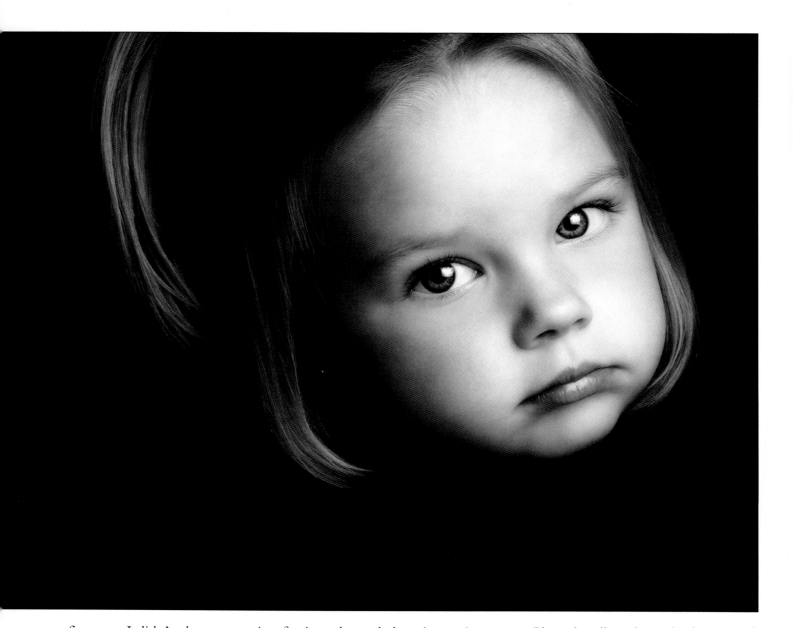

first year I didn't charge a session fee in order to help build a portfolio, and I soon had more business than I could handle. Since I began charging session fees, I have raised my prices about five times. The last increase was substantial, because I heard that if you are busier than you want to be, it is time to raise your prices.

A wonderful source of advertising has been donating to silent auctions. I donate to charity fund-raisers where I can have a display in the middle of my target market. I show a large framed portrait along with a gift bag, with the certificate that the winning bidder receives. I also place a large supply of business cards with the display.

Everything has my logo with my web-site address on it, including pens, guest towels, ChapStick, gift bags, presentation boxes, t-shirts for seniors, etc. Brand recognition

is very important. Photo handbags have also been an effective marketing product. There is no better advertisement than a mom carrying a purse with her child's photo on it. Our photo handbags come from Gina Alexander (www.ginaalexander.com). The image is printed directly on the purse fabric. Alycia Alvarez and I are among the featured photographers on Gina Alexander's web site.

What are your pricing categories?

I consider my work fine-art portraiture and have priced it as such since I moved to the mansion and was able to charge what I thought I was worth. When a client visits my studio, they expect to pay top dollar. I place a huge emphasis on my professional image. I have some clients because we are the highest-priced studio in town. For

their investment they also get a beautiful product and a couture experience. My pricing is probably not considered high in an urban area larger than ours.

Along with our price increase, I began the same pricing for prints that are 8x10 inches and smaller. This discourages clients who "just want a few 5x7s." We don't offer packages; all prices are à la carte. Portraits 8x10 inches and smaller are priced lower if a wall portrait is also purchased. I would much rather my work be displayed on walls than stand on end tables.

Describe your editing and printing process.

I do all of the final editing with Adobe Photoshop CS2. I use a professional lab to concentrate on photography; the workflow time required to do my own printing, spraying, mounting, etc., would not be worth it. I do use an Epson 2200 for quick prints on Ilford Pearl paper. I still do standard adjustments to every image, but children's portraits typically do not need extensive retouching.

How do you present your pictures to clients?

After proofing a session, I upload to an online gallery and send the client an e-mail link to their gallery. A little more than a week later, they come to a presentation appointment in my studio. We have a beautiful room with a huge gold-leaf framed projection screen. My assistant facilitates sales appointments. She invites the client to sit back and enjoy the slideshow set to music appropriate to the subject. We use Prism Projector software to help the client make choices.

All images have had a slight tonal adjustment and have been either sharpened or softened and cropped. I usually choose a few favorites and do the "works," which encourages clients to order my favorite images. Our clients enjoy the multimedia presentation and realize that paper proofs are not an option. With orders over $1,500, they receive a DVD slideshow of all edited session images.

Describe your album layouts and common print sizes.

I haven't ventured into the album thing yet. Because of our pricing system, almost all clients purchase a wall portrait in order to get their gift portraits at a lower price. We sell lots of 8x10-, 16x20-, and 20x24-inch prints, as well as Portrait Collections (collages). Since my portraits are rather timeless, home décor changes typically don't have an impact on what clients order.

Does a photographer's personality influence their success?

After almost every session, the parent is very appreciative and thanks me for being so patient and kind with their child. This used to catch me off guard—as if I could have been anything else! Devotion to children comes so easily that it doesn't feel like part of a job.

There are many people who go to work every day and don't enjoy what they do. I can't imagine doing anything else with my life. I feel like the luckiest girl in the world.

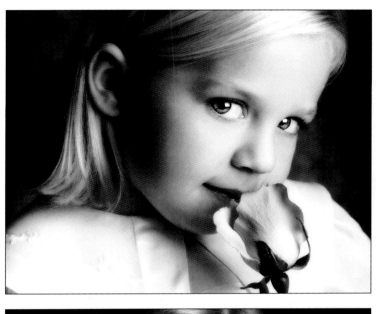

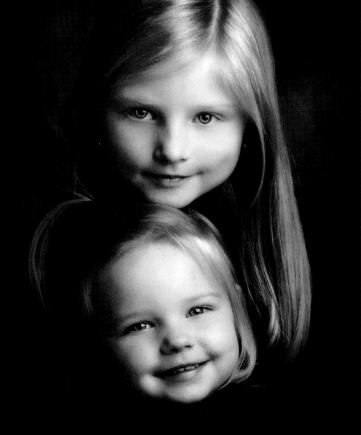

10. JONATHAN PAYNE

Jonathan Payne of Oakland, California, has been in photography-related fields for more than twenty-five years. His career has evolved into capturing the candid moments that show the true personality of children. He prefers to work in natural light, indoors or out, because that helps create authenticity. As a father, he better understands approaches to photographing children. He recommends observing, rather than directing, so kids will relax. To learn more, visit www.photopayne.com.

What is your background?

I got my first SLR and took a darkroom class in high school where I photographed for the yearbook. I studied fine-art black & white photography at Stanford for four years, fell in love with it, and pushed myself to experiment. I learned to use artificial light when I worked on film sets as a camera assistant in Hollywood. At that time, still photography was only a hobby.

I quit the film business in 1994 so my wife and I could move to San Francisco, and I began to learn Photoshop, which made me feel that I could launch a new career. I had a darling subject when our daughter was born in 1997 and I started photographing her. My photography

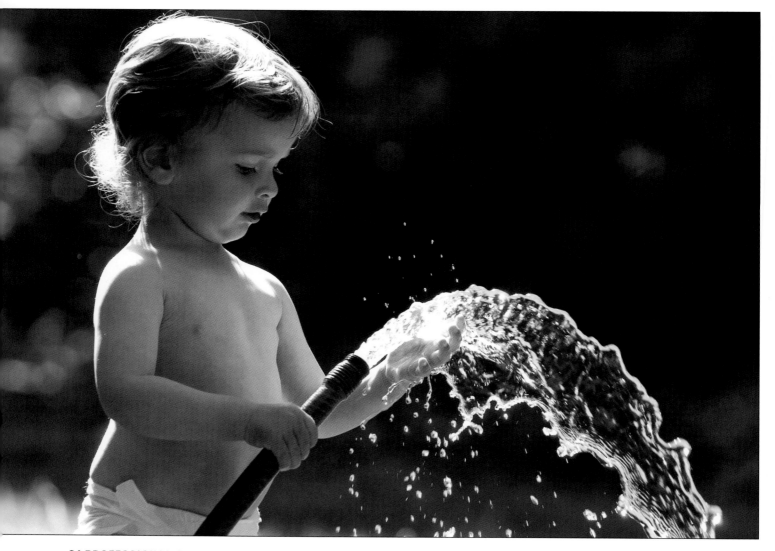

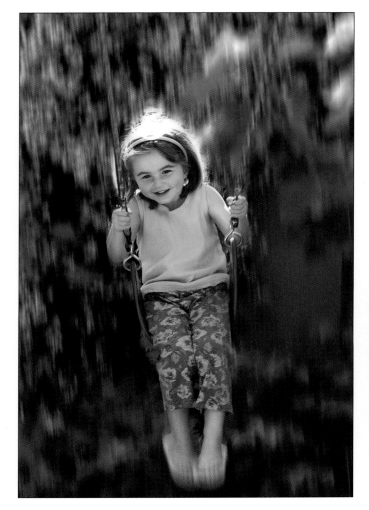
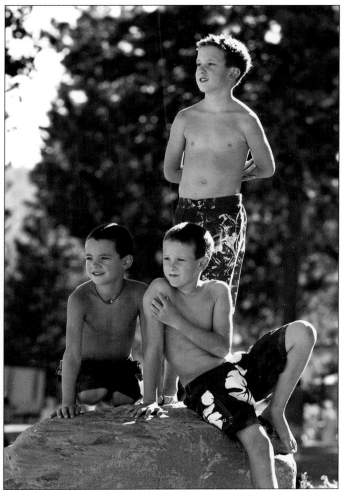

fun doubled when we had a son, and I also photographed friends' kids.

The Nikon D1X was introduced for $5,000; I rented one for a weekend and my experiments were an eye opener. I didn't like photographing within the constraints of my makeshift studio, but I loved digital capture. Another test weekend with children in their own homes utilizing natural light was incredibly rewarding. Now, after five years, children and families are still the majority of my clients, although I also photograph some weddings.

Were you influenced by any mentors or seminar speakers?

I became Photoshop proficient after enrolling in multimedia, web-design, and software-usability courses in San Francisco. My weak link then was my business skills. I read how successful portrait businesses are run and relied on my wife's organizational and marketing expertise; our business is a team effort.

I have received invaluable advice on technical topics, marketing strategies, and more by communicating with photographers in online forums such as Digital Wedding Forum, Focus on Imaging, and I Love Photography. Many successful photographers who really understand my business offer feedback. Many children's photographers, some of whom appear in this book, have critiqued my work and shared experiences. I have also studied the work of photojournalistic wedding photographers and see emotional parallels between their approach to weddings and mine to children.

Describe your studio.

I don't have a studio, because I prefer to photograph on location. I like to work where clients live, and I know this helps children and their parents be themselves. I enjoy the spontaneity; I work harder and pay more attention to my subjects and the light. The cost of maintaining a home office separate from my living space is much lower than sustaining a studio.

My wife is actively involved in our marketing, accounting, and pricing, and I trust her eye as she edits the proofs.

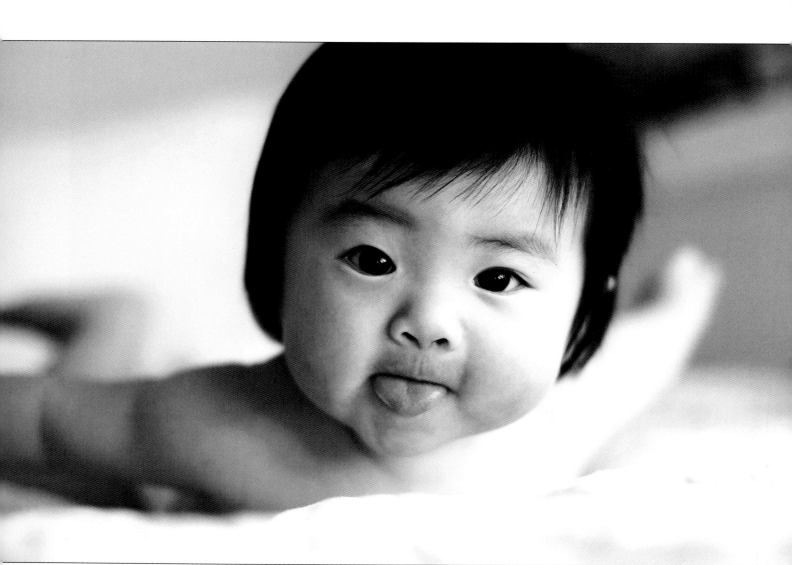

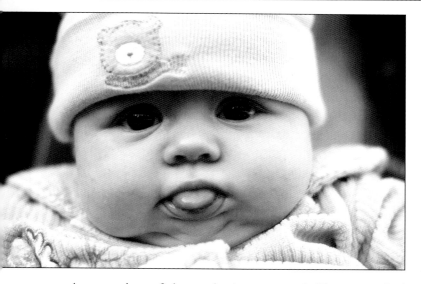

As a mother of three, she is very much like my typical client, so she helps evaluate new promotional ideas.

I currently have one part-time assistant who is talented and wants to learn all aspects of my business.

How do you schedule sessions? When do you take time off?
The parents and I choose the right time of day to photograph, which varies by age and is tricky when kids in a family are at different ages. I emphasize finding the best time for the kids. I charge more on weekends because fewer session times are available; I try to preserve weekend time for my family. I block out session dates two to three months in advance, and I also schedule time-off periods. My schedules are planned around the spread-out geography of the San Francisco Bay area.

I compromise the business, not the family, in the summer, and I am considering splitting vacation time between January, after the holiday season, and July, when I look forward to recharging.

Have your children influenced your business?
We have a daughter who is nine and two sons, who are six and three. Besides being my models, they also taught me

how to get on the ground with my camera and really see them. Because I am in a home office, I can be closer to my family. My wife and I divide the household responsibilities; she works outside the home four days a week, so I shuttle our children to their activities. I can be more available to the kids during the day, and I make up those afternoon hours by working in the office at night. My wife takes care of our financial responsibilities and organizes the studio workflow when necessary in the evening; we enjoy this time together.

When you turned professional, were your expectations realistic? Other photographers told me, and my own observations of small businesses made it clear, that it was going to be hard work. I expected that most of my time would be spent on images. I had no idea that I would spend so much time providing personalized customer service to the 140-plus clients I have each year. After lots of office hours, I now realize how time-consuming nurturing client connections can be.

I also didn't anticipate how demanding creating an efficient workflow would be. I rely on my RAW converter software, Capture One. Before purchasing it, I did a trial to determine its impact on workflow, and I found that it improved my effectiveness. One of my goals is stable image quality that families will treasure for a lifetime.

Describe some of your techniques for photographing children. *Winning Their Cooperation.* I am well trained in the fine art of child temperament, and I can quickly create a natural rapport with kids. I credit a lot of my success to this talent, which parents tell me they admire. I usually sit on the floor immediately and start talking; even one-year-olds respond. I stay calm and don't let tantrums disrupt me. I ask parents to relax to help settle their children. If one sibling has a hard time, I focus on the other, and the first often loosens up and joins in on the fun.

Locations. I work with clients to find what locations would be best. Babies and young toddlers are more relaxed in their own homes. For older kids (three to nine years), families often suggest more adventurous locations, such as parks, where they can run around, and local hiking spots. I also recommend university campuses.

I carry both a black piece of cloth and a white blanket for either laying babies on or covering busy backgrounds. I use large spring clips to attach these to chairs or bookcases when working indoors.

Style. Trying to figure out your personal style can be a journey. I didn't think I had a style when I became a professional, but I slowly started to see it emerge. Now I embrace it and expand it by trying new things. I describe my style as focusing on the natural state of children, looking

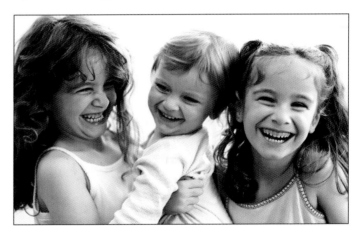

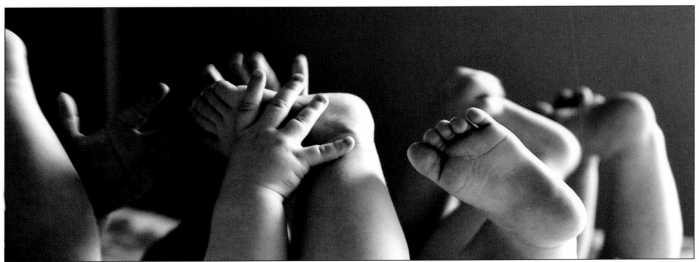

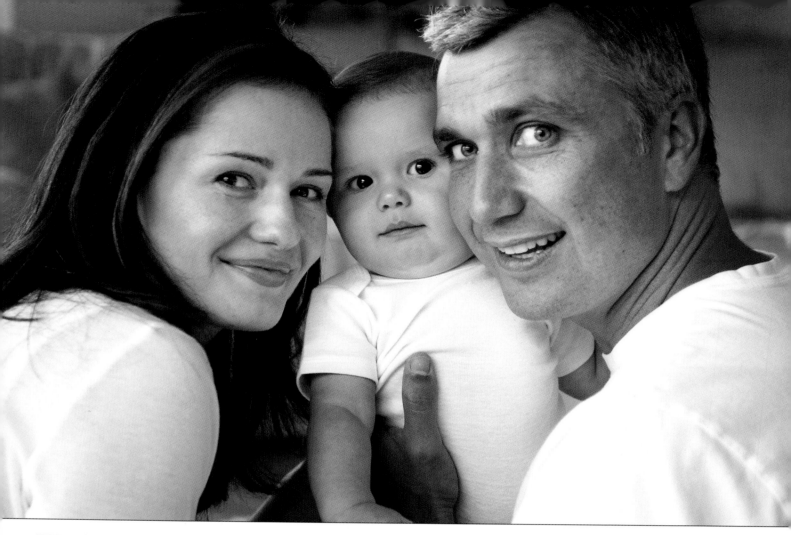

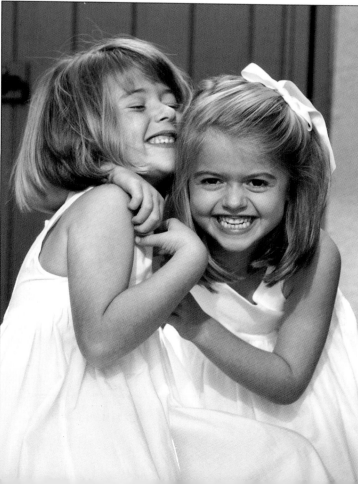

for details, using shallow depth of field, and searching for interesting composition and light and shadow. I think this is similar to musicians who constantly evolve and experiment. Some bands get better with each album. I think about always improving.

Parents. I encourage parents to play with babies and young children. Often I get better expressions of joy from children up close with Mom or Dad. When parental involvement interrupts my rapport with kids who are five or six years old, I ask the parents to leave the room.

Tell us about your lighting techniques.

Combine expert use of light with an eye for expressive moments and you will create priceless images. I photograph everything on location, and I don't mind the pressure of scouting to the find perfect light. Indoors, I love big windows for indirect or direct light. Outdoors, I place my subject at the edges of open shade, against a darker background such as trees or foliage. I often choose backlight positioning for at least some images. Outdoors, backlight can be lovely in the golden glow as the day ends.

Between the "best" exposure and Photoshop, I am confident. I occasionally use a reflector for group shots, and I have used a silver reflector to add indirect lighting to a room.

We had incredible backyard afternoon lighting when we lived in Berkeley. The wall of apartments next door acted like a giant 30x30-foot reflector in late afternoon. I loved the feel of that light, and I look for similar situations happening naturally elsewhere.

I have always disliked head-on flash; it seems so unnatural. However, I *will* use a bit of fill-flash for proper exposure when the child seems comfortable. When I use flash indoors, I always try to bounce it. Recently, I photographed a mother and her three girls all snuggled on a couch, so I aimed my flash at the ceiling using a Stofen-esque diffusion cover to capture some delightful images. I have found that it is critical to have additional external power in order to fire flash every second or two.

Describe some of your session techniques.
I don't put time limits on a session. I can get some great images right away when kids are curious about me. I try as many angles and viewpoints as possible. Though I dislike photographs of children from adult height, I do love getting steep angle shots with kids looking up at me. To help capture expressions, gestures, and emotions, I have parents and children play together. Photographing occasional bursts helps create a whole photographic personality. While editing, I often include quirky expressions that please some parents. Because digital offers so much diversity, I am having more fun photographing in color, looking for colorful backgrounds and contrasts.

My technique developed from shooting in a photojournalistic style in college. For a typical baby or child session I will photograph 250 to 400 frames and deliver a proof set of sixty to eighty images. I aim to capture many expressions, positions, etc. I'm not trying for perfect portraits, but rather to produce thirty to forty different appealing images. I move around a lot and encourage children to move around for visual variety. After I found this approach was successful, I added leather albums so clients could create a beautiful book.

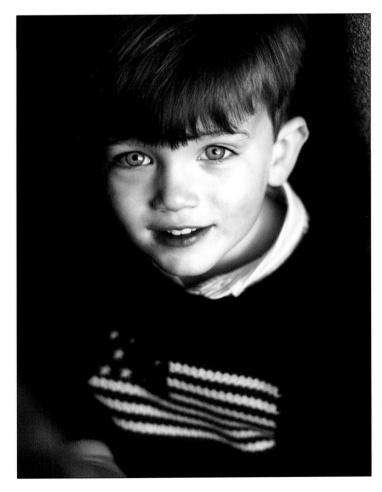

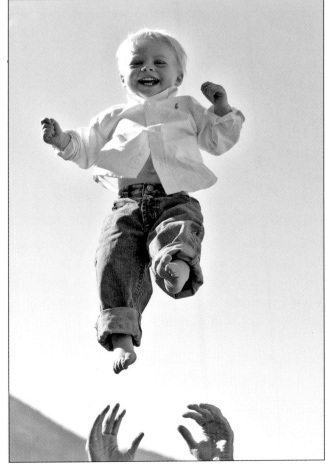

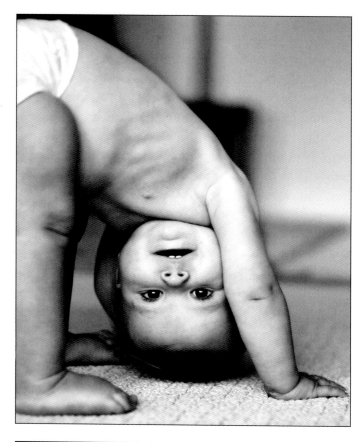

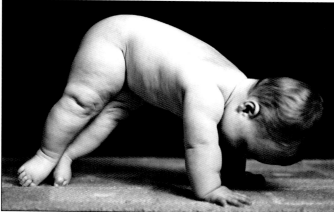

In general, I keep my cameras in single-shot mode, but I do fire off fast sequences when it's called for. When trying to create good family pictures, I photograph a lot of frames, particularly since you never know when you might get "the one" with a group.

Camera and lenses?

I use a Nikon D2H, which I originally bought to back up my Nikon D1X. The smaller files of the newer camera are a benefit in my view. I have had great success printing image up to 20x30 inches, which seems to be large enough for my clientele. My favorite lenses are the 50mm

f/1.4, which I use most, often wide open; the 17–55mm, ideal for most situations; and a 70–200mm, mainly for kids three and older on playgrounds.

How do you promote your studio?

At first I e-mailed everyone I knew and produced post-cards I left in high-end children's clothing shops and toy stores. I arranged to display images in some doctors' and dentists' offices. I offered to teach parents about how to take great pictures at the local baby stores. Results: I got my name established pretty quickly as an expert.

I also bought advertising in six different local parent newsletters. I tracked how many clients heard about me from each newsletter and only continued advertising in two. I also wrote photography tips for each newsletter. However, about 50 percent of my new clients come from family referrals, and an additional 30 percent are referrals from a moms' group. Success was generated by word of mouth in a community dominated by moms who have the resources to pay for good photography.

I built my web site for four years and overhaul it annually. I have since made it easier to update and to add client galleries. I plan to create a blog alongside the web site to highlight recent session images.

What are your pricing categories?

I have tried to keep pricing simple, with periodic revisions based on supply and demand. My session and print prices have only increased 20 to 30 percent since I started. I charged the same for prints 8x10 inches and smaller my second year. A year later I found that my clients didn't realize there wasn't any difference, so I increased the price of the 8x10-inch prints.

I charge a session fee up front, plus prints, albums, and other options. When a client wants more options than my price list offers, I work up custom collections. Several are available, which entice clients to purchase more in order to receive a discount. I have heard that if you are not getting people who think you are too expensive, you are not priced high enough. I charge extra for weekend work and travel beyond twenty miles. I have never set a minimum order.

Describe your editing and printing process.

I do my own processing and file preparation and use outside labs for proofs and final prints. Reliability in print

quality/calibration and in turnaround time are the keys to selecting a lab. I do some watercolor paper printing on my Epson 2200.

How do you present your pictures to clients?

To start, I take (or send) clients a DVD slideshow of images with music. I rarely do any Photoshop work on images of children, except for blemishes for final prints. Though some clients could work with online proofing, most appreciate paper proofs (which arrive with the DVD) for sorting and arranging. I encourage clients to create triptychs and collages, and to prioritize. My 4x6-inch proofs, included with the session price, are image numbered to facilitate ordering.

I show 75 percent black & white at the proofing stage. Some clients go with my choices, some ask for 50/50, some buy all color. I was pleased when my lab got their dedicated black & white digital printer. This meant no more wrestling with digital black & white prints, some with weird color tones. I sell proof sets as 4x6-inch prints in albums, and I won't go back and redo proofs without an upgrade fee.

Describe your album layouts and common print sizes.

I have been designing layouts for many years, so I eagerly tackled the challenge of album creation. I try to keep designs simple and to create albums that will look classic and beautiful for a lifetime. Many of the albums are 5x5 inches, but I feel that photographers can influence what sells. For example, if I wanted to focus on large wall prints, I am sure that I could gradually make that successful, but my clientele would also change.

Most of my photographs are 5x7 inches, followed by 8x10- and 4x6-inch prints. I sell many 11x14-inch prints and an occasional 16x20-inch print, plus a lot of baby collages, based on a nine-image grid.

Does a photographer's personality influence their success?

Yes. The ability to make great images is important, but this must be coupled with a sociable personality, as well as keen business and marketing savvy. Personality enables you to relate well with kids and build a friendly and easygoing rapport with parents—even before you meet them. Relationships are also generated by your own satisfaction with your images and your career.

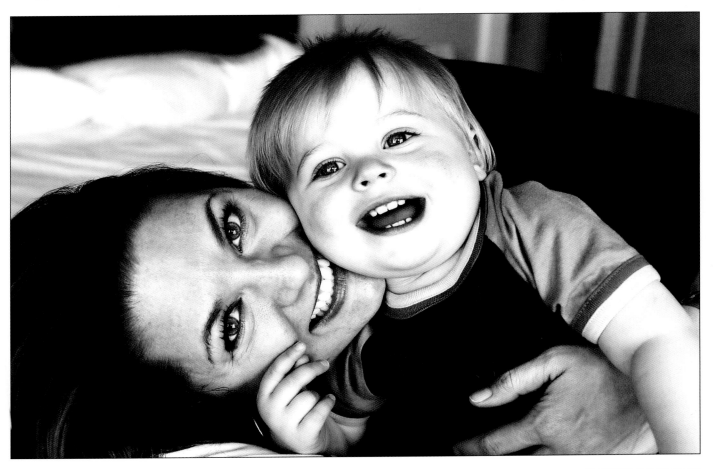

11. LAURA CANTRELL

Laura Cantrell and sister Lisa of Mobile, Alabama, grew up with a photographer father who had once installed Hasselblad cameras on space satellites. "His style of portraiture," Laura says, "was influenced by Mortensen, and he became a master of lighting, which I learned to emulate." On Laura's first big commercial assignment, a train wreck for a railroad attorney, she made a few hundred dollars and was hooked. She inherited her father's studio and revamped it to photograph children and grownups. Lisa joined her a few years later to handle sales and other business matters. The sisters had to make extensive repairs on their studio after Hurricane Rita. To learn more, visit www.lauracantrell photography.com.

What is your background?
I was peeling prints off a drum dryer in Dad's studio from the time I could sit on a tall stool. I also spent countless hours in the darkroom with my mother, and my first "photograph" was my contact-printed hand on Kodak 8x10-inch glossy paper. I trained by doing chores like twenty black & white passport pictures delivered in an hour—quite fast in 1974.

By 1977, I was photographing weddings as Dad's assistant. He set the 80mm Hasselblad 500c lens at f/11, the flash for about twelve feet, and said "have at it." I learned guide numbers to adjust the flash and realized the effects depth of field had on my final images. I also enjoyed photographing people unaware of my presence. Children were my favorite subjects and the response from parents' checkbooks quickly made my Daddy glad to keep a camera in my hands.

Were you influenced by any mentors or seminar speakers?
I attended college but dropped out without taking any classes in photography. My mentor was my father, Lawrence Cantrell, who passed away in 1993. Over the years I have picked up tips and techniques from many great photographers, but mainly, I have to credit Frank Cricchio for teaching me how best to expose film, Don Blair for making me really see the effects of light, and books by William Mortensen for revealing the beauty of a correctly posed human figure.

I have been at some wonderful seminars sponsored by the PPA where the training I received from other photographers has been valuable, because it came from their hands-on experience. Their passion for their art and willingness to share with others has been a real bonus.

Please describe your studio.
It is roughly 3,000 sq. ft. in a two-story building that has evolved with my style of photography. I have windows facing south that span floor to ceiling over the entire front of the building. Daylight from the windows presents quite a photographic challenge in late fall and winter months when the afternoon sun dips low in the western sky. To manage light for my "natural look," I curtain the win-

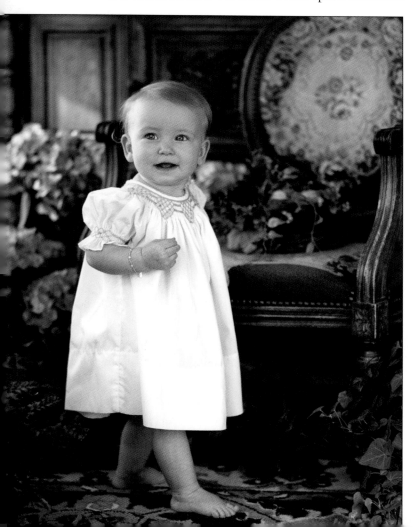

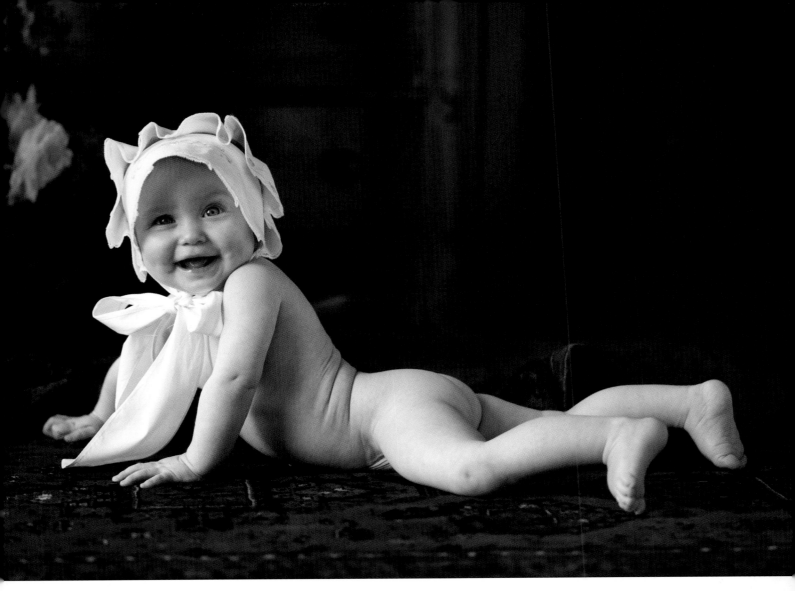

dows or tape up big sheets of foamcore or hang rolls of white paper towels (wonderfully translucent stuff).

I work with an assistant. I also have a receptionist and a salesperson extraordinaire—my sister Lisa.

How do you schedule sessions? When do you take time off?

We use Successware software to schedule appointments every hour, beginning at 9:00AM. We will occasionally give additional time for an expanded session if there are more than five in a family and they want the group to be photographed individually as well.

I stopped photographing weddings six years ago, so I now have weekends free. We take a week off between Christmas and New Year's, and a week around the Fourth of July. We close Mondays between Memorial Day and Labor Day and never work past noon on Fridays.

Photography is my hobby as well as my profession. I love what I do and don't like to be away from the studio

for long. I enjoy the company of my staff, kids, and parents—plus daily long lunches with my sister when we talk about business, marketing, and the personalities of our clients. What could be more fun?

Have your children influenced your business?

My husband, Clay, and I raised four children who are now all living on their own. His three children came to live with us shortly after we married, and raising a blended family has its own difficulties. I was fortunate to have a flexible schedule to meet their needs. That influenced every aspect of our lives. My experience says be good to your spouse, because your children will eventually have lives of their own. Now is the most fun I have had in life.

When you turned professional, were your expectations realistic?

As a child of self-made parents who owned and operated a small photography business, I never worried about ex-

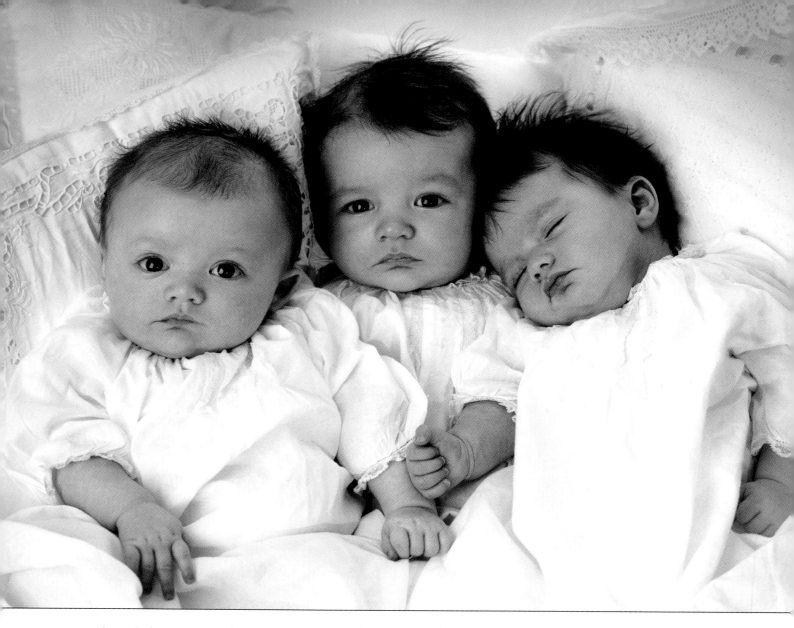

pectations. I always assumed that my star was on the rise. I never expected more than a good living for my son and myself. I thought my parents would live forever and that as long as I checked my equipment regularly and took regular meter readings, I could never fail!

My advice to professionals is: The only difference between us and good amateurs is that we must produce attractive images 100 percent of the time, so we must be more skilled, conscientious, and reliable than amateurs, who only need to please themselves.

Describe some of your techniques for photographing children.

Personal Satisfaction. Make it fun. If photographing children becomes a bore, find another specialty. My satisfaction runs the gamut between "the thrill of the hunt" (capturing the perfect expression at the perfect moment)

and "wrapping the perfect present" (watching a client's face when they see their child's 24x30-inch portrait for the first time).

Lighting. Natural light works best because the child can often move around the set with only minor exposure changes. I also use strobes in softboxes in combination with a spot fill. In my natural-light studio and outdoors, I also use reflectors, which offer flexibility.

Flash blends easily with natural light in four of our photography areas. South light from nine-foot windows is controlled with curtains, diffusers, and sometimes cardboard masks in three areas. The fourth space is a courtyard with north light all day.

When I do photograph with flash, I use a large softbox as my main light, a small barebulb just to the side of the camera for my base density, a hair light, and a background

light when necessary. I use a 4x6-foot reversible gold/white reflector to improve lighting when needed; it is easy to take on location.

Backgrounds and Props. Before the session begins, I offer a variety of sets and encourage the parents to pick several favorites. By far our most requested settings are in the courtyard behind the studio. We have a variety of antique iron and wicker chairs as well as some purchased from Denny Manufacturing. I also use a faux stone wall, also from Denny. Also popular is a window setting where the children can look out at the skyline and watch the birds and view the traffic below. These scenes provide topics of conversation that the children enjoy and understand at all age levels.

Assistant. An assistant is mandatory for my operation. I must have someone trained to engage the child's attention, have the child look in the direction of the light source, and help keep him/her animated. I occasionally use a parent as an assistant, but they don't always listen or understand my directions. It can be awkward if a parent cannot produce a smile in their children, especially when I prefer soft smiles; a big grin distorts most features. However, I try for a smile or two to please the parents and give them choices of expressions, especially for gifts to grandparents.

Parents Present. I want them at the session to control their children and keep them safe ("Mrs. Smith, please kneel next to your son so he won't fall off the chair."). I always have a parent present unless they ask to be excluded. Older children sometimes do better without a parent watching, but I start the session with the parent there and invent a reason for them to leave if needed.

How do you anticipate gestures and expressions?
Timing is everything. The more you photograph, the more adept you become at capturing just the right moment. I feel timing is where individual talents are best distinguished, where style is truly defined. I look for delicate expressions and gestures in some subjects, but stronger faces in others. Some kids smile often, others are captured best looking solemn, and there are always children in constant motion.

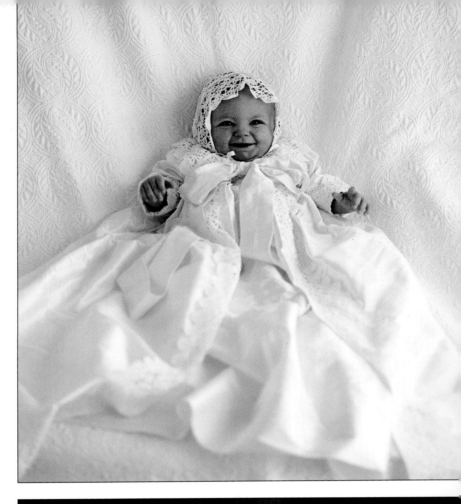

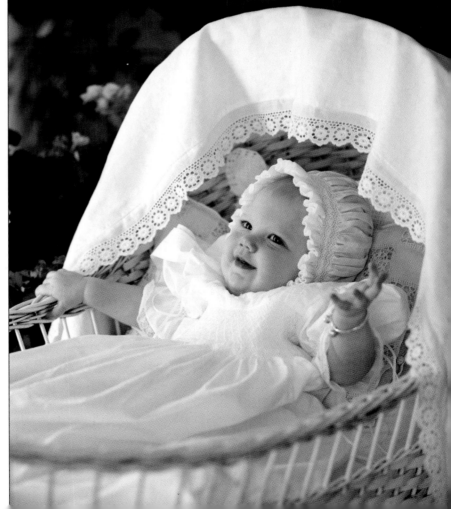

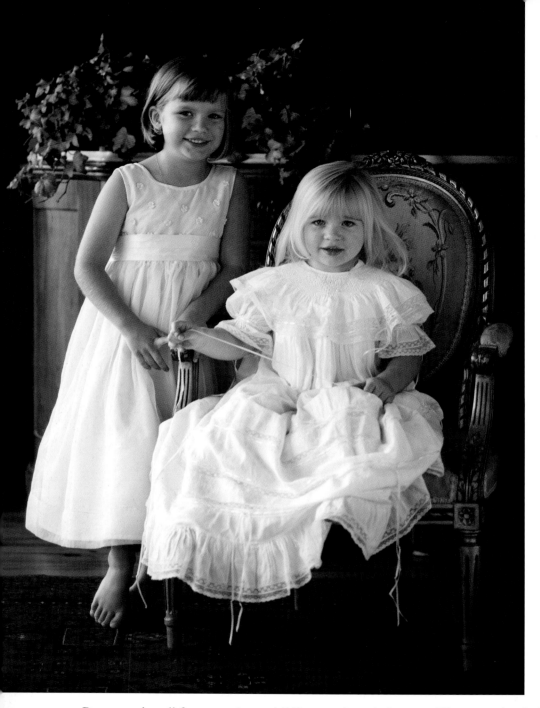

burned to a CD at the lab for projection in a viewing theater at the studio. We use the Kodak Proshots program. The final portraits are all produced from film.

I am a purist who still sees a difference between photographs from black & white film versus digital. We have customers that appreciate and pay for film-based products printed on fiber-based papers. I believe there is a big difference in texture and quality of a fiber print, as apparent as the difference between a fine linen tablecloth and a plastic one

Camera and lenses?

My camera of choice is the Mamiya RZ67, and I use the 180mm lens almost exclusively, always on a rolling camera stand in the studio. I use a regular tripod when shooting outdoors in our courtyard. For commercial work, I photograph with the digital Fuji S3 Pro.

How do you promote your studio?

Customer satisfaction and word-of-mouth referral is our best method of promotion. I also find a mall display is valuable. For our monthly specials, we use direct mail cards from Marathon Press with images that reflect the nature of the promotion.

Props work well for capturing a child's attention. A six-month-old baby will laugh at a puppet; a one-year-old may reach out for the toy and cry until he gets it. A three-month-old baby will always respond to a soft voice and smiling face, but might frown at the sight of a puppet. You learn to know your subjects.

Digital or film?

I use film in my studio. We are a fine-art studio that primarily sells portraits that will decorate walls in homes and offices. I love to capture digitally for commercial work, although I do very little of it. Selected negatives are

We created a baby plan to show the first years of a child's life. Kids begin as early as six weeks and up to six months. The plan includes four portrait sessions covering two years. After each viewing, a portrait is chosen, printed, and archived. These are presented in a matching set at the plan's completion. Additional poses can be purchased at any viewing. Children and families stay with us and the plan is a business asset.

We have a basic web site and we get a lot of response from people surfing the net; that adds to our marketing strategy. Our web site is more valuable than printed brochures were.

What are your pricing categories?

We price photographs in packages and à la carte. Wall portraits are all individual pieces with different finishes and retouching needs and are priced accordingly. We have a base price for portraits; we then build in additional costs for finishing.

We are considered high-end for our area, and few local studios offer some of the products we do. For example, we find Giclée or watercolors look best with feminine subjects on a high-key background. Portraits on canvas, heavily retouched and even painted over entirely, appeal to our clients for both boys and girls. Individual portraits are priced according to the amount of time needed to work on the prints. My sister, Lisa, expertly handles that area of our business.

How do you present your pictures to clients?

We make appointments for our clients to come back to view the photographs in our studio. We project our images digitally on a 5x9-foot screen in a darkened theater. The images are set to music and the initial presentation is for enjoyment only, though customers often tear up seeing their kids on the big screen. Lisa makes the presenta-

tion using Kodak's ProShots, which allows image comparisons and cropping if necessary. Projecting images produced a remarkable jump in sales compared to paper proofs. Customers don't necessarily order more, but they

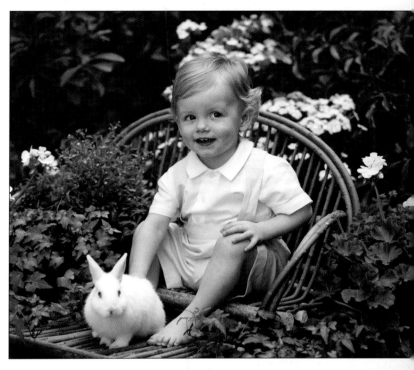

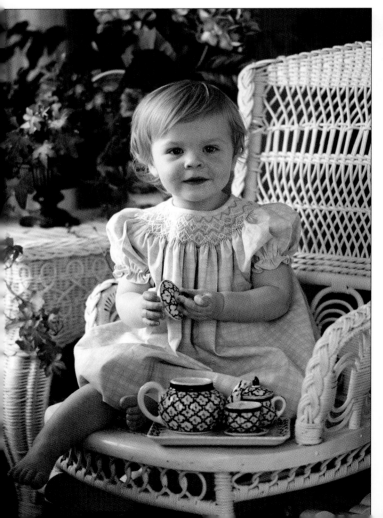

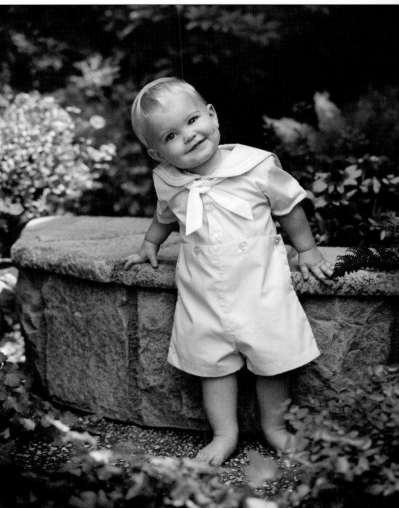

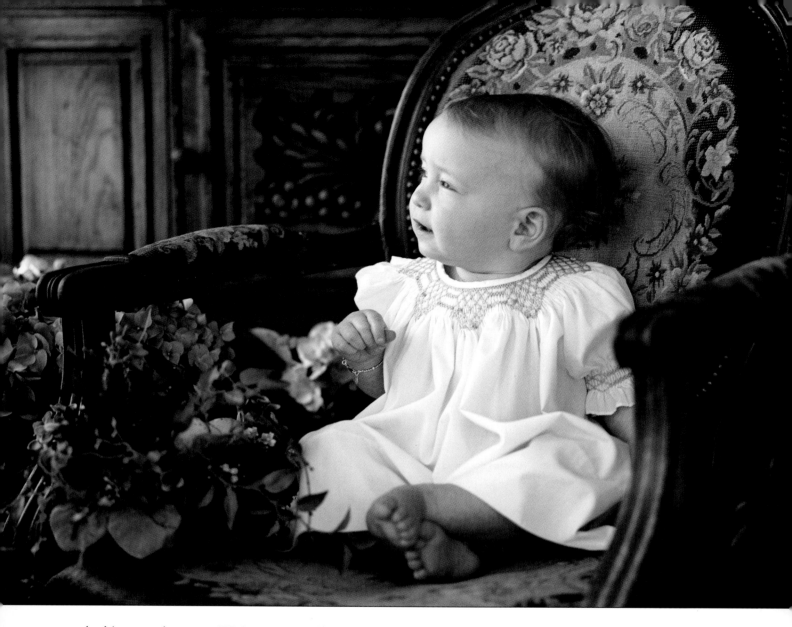

order bigger and smarter. We impose an order deadline of ten days and require deposits.

For out-of-town customers, we make low-resolution, 4x5-inch proof images, four to a page. We also give clients a paper printout of images they purchase to show to friends and family. Gallery frame sales are a separate appointment after the clients' prints arrive, and frame sales have increased dramatically.

We make some use of Photoshop enhancements but prefer old-fashioned negative retouching for prints, which depends on the sizes of prints ordered. Prints of children, up to 11x14 inches, may need little or no retouching.

Describe your album layouts and common print sizes.

Designed in-house, our albums may include from 4x5- to 11x14-inch prints, though 5x7-inch prints are the most popular. We recommend the larger wedding-type albums for individual children's portraits. These offer an heirloom storage method for smaller prints. Clients add to their albums at each session. Wall portraits are mostly 20x24 or 24x30 inches; however, we noticed a large increase in 30x40-inch print sales after displaying more of that size plus a 40x60-inch canvas in our gallery area.

Does a photographer's personality influence their success?

Yes. As an extrovert, it is natural for me to communicate my excitement during a session. Because I am having fun, children have fun. I have been told by first-time customers that I make it easy for kids—feedback that makes me feel that being effervescent plays a large role in the overall photo experience for the children.

12. CARRIE SANDOVAL

Carrie lives in Fallbrook, California, north of San Diego. She earned a B.F.A. from California State University–Fullerton and was an art director before becoming absorbed in photography. She says, "As a kid, I was fascinated with finger paints and as an adult, my awareness evolved to oil paints and now Photoshop. In July of 2000, I made a major career change by having my first baby, leading me to buy my first digital camera. Becoming a mother was the catalyst that made my love of photography blossom. Capturing the innocence of children led me to another career." To learn more, visit www.capturedbycarrie.com.

What is your background?
I took Photography 101 in college as a requirement for my degree in art, but I thought I was lousy. After graduation I worked as a graphic designer for an ad agency. I felt that was what I was meant to do. My husband and I had a difficult time trying to have children, and when our son was born in 2000, I took hundreds of snapshots of him. However, I didn't get really interested in children's portrait photography until my twin girls (born in 2002) were ten months old. I bought my first digital SLR, and six months later I was photographing not only my children, but kids in our play group, and those of friends and family. I had fun, gave out prints, and word of mouth began rolling and still does. Now I love photographing children, but 85 percent of my subjects are between zero weeks (extremely fresh babies only days old!) and one year. I also photograph pregnant women.

Were you influenced by any mentors or seminar speakers?
Ten years of graphic design and Photoshop experience before getting into photography helped my learning curve immensely. I am still lousy at photographing architecture, landscapes, and sports, though.

I had no mentors; I was 100-percent inspired by my own children. I did frame and hang images of my first born made by a professional chain, but I found more pleasure looking at my technically wrong, badly composed snapshots. My child's expressions were truer and

made me smile. Now I have a deeper appreciation and admiration for other child photographers, and I have hired other professionals to photograph my children since I became one. I also have a list of photographers that I would love to hire in the future, because I am curious to see how they view my kids. We are all artists who see differently.

Describe your studio.
My studio is everywhere the sun shines. I have no employees. Sometimes I may seem like a crazy, one-woman

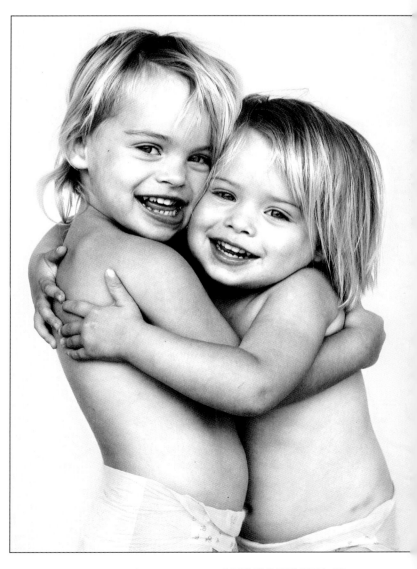

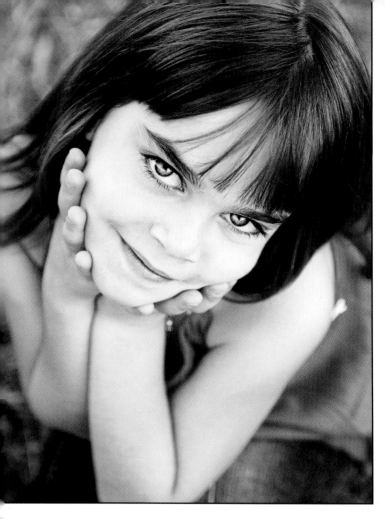
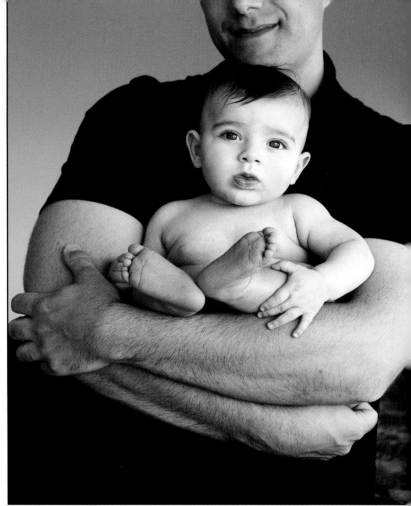
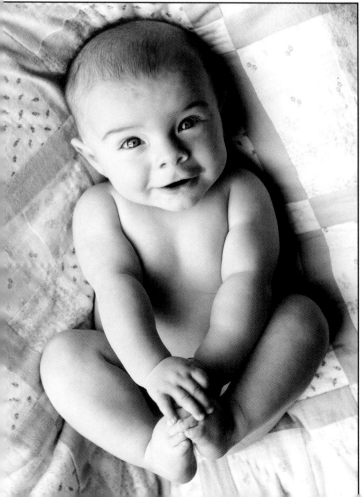
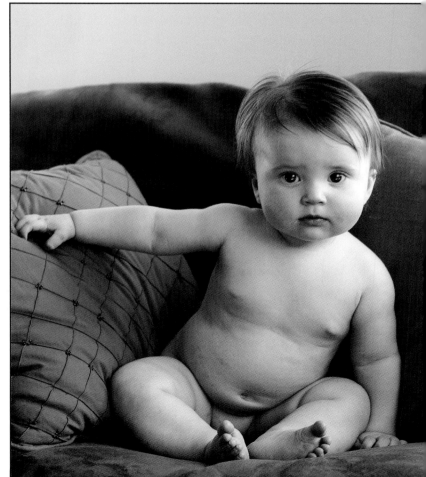

show, especially when I am putting on a silly act to make kids smile so I can snap the shutter as they give me that great expression.

I photograph in my home, my client's home, beaches, or parks. I look for huge windows or doors that don't receive harsh, direct sunlight in the client's home. Outdoors, I look for open shade. Photographing at the right shady distance from a large tree with wide open-sky behind the subject is ideal. For beach sessions, I cross my fingers and hope that there will be an overcast sky or light clouds.

How do you schedule sessions? When do you take time off?
As I write, I am booked six months in advance. I schedule only two sessions per week so that I can maintain my desired level of quality and service. This arrangement assures me time to spend with my own children.

My clients call and we agree on a date, though once in a while it gets adjusted by the time the session day rolls around.

How have your children influenced your business?
My son, Michael, and my twin girls, Makenna and Kalynn, were so cute that I started taking pictures of them and they had a heavenly influence on my decision to go into business. I planned on taking the professional leap when the twins started preschool, but it happened earlier. I now have regular sessions on Friday, and since I charge more on weekends, it keeps that time free for my family. During the week I work on the computer proofing pictures while the children sleep. In turn, I sleep very little. It's genetic. My father is a creative type as well, and our minds are always on the go. We both require little sleep (six to seven hours per night).

Were your expectations realistic when you turned professional?
When I first started, I had no expectations. I was a stay-at-home mom who had found a new hobby. I had photographed the children of a friend, and she posted the pictures on an Internet forum. This free advertising brought me my first "cold" client. I didn't anticipate get-

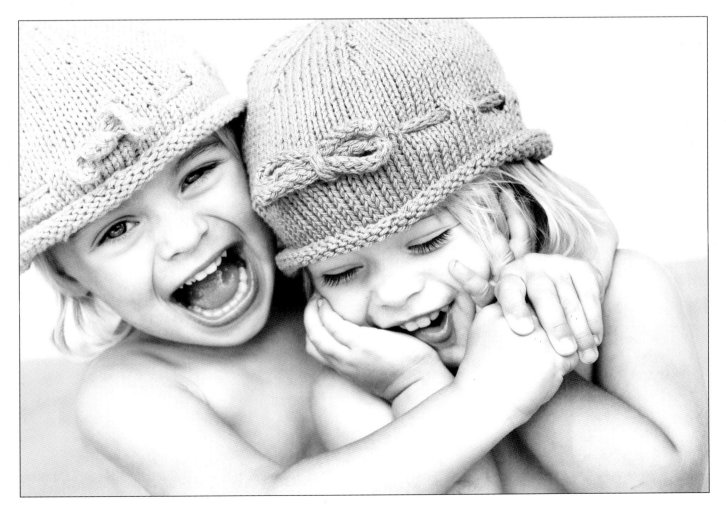

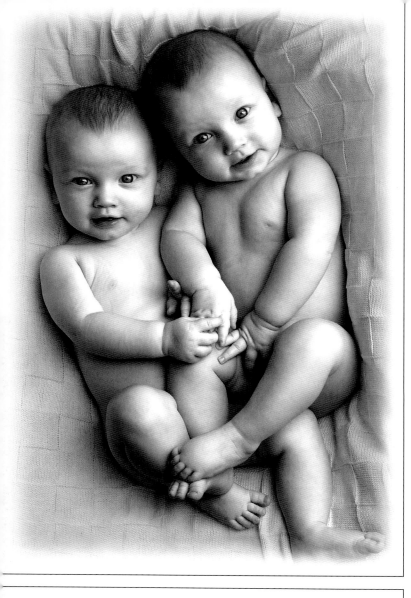

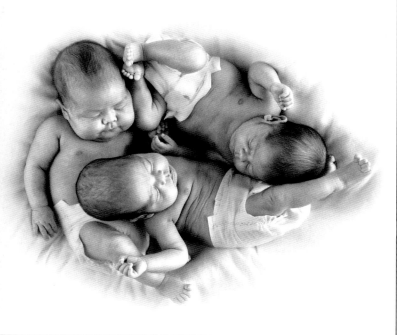

ting more, but they kept calling. I could never have guessed that I would be in a going business today.

My dreams never included scheduling many sessions per week. I preferred to be exclusive, and I am still looking forward to that status. I discovered that the most undesirable part of business is everything after posting the client's gallery. I hope to hire someone to do invoicing, ordering the prints, dealing with the lab, etc.

Describe some of your techniques for photographing children.
Winning their Cooperation. This is the most rewarding part of a session to me. Some of my favorite compliments are about how I connect with children. One client told me that her four-year-old had never warmed up to a photographer before—but, luckily, that was *after* our session. The boy was a bit shy at first, but after our fair share of high fives, jokes, and conversations about baseball, I had him giggling, flexing his muscles, and hanging off tree branches like a monkey!

Before I photographed a brother and sister, my first set of autistic children, I had read how difficult it is to connect. So I never asked them to look at the camera. Instead, I dressed it up like a frog and asked them to name it. I asked them how many eyes "Mr. Greeny" had, what color he was, and what color his tongue was. It worked beautifully. I managed to capture many split seconds of eye contact among the bloopers; the family can now see their children as they do everyday.

Lighting. I work on location and warn clients that I will explore every room in their home. I usually end up on the second floor if there is one, because these rooms have no patio cover or trees to obstruct the window light. I am also known to take the screens off windows, which may seem strange to clients, but it always gives me faster shutter speeds. Since most sessions are in the morning when babies are happiest, I look for windows that face all directions and find the brightest room.

I love using the wall next to a window as a setting, and I will drag couches, chairs, and tables close to the window. When interior lighting permits, I let the baby sink into Mom and Dad's bed, or I throw a piece of black velveteen over chairs and bring clamps to hold the fabric for what I feel is the classic, low-key look. In each case, I try to get subjects as close to the window as possible.

Outdoors. Where I photograph depends on the time of day. Around noon, I escape under trees with nice shade,

especially with dense shade from other trees or a wall or fence behind them. This makes the subject stand out better with a less distracting background. When possible, I prefer to wait until just before sundown with long shadows and I have a larger palette to work with. My favorite local outdoor location has a curvy wooden boardwalk surrounded by native shrubbery and trees.

Props and Parents. I sometimes use props. If I do, I use something that belongs to the child or has special meaning to the family. Even if the purpose of the session is to photograph the children only, I still try to encourage the presence of the parent, a hand, a shoulder, feet. As for newborns, I often use parents for props. These little humans are so attached to their parents, and I feel the need to document that.

How do you anticipate gestures and expressions?

For newborn babies, it seems that my best exposures are captured in the last twenty minutes when I have tired them out with gestures and stimulation. When they pass out I can bend them any way I want! After I lose a baby's attention, I have rattles and squeakers—the kind that go inside baby toys. I squeeze them between my teeth. Babies will look at me but it only works a few times. After that, out comes Mr. Frog—a prop that I made myself. He is a green-haired scrunchy, with two popping eyes and a pink tongue, and I put it around my lens. I have found that most kids tire of this in a short time, as well.

With older children who walk, my best images are captured within the first twenty minutes. After that, subjects tire of the whole process. I usually don't need visual aids during this time. I sing and talk and pop my head out from behind the camera.

Digital or film? Black & white or color?

All images are captured in color with my digital camera, but 90 percent of the time I convert to black & white. I consider conversion half my art, because I believe it is equivalent to buying the best professional black & white film and knowing how to use it. Black & white is timeless and seems to bare the soul of the subject. When I choose to keep an image in color, it has to feel right. It is as if I am inspired by the wall color in my client's home or if outdoor colors are appealing or sunlight is warm at certain times of day.

Do you shoot sequential bursts?

I shoot sequences when the subject is telling a story that requires concentration and elicits many expressions, and I want to include the whole story. When a toddler is danc-

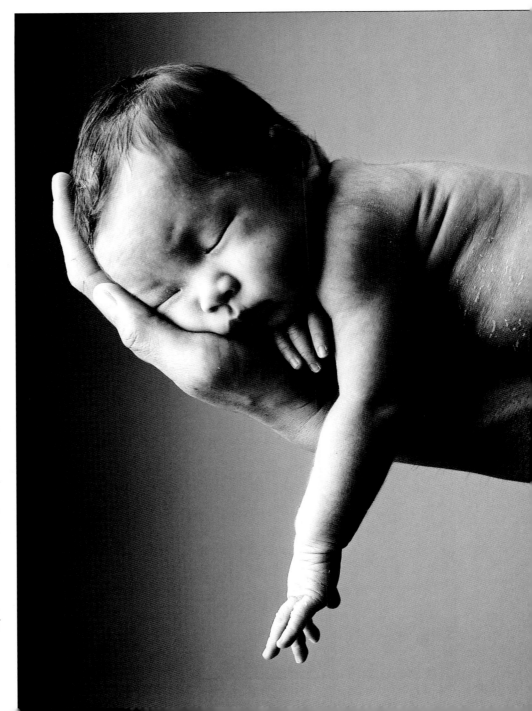

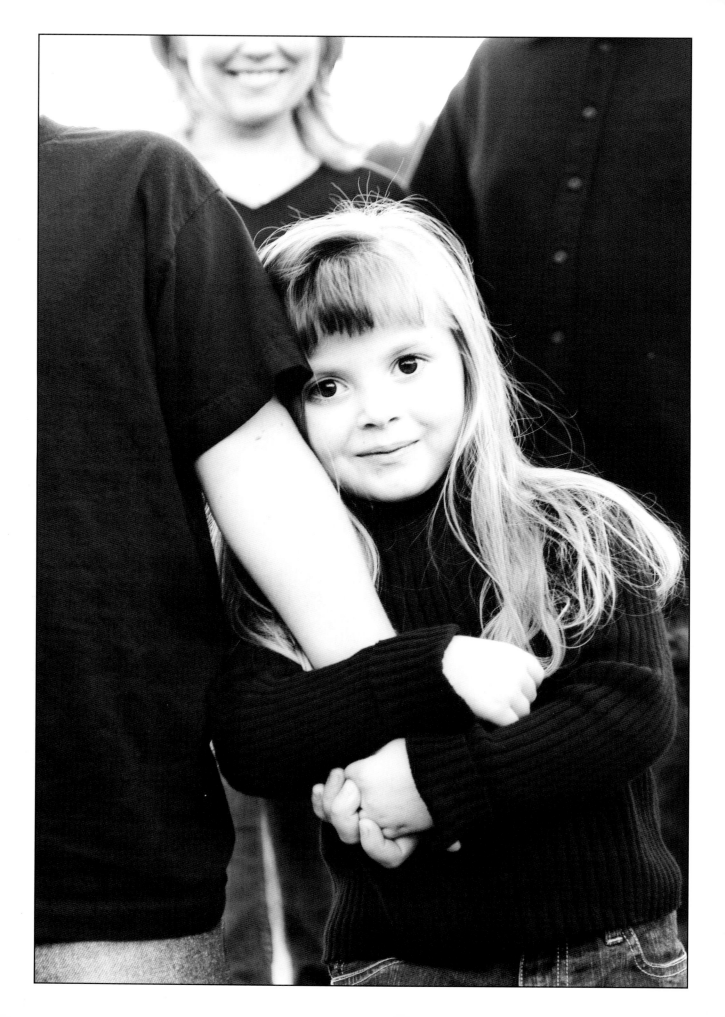

ing on the beach, or a five-year-old refuses to smile but then can't contain the giggles any longer. When a newborn stretches and squirms trying to get comfortable, or a baby explores his toes, or grabs them to chew on. When a family is walking down the boardwalk, thinking the session is over, and interacts naturally.

Basically, I photograph sequences when the subject is naturally performing.

Camera and lenses?

I have photographed with several fine Nikon models and I am now comfortable with the D2X. I use Nikon lenses, and my favorite is a 50mm f/1.4, which I use 100 percent of the time for window light. Outdoors, I prefer my 28–70mm f/2.8 AFS. A zoom is nice when my subjects have so much room to roam.

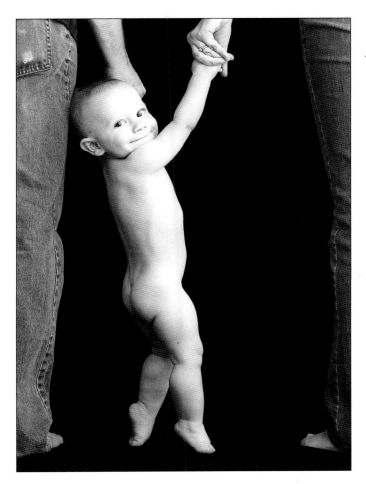

How do you promote your studio?

My first clients were families in my children's play group. I didn't charge session fees, and I opted to price prints at rates I hoped to charge a year later, and offered discounts until then. That way, clients knew what my prices would be when I was established. Looking back, I don't think my prices were ever too low, but they are now double what they were at first. My web site is very important and helps promote word-of-mouth support. When clients share their online galleries, viewers are inclined to view my portfolio. I try to change my images monthly, although intervals may be longer. I suppose it's a good thing to be too busy.

What are your pricing categories?

I try to keep pricing simple. I offer two session plans: a mini-session in local locations with twelve images shown, and a full session in more distant locations with up to thirty images shown. Prints are priced separately. I have never offered print packages, but I do offer an album with 5x7-inch prints priced as a unit. I have tried combinations such as maternity plus newborn sessions, or four sessions during a baby's first year for a discounted session fee. This worked well for me while I was building my client base. In fact, it worked too well, because I was busier than I hoped. So now my sessions are separately priced and clients always come back for more. I raise my prices based on how far in advance I am scheduling—that meant raising them twice in the past year.

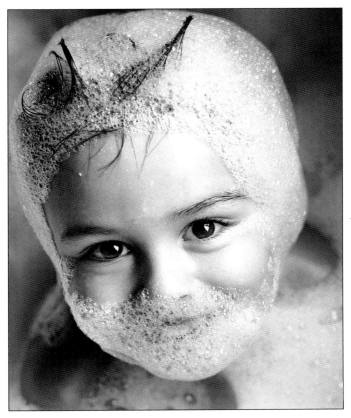

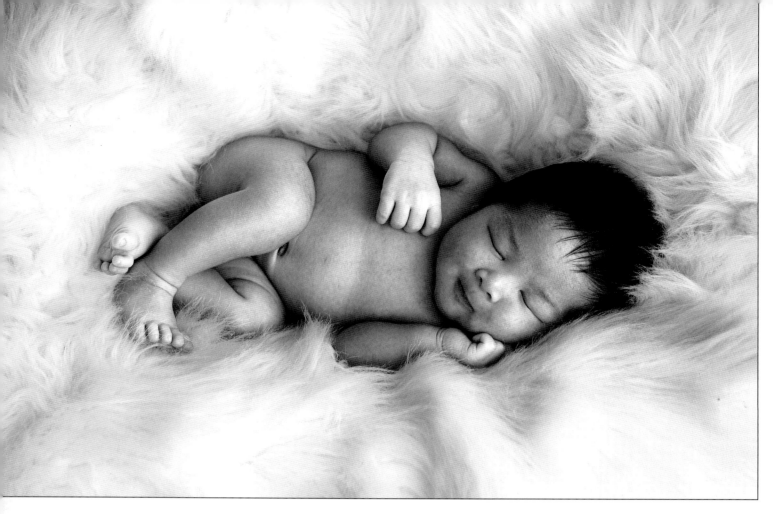

Describe your editing and printing process.

I edit images myself in Photoshop, which is my favorite part of the process. I use Photoshop to convert from color to black & white and to keep my highlights bright, but not blown out, with smooth gradations into the shadows. I order prints from a professional lab. All files are uploaded from my computer via the Internet to their server; a modern-day convenience at its finest.

How do you present your pictures to clients?

I present images to clients in an online slideshow. I don't consider any of my images "proofs," meaning that they don't need any additional work besides cropping once the client orders. I don't want parents to have to imagine what the final images will look like. I do not sell the digital files, but I do offer an album that contains all the 5x7-inch prints from the session.

Describe your album layouts and common print sizes.

I mount only one photograph per page, so the layout is not very labor intensive. I do pay attention to the order of the images so that they tell a story of the session. Due to lack of time, I do not offer coffee-table books, but I would love to in the future. With my graphic-design background, I will absolutely do the design myself, because I am a control freak and I love to do it.

My most-ordered print size is 5x7 inches. As for wall portraits, 11x14 inch prints have been the most popular size, but I have recently had quite a few 16x20s requested. I am excited about my clients wanting to display their images big, and my Nikon D2X can easily handle a 30x40-inch file size.

Does a photographer's personality influence their success?

Recently a client made my day. At the beginning of a session with a bubbly four-month-old, I put on my baby face and voice, and the baby was enjoying me. I overheard the Mom say to her helper, "You can tell she really loves babies." I wanted to stop and thank her, but I kept going. I really believe that connecting with subjects is a key to capturing genuine expressions that reflect their feelings. Yes, a photographer's personality plays a big part in the connection—and with parents as well.

13. THOMAS BALSAMO

Thomas Balsamo operates a thriving portrait business, specializing in children and families, from his studio located in a busy mall in Barrington, Illinois. He is self-taught and has been creating portraits since his teens. He credits his advanced education as coming from seminar and convention speakers. Thomas is dedicated to black & white imagery, which he feels allows viewers to better understand the soul of young children. He also produced images for a lovely book titled *Souls Beneath and Beyond Autism* (McGraw-Hill, 2004) by Sharon Rosenbloom. The text and photographs offer a meaningful view into the multiple challenges of autism. To learn more about Thomas, visit www.portraitsby thomas.com.

What is your background?

I received a Kodak Instamatic for my tenth birthday in 1970 and began photographing people in a suburb of Chicago. A friend introduced me to the darkroom where I started processing and printing.

I opened a lawn-mowing business to support my photography and saved enough for my own darkroom when I was twelve. As a sixteen-year-old, I had a job at the local camera shop where I chatted with many photographers and customers who often asked for photographer referrals. I had business cards printed and started creating Portraits by Thomas when I was a junior in high school.

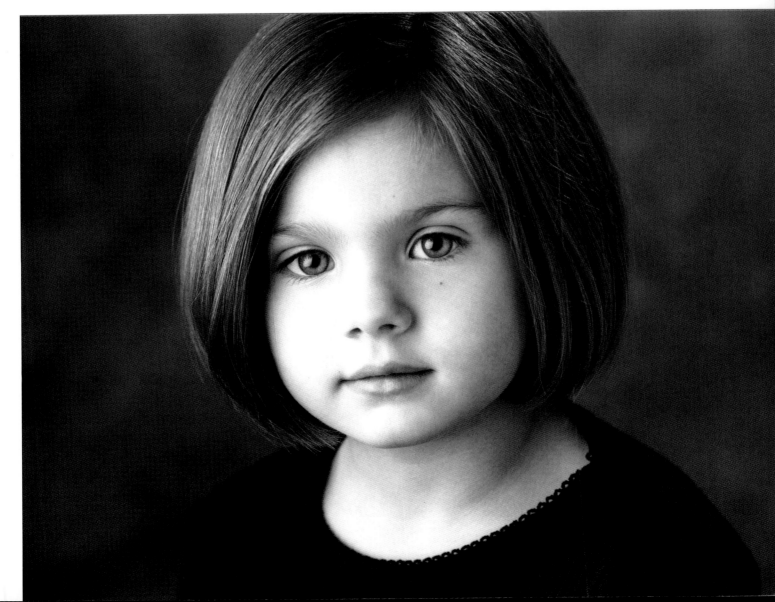

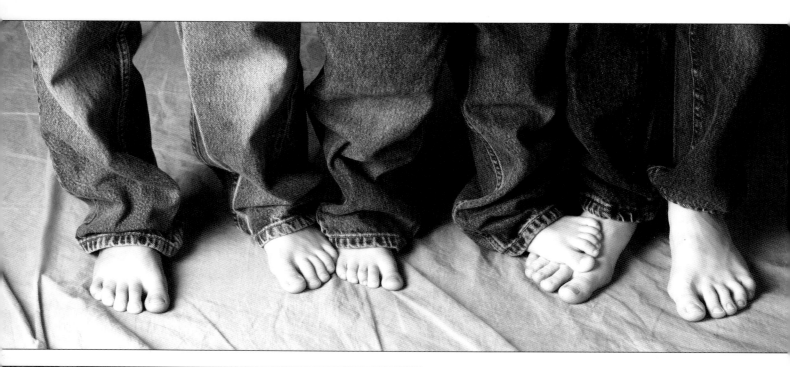

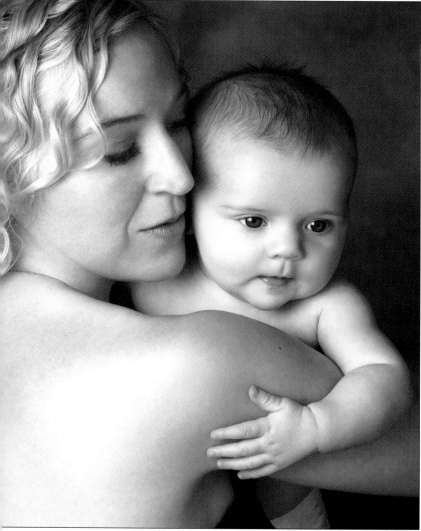

My supportive parents let me set up a camera room in their basement, and my business expanded into their living room as well. Since then, I have carefully developed an appreciative clientele for my black & white interpretive style. Occasionally, I do new projects for clients who remember my basement photo studio and the young man who did portraits. Now I am very fortunate to have a clientele that is not only local but spread out across the USA as well as a few foreign countries.

Were you influenced by any mentors or seminar speakers?
In the early 1980s, as I was building my portrait business, I decided to get a liberal arts degree, which did not include photography studies.

I have learned much from assorted workshops and seminars through the years; however, the bulk of my education comes from studying thousands of photographic images and portraits in photo books, often in libraries and bookstores. As I viewed the pictures, I would ask myself, how does each make me feel? And why do I feel that way? I found there is something magical about peoples' eyes that are the windows to the soul.

An important part of my revelation came from the work of Karsh. I was moved by his ability to capture eyes, and his influence helped solidify my direction. Other favorite photographers who really capture eyes

are Arnold Newman, David Bailey, Greg Gorman, Patrick Dimarchler, and David Hamilton.

For years, I was not satisfied with my work. I would compare it to photographs by the artists listed above, and I knew I could learn to create images with similar impact. I was on a quest to find a style that would come from my heart and mind. As I grew into finer portraiture, I continued to expose myself to thousands of images in photo books. I remember times I became so lost in imagery I would find myself weeping in public. I guess you can say I developed my style by following my heart.

Describe your studio.

My studio takes up two units in a strip mall located at a busy intersection. It consists of a front waiting room, camera room, frame sales room, digital lab, and my office, which is also the sales and projection room. The of-fice is my favorite room, where I keep my fossil collection in a display cabinet. It contains dinosaur fossils, mete-orites, and neo-man hand tools. My adult clients love to

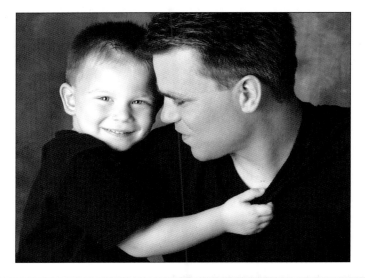

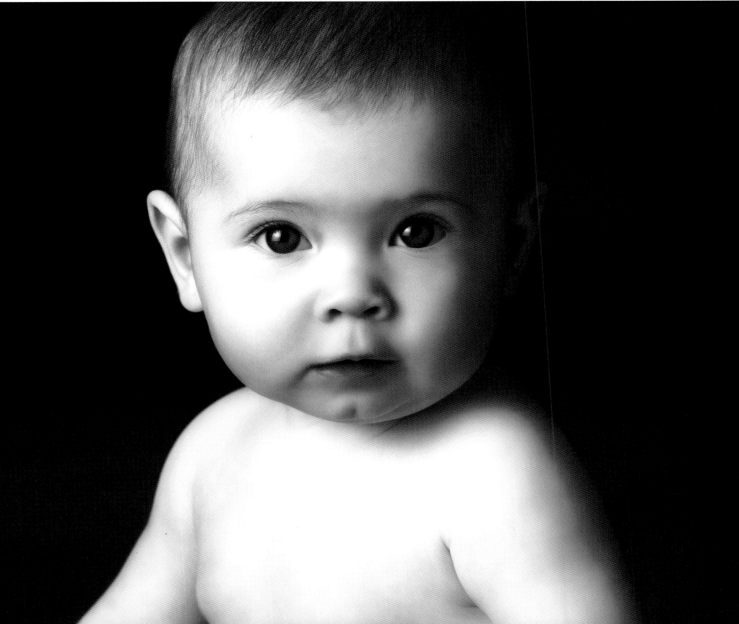

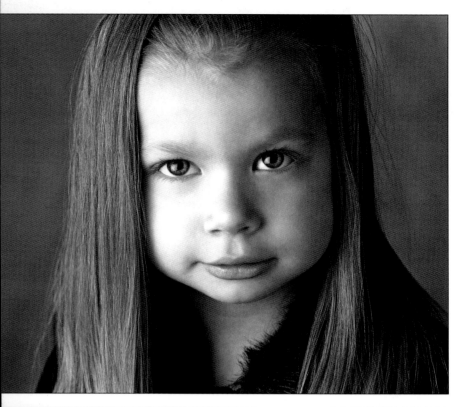

examine the specimens and the kids enjoy my salt-water reef tank. I have tried to create a relaxing environment with an eclectic décor in browns and calming colors. The studio has three full-time employees, a studio manager, a production manager, and a frame-shop manager.

How do you schedule sessions?
When do you take time off?

I have a four-day work week. I schedule pre-portrait meetings a day prior to sessions, which is when I consult with parents and show them some of my work. I highly encourage pre-planning meetings; some out-of-state clients arrive a day early at my request. I explain to parents that I need to understand children to truly capture them and their families. I emphasize how I work, and I encourage them to relax and enjoy the portrait experience. "Be in the moment, be yourselves," I suggest, "and the pictures will be spontaneous."

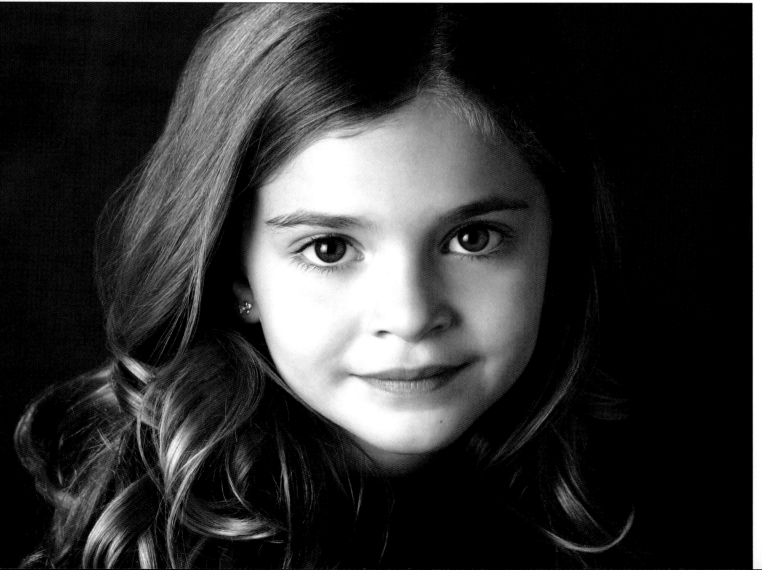

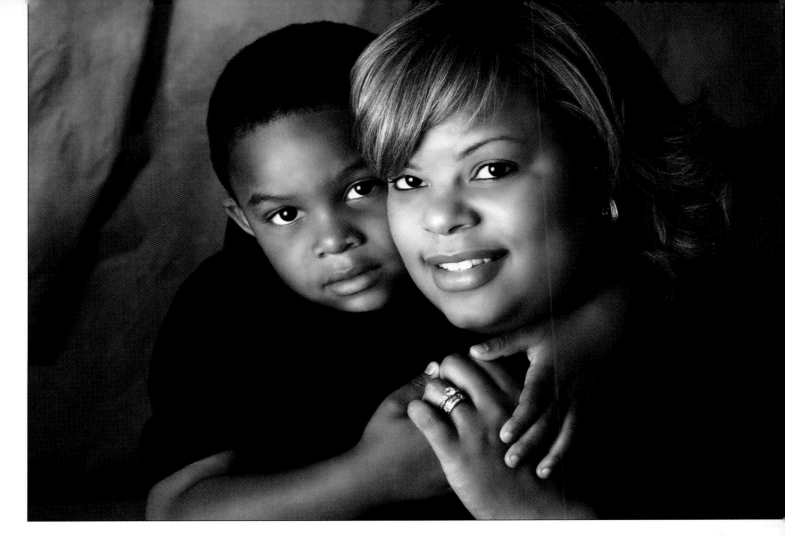

My whole operation is geared to helping clients let their guard down and trust me completely as I photograph their kids.

Have your children influenced your business?

I have three boys. The oldest is Nickolas, a high-school sophomore and a hard-working student. My second, Wade, is twelve and wants to be a scientist. Michael is seven with a smile that lights up the room. I have photographed them often, but I understood the process of children's portrait photography before I had children of my own. For almost thirty years I have been photographing families, so I had a lot of experience with children when I decided they would be my specialty.

My philosophy is to create valuable portraiture by capturing souls, and it's eyes that reveal this essence in each individual. This has been validated in my understanding of children. Childhood goes by so fast that it is important to preserve accurate interpretative portraits along the way. The most valuable images are those that are truthful depictions, not merely physical records.

When you turned professional, were your expectations realistic?

I am not sure I had any specific expectations when I started in business; I just loved what I was doing. As I progressed, I developed an understanding about how important it was for me to capture images that helped reveal the essence of childhood. Some years ago I learned a lot when one of my client-parents died the day after our session. He was in a portrait with his family, including a one-year-old son, so they had the photograph to help remember him. Before the film was developed, I had been concerned about having any quality images because the session was difficult when the baby was involved. But the photographs were successful, and the experience empowered me to continue learning how to create portraits that are honest and emotionally valuable. It is a huge responsibility to do our best at every session.

Describe some of your techniques for photographing children.

Winning Their Cooperation. My first priority is to earn the trust of the children and help them understand about relaxing and enjoying the portrait experience. I talk to the

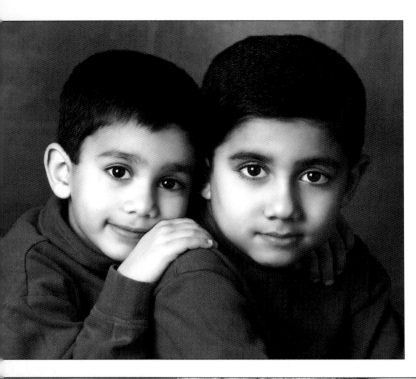

parents as well as the children so that we can all be on the same wavelength. I let my subjects be natural during a session. We do poses, but I don't emphasize them. I talk to the kids frequently to make them feel comfortable. I focus my attention on them by asking questions: What do they like to do? What do they like to eat? They don't think about being photographed when they are distracted. As we converse, I can capture moments as they are just being themselves without being self-conscious. I strive for a range of expressions, some warm and some more pensive, hoping to create worthy portraits.

Parents. I encourage Mom and Dad to step back and relax. I prefer not to have them standing behind me giving me bunny ears. If the subject is insecure or nervous, I let Mom and Dad look through the lens at them. We make a big fuss about how great they look, and the parents gush and help create another great moment to capture. Moods and lighting evolve throughout the process.

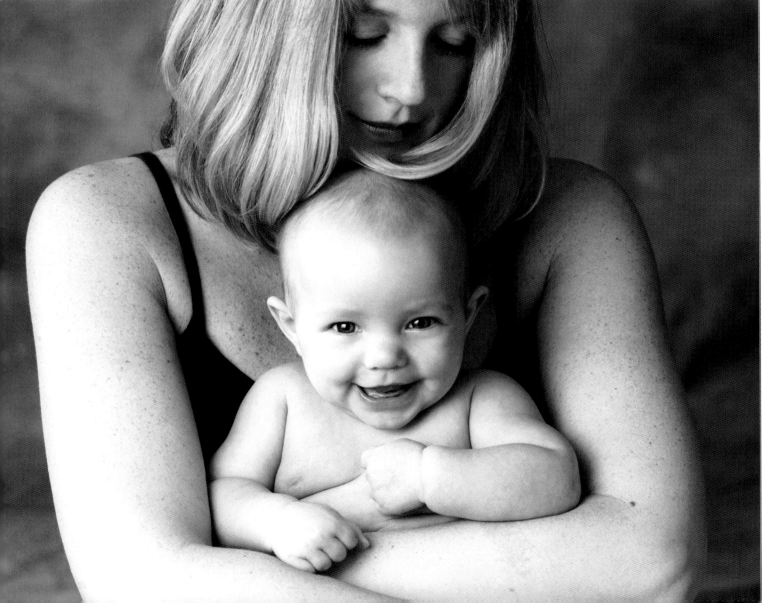

Stress must be avoided in the camera room. When parents are stressed out, the children will also be stressed out; try not to allow it in your studio. If parents hinder my work, I suggest they excuse themselves and hide in the dressing room or the reception area.

Lighting Indoors. I work with two softboxes so I can photograph in a zone large enough for kids to move around. I like soft lighting that emulates window light. The lighting arrangement is kept simple so I can focus attention on my subjects. I used only one background for a year, a midtone gray muslin with some texture in it. Backgrounds are not a big deal, but my subjects' faces are. I use a reflector for fill to help emulate window light. Most all of my work is created in the studio. I don't use many props, although I have an antique tricycle that has saved the session many times.

How do you anticipate gestures and expressions?

The first thing is to know what to look for. My approach to capturing the spirit of the individual is to take time to understand the personality of the child I am photographing. Some children are more outgoing, some are shy. Some smile all the time, some rarely do. My job is to truthfully interpret each of my subjects. When they are engaged and are not intimidated or nervous, they will be themselves. It is at this time that I can talk and interact to help them feel good as I push the shutter release.

Digital or film?

After twenty-five years of using film, I chose to switch to a digital camera, and I feel it has helped me deliver a better product. Digital is more efficient in most ways, though it takes more time in front of the computer, editing down to a reasonable number of images that won't overwhelm the client.

I specialize in black & white because it does a more effective job of drawing viewers to the eyes of the subject. I capture color images in the camera, and then I convert the files to black & white in Photoshop. Digital allows me to capture as many images as I wish, and I don't have to deal with chemicals. I would never go back to film.

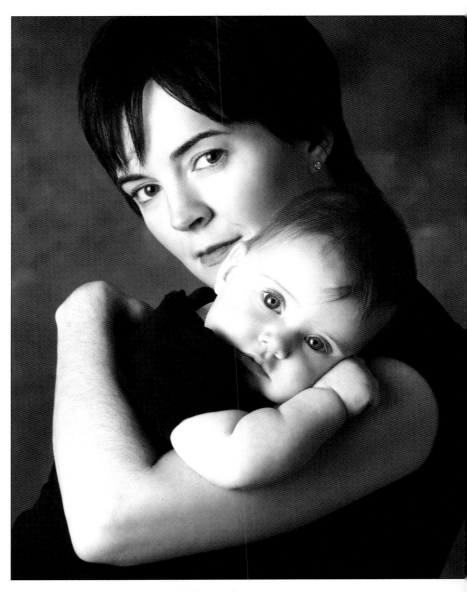

Do you shoot sequential bursts?

Sometimes I am looking for a natural moment where eyes are smiling, which happens when kids laugh, and I take a fast series of exposures. Once I have a strong pose I frequently make sequential bursts to capture the nuances in faces. When I am trying to capture expressive moments, even the smallest change can improve an already great image.

Camera and lenses?

I use a Cannon 1DS with a 70–200mm lens and mount it on a mono stand in my camera room. I use Dyna-Lites and two Larson softboxes. I photograph almost exclusively in the studio because I like the control of my simple lighting setup, and I can avoid distraction to focus my attention on children and not mess around with equip-

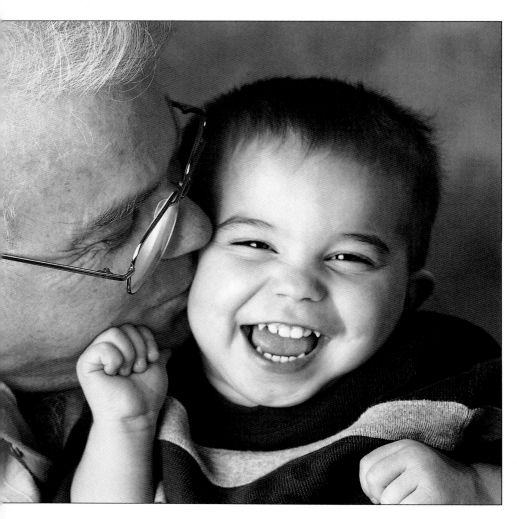

Describe your editing and printing process.
After each session, I make a set of black & white JPEGs and edit them for viewing. I have a full-time printer technician, and we print everything in-house on our Epson wide-format 9800 printer. I like the control and efficiency we get by printing our own work; it seems consistent with my creative efforts.

How do you present your pictures to clients?
I enjoy doing viewing appointments. I project digital files on a screen in my office, starting with a slideshow to get parents emotionally involved. Then we begin the selection process and choose print sizes. We discuss where pictures will be displayed in their home, and I recommend a mix of wall portraits and smaller desk portraits.

Describe your album layouts and common print sizes.
We offer family and children's portrait albums, and all the designing and layout is done in-house. Our most popular portrait orders are wall sizes: 16x20 to 24x30 inches. People decide on picture size based on their walls and display spaces. We also discuss viewing distances. I feel strongly that larger sized portraits should be images in the "classic" pose and expression category. Portraits in the "fun" category (big smiles) should be smaller prints.

Does a photographer's personality influence their success?
I am a type-A person and have always been goal-oriented and kind of high-strung. I had to learn to relax so I could influence my clients to relax and enable me to capture natural moments. I have also learned that relaxing is better for one's health, and it makes for a better life—especially as a person gets older (not to mention that my wife appreciates me more when I'm relaxed!).

ment. I use shorter focal-length lenses when I am photographing a spread-out group, but never for individuals or small groups.

How do you promote your studio?
Word-of-mouth advertising has always been my main source to bring in new clientele. I put my whole heart into every project and my clients believe that I am capturing their child's most flattering poses and expressions. I also place some ads in magazines aimed at mothers and parents, and I place several portrait displays in restaurants, doctors' offices, hair salons, and malls.

What are your pricing categories?
My prices are on the high end, and I raise them yearly, depending on need and how busy I am. At the high-end, the number of people who can afford you diminishes. Trying to broaden my market area is a constant endeavor, but lowering prices is not a suitable option for me.

Audrey lives in a suburb of Chicago with her husband and four active sons. "Once I knew I wanted to be a photographer, there was no question that I wanted to specialize in children." Her available-light work has been seen in *InStyle*, *Chicago Magazine*, and *City Baby Chicago*. It is also on display at businesses along the Gold Coast. Audrey strives to create memories with spirit in a business where she has flourished. To see more of her images, visit www.alwphotography.com.

What is your background?

I am a self-taught photographer and mother of four children. While I was a computer programmer, my first two children were in daycare or school, but I became a stay-at-home mother once our third child, now five, was born. My husband came home one day with a 1.3MP Fuji FinePix digital camera he bought from his sister for fifty dollars. He told me, "Here you go! Maybe this can keep you further occupied while you're home." I thought: Wow! Instant gratification! I will actually see my pictures as soon as they are captured. I never actually realized I had a gift for photography, or that I would enjoy doing it as a professional.

I began taking pictures of my kids daily and converted the best to black & white with Adobe PhotoDeluxe. I

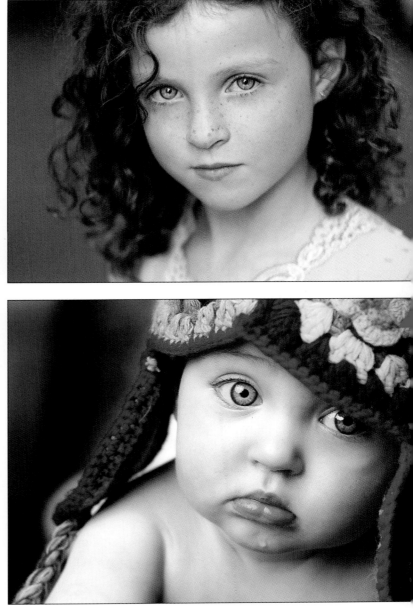

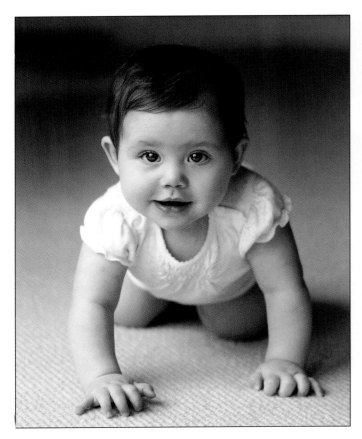

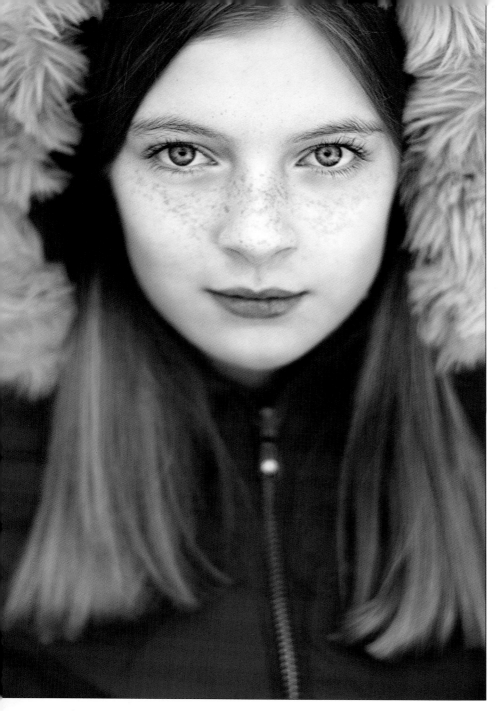

tion. Both my husband and my father are brilliant businessmen, and they helped guide me from point A to point B.

Describe your studio.
I work entirely on location and rely on natural light within my clients' own surroundings. I learned to find the right settings in peoples' homes by trial and error. I work without an assistant; I am a one-woman show.

How do you schedule sessions?
When do you take time off?
I schedule one or two photo sessions a day during the week. On days that I don't do photographic work, my time is dedicated to my family. My husband is home with the children while I am on location. We tend to plan vacations very early, and I block those intervals off in advance. I encourage all clients to check with me at least four weeks prior to planned appointments. I will schedule sessions on weekends, but my fee is substantially higher for those premium times. If a location is too far away, I will refer parents to a closer photographer.

Have your children influenced your business?
My four beautiful boys are the reason I am in this business, because they are not the type of children who can sit patiently in a studio environment. Chasing them around during my learning period helped teach me how to handle fast-moving kids, often in low-light conditions. I have mastered the technique of steady hands, which is of key importance when using very wide apertures between f/1.8 and f/2.8, which is what I typically use. I may photograph at $^1/_{125}$ second or higher, depending on the brightness of light. I don't usually set my shutter speed lower than my lens focal length to avoid camera shake.

Currently, my husband and I work tag team. We prefer that our younger children spend the majority of their time with one of us; therefore, we do not use babysitters or nannies. Synchronized schedules are a must. In addi-

haven't looked back. I have never taken classes or assisted another photographer; I just practiced, and I practiced a lot. Only recently, I also began to photograph teens represented by the Ford Model Agency.

Were you influenced by any mentors or seminar speakers?
Coming from a family of business professionals, I have always had a keen business sense, which helped me build my business. I haven't been influenced by any photographer, nor have I had any photography mentors. I began by documenting the honesty in my children's everyday lives. I often look to magazines for photographic inspira-

tion, we are fortunate that our parents enable us to have some "alone time" by caring for our children.

Were your expectations realistic when you turned professional?

I think my attitude and expectations were very realistic. However, I made an unexpected discovery that presentation is everything. All the impressions you want to create about your business should show in your work. Your photography has a style and your business aspects should reflect that style. I also discovered that setting policies is a must. One policy is how long clients have to place an order; another is that proofs never leave my possession. Portraits must be paid in full at order time. Policies will help give you confidence and streamline your business; they also improve your client communications.

Describe some of your techniques for photographing children.

Winning Their Cooperation. I try to make my approach to kids the least invasive possible. I get to know the children when I first arrive at their homes. I like to have them show me their toys or their room; having children of my own makes this very easy. I usually know what the popular toys or cartoons are; I try to get on their level, like a friend.

Thoughts About Lighting. Photography is all about light, and I use natural light without reflectors, which keeps me on my toes creatively. I adore natural catchlights. Because I am usually not sure what the lighting conditions will be before I arrive at a client's home, I can't preplan my photo sessions. I like it that way, because I firmly believe that I can always find sufficient ambient light. You just have to be resourceful enough to discover it and make a location work for you and your subject. I have had many sessions in bathrooms, because that is

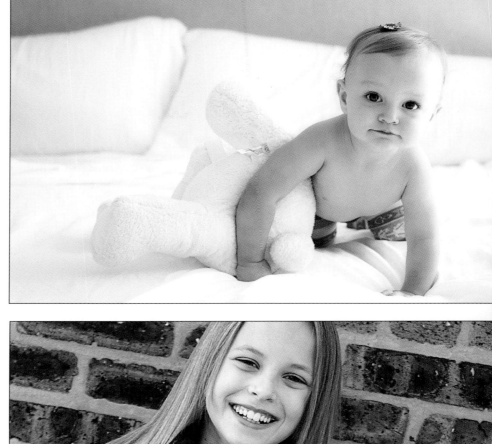

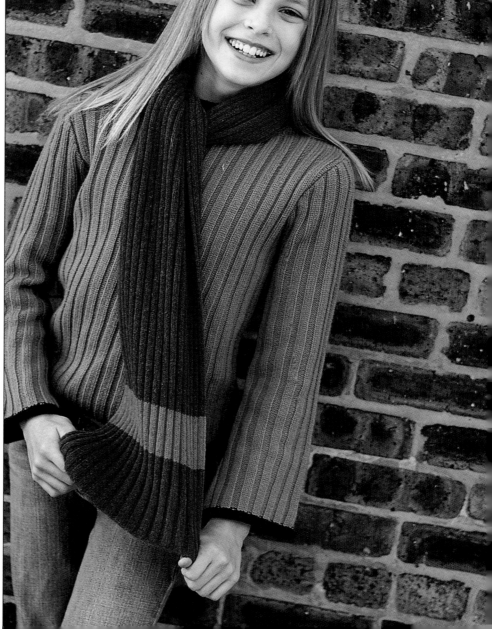

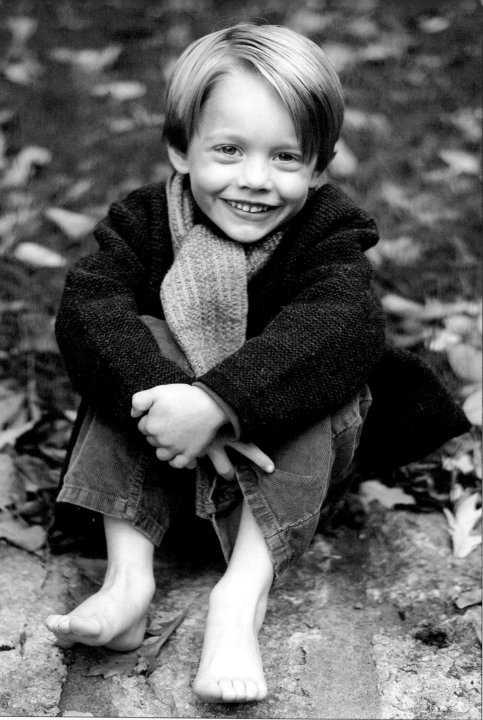

one parent (or both) wants to stick around, I tell them that they will have a lot of images where the child is looking off to one side or another, and then I suggest that they step out of the room.

Photographing Outdoors. I try to stay in open shade, which is softer and ensures the subjects do not squint. I also try to avoid a session with the sun at its highest point; but when I have to schedule an outdoor session around noon, I always look for open shade. If there isn't any, I keep the sun behind my subject and make the most of backlighting.

For outdoor settings, I use background trees, the beach, a brick wall, or an alley. I stay away from some backgrounds to avoid repetition and keep things fresh. I do allow kids to run freely, and I usually run with them. When they stop, I'm ready to photograph. I interact with them rather than just watch. For eye contact, I must interact with my subjects.

How do you anticipate gestures and expressions?

All children, regardless of age, have appealing expressions, gestures, etc. I try to capture these by gaining their trust. It doesn't take long for them to feel at ease. Because I can be a big goofball, I catch some genuine smiles. I don't tell stories, but I say things to make them laugh, or we will play games that engage them; I do not use props.

Digital or film?

I photograph digitally and show both color and black & white images. I think black & white photography has definitely made a comeback, and rightfully so. It is beautiful, but I love color images as well. I don't ask clients to decide ahead of time. If an image looks good in both black & white and color, I show it both ways. Images that are better in color I show that way. I photograph between ISO 100 and 400, rarely at 800.

Do you shoot sequential bursts?

I don't usually plan to capture any sort of sequence photos. I don't often try to be a candid shooter. I crave eye

where the best light was. Luckily, bathrooms are almost all bright enough to reflect the light.

I explore the house for the best available light, and I conduct the session there. I look for items that would be picture friendly, such as furniture, walls, pillows, and rugs. I also pick out clothing for the session. I usually take the children off by themselves; while I work, parents can do chores, make telephone calls, or watch television. A few parents just want to be there, but I don't want the parent to direct their kids; I need their eye contact. To avoid confusion, I talk to the child and the parents alternately. If

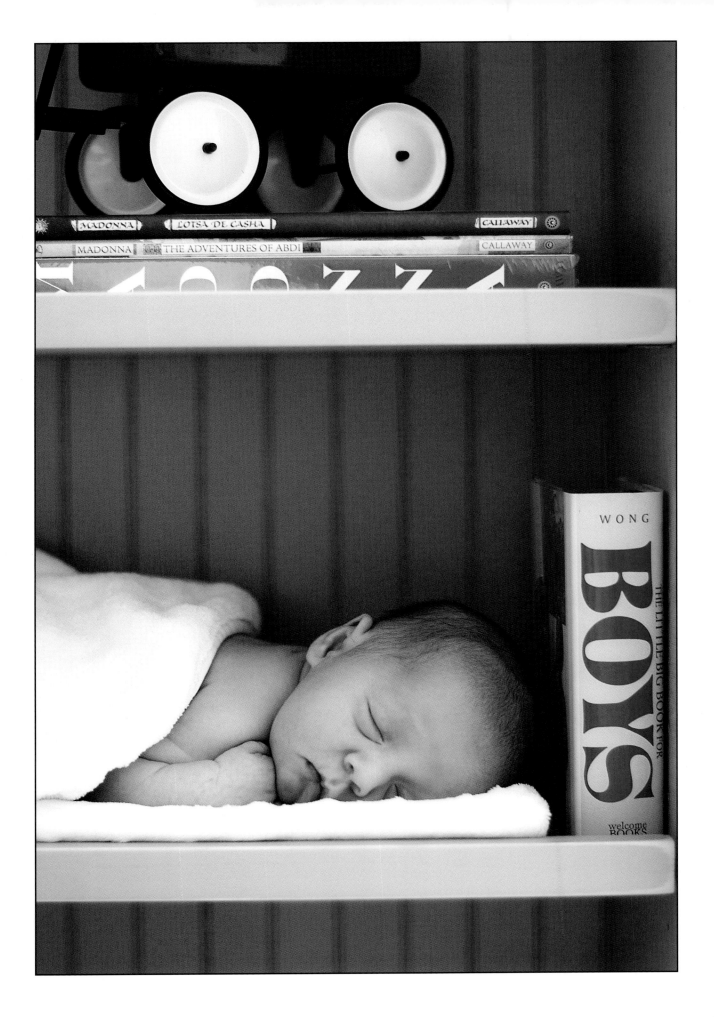

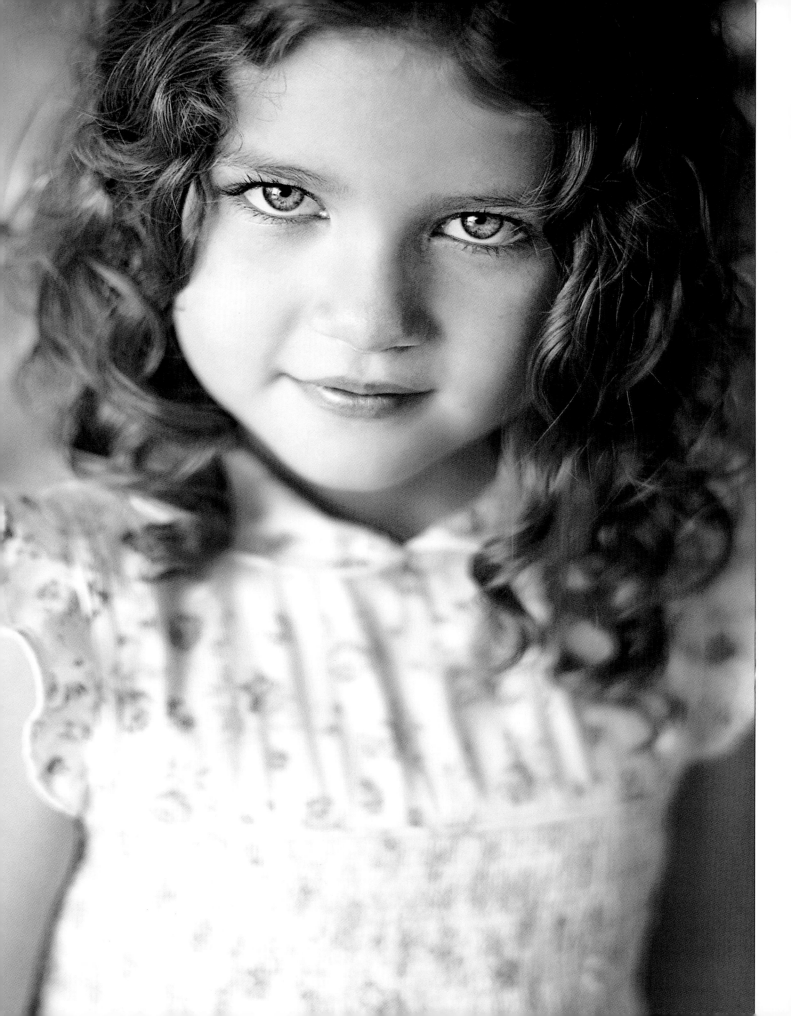

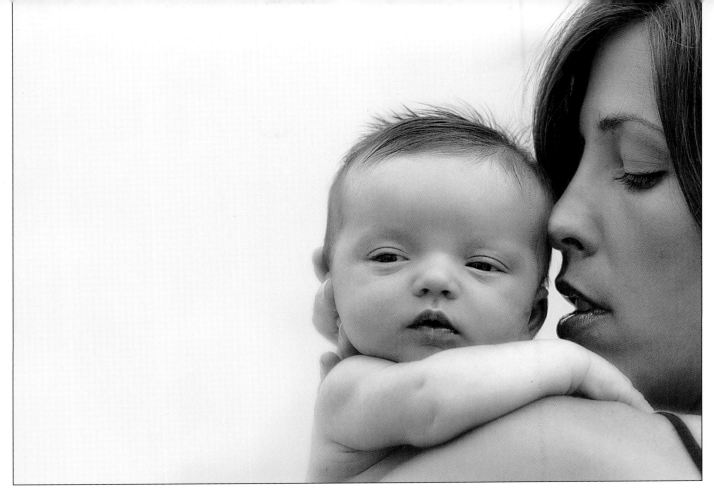

contact, which is the reason I don't photograph sequences, except when a child is learning to walk or is doing something cute. In my mind, sequenced photos are all fairly similar. Each image I show is rather different.

Camera and lenses?

I am presently using a Fuji S3 Pro camera that takes Nikon lenses, and my favorite is the Nikkor 50mm f/1.4. Prime lenses are perfect for indoor, natural-light photography at wide apertures. I feel they are sharper than zooms. I like to think that my sessions are pretty intimate, so using the 50mm allows me to get up close and personal with each of my subjects while taking their pictures.

How do you promote your studio?

My web site is my single most effective marketing tool. It is how I show my work to present and future clients, and it is how I communicate with them as well. I keep my web site very current with monthly updates to encourage people not only to visit but come back often. I think that my style is always evolving.

When I began, I made an alliance with a business in the area where I wanted to create a clientele, and I put up a display of large images, which happened to be pictures of the owner's children. Those people are still my clients and friends, and I photograph their nuclear family and extended families regularly.

Currently, I also have canvas prints displayed in Chicago at Madison and Friends Children's Boutique. I have become known by word-of-mouth advertising from satisfied clients and through web-site exposure.

What are your pricing categories?

I have a session fee for my time only and print prices based on size. I would describe my pricing as medium high, though pricing is so relative to individual markets. Compared to some photographers in my area, my prices are not high; compared to photographers in more rural areas, I would be considered very high. I raise prices nearly every year, based primarily on sales volume.

Describe your editing and printing process.

I edit all my pictures and I use a professional lab to print them. With my family and my workload, a lab is my very best option. However, for my commercial teen model work, I don't print anything. I give them images on a CD,

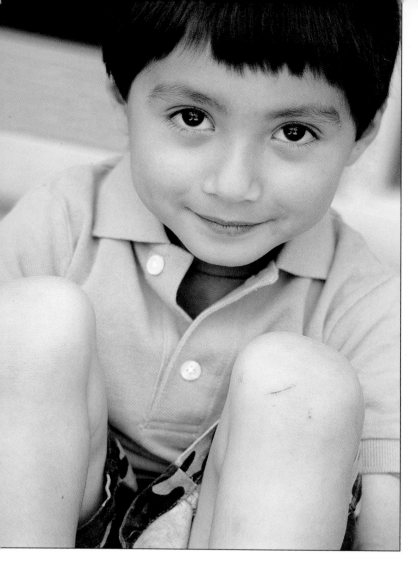

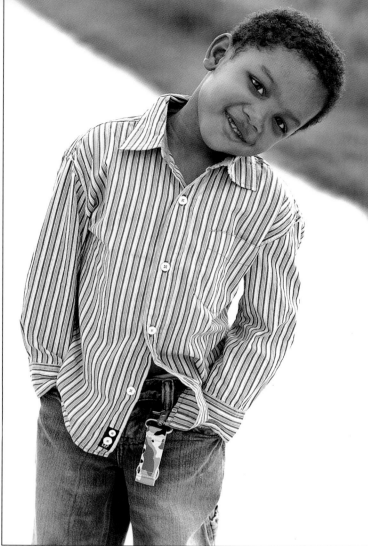

and the clients have their own prints made. I offer a flat rate for photographing a model's portfolio, which is not the same as in traditional commercial photography where I would charge usage fees. With my teen models, I turn over JPEG files and my lab does all the retouching before printing. The lab also does a minimum of retouching on my children's portrait photography. I feel that children don't need a lot of Photoshop work. If a child has drool on his or her face, it stays. I have a picture of a baby on my business card with drool coming down her lip. Children are not always "perfect," and I don't intend to make them appear that way.

How do you present your pictures to clients?

After we set up an ordering appointment, I take paper proofs to my client's home. They make choices then and there. Clients may keep the session album of proofs if they purchase it.

Describe your album layouts and common print sizes.

I sell a handmade album that contains all the edited images from a session. I assemble prints in the album myself. They are usually 5x7-inch prints, and I keep designs pretty simple. The most popular sizes that my clients purchase are 8x10- and 16x20-inch prints. Because my style of photography is not traditional, I tend to attract a very contemporary clientele whose homes are decorated in a similar fashion.

Does a photographer's personality influence their success?

I think my personality is a key to my success. I am very much a people person, and I am very interested in all of my clients. I love talking with them and learning about them. I am always pleased to find that we have a lot in common, and I am good friends with many of them; I am flattered when they welcome me into their homes as an old friend. I think that when you are working with children, if you aren't personable, you can't be successful!

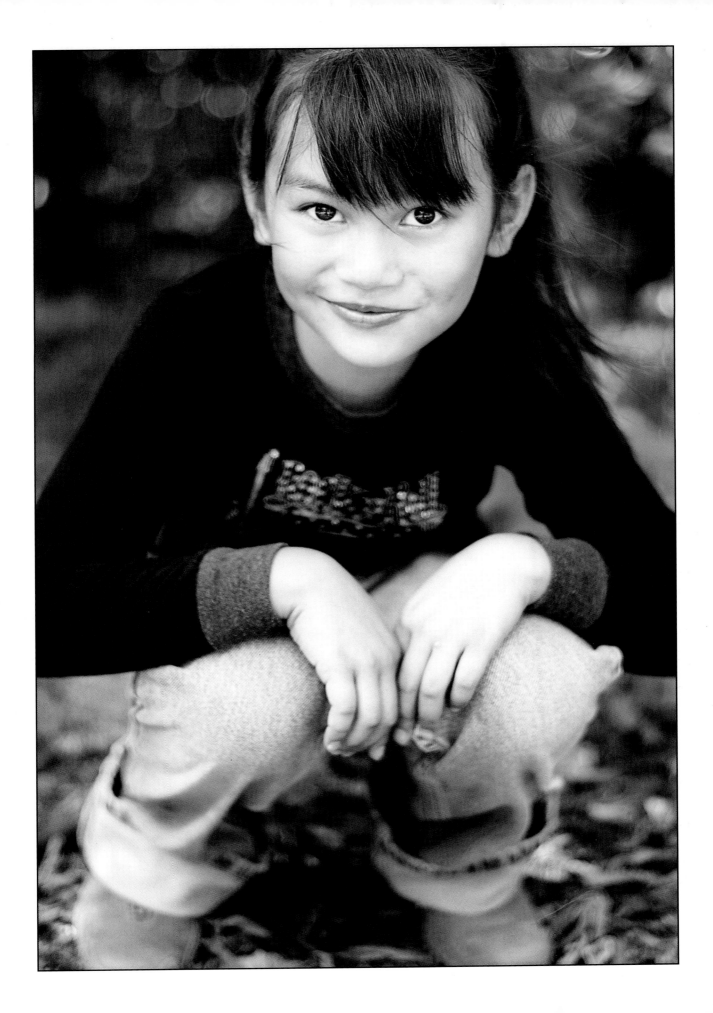

CONCLUSION

As I finished writing this book, I thought about what I had learned from fifteen versatile and helpful people. One thing that stands out is the need to really love and understand kids in order to succeed in this most challenging of portrait fields.

Another common thread is that, as parents themselves, most of the photographers in this book face the challenge of balancing their career with the needs of their families. As each example shows, however, they are able to rise to the challenge in a variety of ways.

Additionally, most of these talented photographers are self-taught. They have turned photography from a hobby into a career by working hard, studying the work of other photographers, and drawing on the experience of mentors and other experienced professionals.

Finally, most of those artists profiled place little emphasis on equipment. Many even use exclusively natural light to capture their precious images.

Whether you come to it as an enthusiastic novice or a trained professional, it is your personality, your creativity, your patience, and your ability to connect with children that will determine your success in this field. As these examples show, for the right person, a career in children's portrait photography can be both creatively and professionally rewarding.

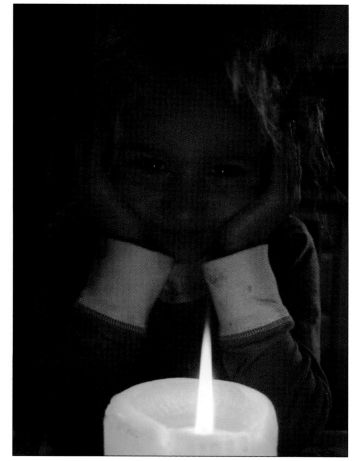

PHOTOGRAPH BY LOU JACOBS JR.

INDEX

PHOTOGRAPHER'S LIGHTING HANDBOOK

Lou Jacobs Jr.

Think you need a room full of expensive lighting equipment to get great shots? With a few simple techniques and basic equipment, you can produce the images you desire. $29.95 list, 8½x11, 128p, 130 color photos, order no. 1737.

TAKE GREAT PICTURES

A SIMPLE GUIDE

Lou Jacobs Jr.

What makes a great picture? Master the basics of exposure, lighting, and composition to create more satisfying images. Perfect for those new to photography! $14.95 list, 9x6, 112p, 80 color photos, index, order no. 1761.

HOW TO START AND OPERATE A
DIGITAL PORTRAIT PHOTOGRAPHY STUDIO

Lou Jacobs Jr.

Learn how to build a successful digital portrait photography business—or breathe new life into an existing studio. $39.95 list, 6x9, 224p, 150 color images, index, order no. 1811.

MASTER'S GUIDE TO WEDDING PHOTOGRAPHY

CAPTURING UNFORGETTABLE MOMENTS AND LASTING IMPRESSIONS

Marcus Bell

Learn to capture the unique energy and mood of each wedding and build a lifelong client relationship. $34.95 list, 8½x11, 128p, 200 color photos, index, order no. 1832.

PROFESSIONAL PORTRAIT LIGHTING

TECHNIQUES AND IMAGES FROM MASTER PHOTOGRAPHERS

Michelle Perkins

Get a behind-the-scenes look at the lighting techniques employed by the world's top portrait photographers. $34.95 list, 8½x11, 128p, 200 color photos, index, order no. 2000.

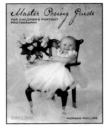

MASTER POSING GUIDE

FOR CHILDREN'S PORTRAIT PHOTOGRAPHY

Norman Phillips

Create perfect portraits of infants, tots, kids, and teens. Includes techniques for standing, sitting, and floor poses for boys and girls, individuals, and groups. $34.95 list, 8½x11, 128p, 305 color images, order no. 1826.

BEGINNER'S GUIDE TO ADOBE® PHOTOSHOP®, 3rd Ed.

Michelle Perkins

Enhance your photos, create original artwork, or add unique effects to any image. Topics are presented in short, easy-to-digest sections that will boost confidence and ensure outstanding images. $34.95 list, 8½x11, 128p, 80 color images, 120 screen shots, order no. 1823.

THE BEST OF FAMILY PORTRAIT PHOTOGRAPHY

Bill Hurter

Acclaimed photographers reveal the secrets behind their most successful family portraits. Packed with award-winning images and helpful techniques. $34.95 list, 8½x11, 128p, 150 color photos, index, order no. 1812.

DIGITAL PORTRAIT PHOTOGRAPHY OF
TEENS AND SENIORS

Patrick Rice

Learn the techniques top professionals use to shoot and sell portraits of teens and high-school seniors! Includes tips for every phase of the digital process. $34.95 list, 8½x11, 128p, 200 color photos, index, order no. 1803.

THE BEST OF PHOTOGRAPHIC LIGHTING

Bill Hurter

Top professionals reveal the secrets behind their successful strategies for studio, location, and outdoor lighting. Packed with tips for portraits, still lifes, and more. $34.95 list, 8½x11, 128p, 150 color photos, index, order no. 1808.

MARKETING & SELLING TECHNIQUES

FOR DIGITAL PORTRAIT PHOTOGRAPHY
Kathleen Hawkins

Great portraits aren't enough to ensure the success of your business! Learn how to attract clients and boost your sales. $34.95 list, 8½x11, 128p, 150 color photos, index, order no. 1804.

MASTER LIGHTING GUIDE

FOR PORTRAIT PHOTOGRAPHERS
Christopher Grey

Efficiently light executive and model portraits, high and low key images, and more. Master traditional lighting styles and use creative modifications that will maximize your results. $29.95 list, 8½x11, 128p, 300 color photos, index, order no. 1778.

FANTASY PORTRAIT PHOTOGRAPHY

Kimarie Richardson

Learn how to create stunning portraits with fantasy themes—from fairies and angels, to 1940s glamour shots. Includes portrait ideas for infants through adults. $29.95 list, 8½x11, 128p, 60 color photos index, order no. 1777.

PHOTOGRAPHING CHILDREN WITH SPECIAL NEEDS

Karen Dórame

This book explains the symptoms of spina bifida, autism, cerebral palsy, and more, teaching photographers how to safely and effectively work with clients to capture the unique personalities of these children. $29.95 list, 8½x11, 128p, 100 color photos, order no. 1749.

THE BEST OF CHILDREN'S PORTRAIT PHOTOGRAPHY

Bill Hurter

Rangefinder editor Bill Hurter draws upon the experience and work of top professional photographers, uncovering the creative and technical skills they use to create their magical portraits of these young subejcts. $29.95 list, 8½x11, 128p, 150 color photos, order no. 1752.

LIGHTING TECHNIQUES FOR
HIGH KEY PORTRAIT PHOTOGRAPHY

Norman Phillips

Learn to meet the challenges of high key portrait photography and produce images your clients will adore. $29.95 list, 8½x11, 128p, 100 color photos, order no. 1736.

STUDIO PORTRAIT PHOTOGRAPHY OF CHILDREN AND BABIES, 2nd Ed.

Marilyn Sholin

Work with the youngest portrait clients to create cherished images. Includes techniques for working with kids at every developmental stage, from infant to preschooler. $29.95 list, 8½x11, 128p, 90 color photos, order no. 1657.

PHOTOGRAPHING CHILDREN IN BLACK & WHITE

Helen T. Boursier

Learn the techniques professionals use to capture classic portraits of children (of all ages) in black & white. Discover posing, shooting, lighting, and marketing techniques for black & white portraiture in the studio or on location. $29.95 list, 8½x11, 128p, 100 b&w photos, order no. 1676.

PROFESSIONAL SECRETS FOR PHOTOGRAPHING CHILDREN

2nd Ed.
Douglas Allen Box

Covers every aspect of photographing children, from preparing them for the shoot, to selecting the right clothes to capture a child's personality, and shooting storybook themes. $29.95 list, 8½x11, 128p, 80 color photos, index, order no. 1635.